SCOTTISH AND MANX LIGHTHOUSES

A PHOTOGRAPHIC JOURNEY IN THE FOOTSTEPS OF THE STEVENSONS

IAN COWE

NORTHERN LIGHTHOUSE HERITAGE TRUST

EDINBURGH

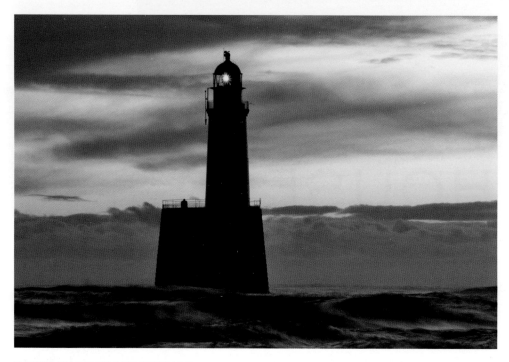

RATTRAY HEAD LIGHTHOUSE

FOR EILEEN AND RACHEL

The light shines in the darkness, and the darkness has not overcome it.

JOHN 1 VS 5

Published by
The Northern Lighthouse Heritage Trust
84 George Street,
Edinburgh,
EH2 3DA

© 2015 Text: Northern Lighthouse Heritage Trust. Photographs: Ian Cowe

ISBN 978-09567209-1-7

Print managed by Jellyfish Solutions Ltd

CONTENTS

BUCKINGHAM PALACE

Having served as Patron of the Northern Lighthouse Board since 1993, I have had the privilege of travelling on the Board's vessels PHAROS and POLE STAR, seeing our lighthouses and Scotland at its very best.

Ian Cowe's journey by foot, car, boat, plane and helicopter around our coast capturing the great lights built by the Stevenson engineers shows a real dedication. The buildings, their remoteness and exceptional natural beauty have been captured and shared throughout this book. The lighthouses stand testament to the dedicated work of the Stevenson engineers – built to last for the benefit of the mariner. Each light being quite different from the next as the generations of an engineering dynasty developed their own style but still very obviously and easily recognisable as Stevenson lighthouses. This book celebrates their work, which took them further afield than just our shores as world renowned lighthouse engineers.

The Northern Lighthouse Board is, and always has been, a changing service as advances in technology are made but the network of lights established from as early as 1787 by the Stevensons still remain fundamental to today's service and network of modern aids to navigation – merging the old with the new. I congratulate Ian Cowe on producing this book which I am sure you will enjoy.

Anne

PREFACE

The Northern Lighthouse Heritage Trust is proud to publish this book. The Trust was set up as a charity by the Commissioners of Northern Lighthouses with the principal aim of raising public awareness of the wonderful lighthouse heritage to be found in Scotland and the Isle of Man. Ian Cowe's book will do just that and Ian has generously decided that any profit from the book will go towards the work of the Trust.

In addition to supporting the publication of this and other books, the Trust has mounted an oral history project to preserve for posterity the voices of lightkeepers and their families, many of whom spent lonely lives in far away places keeping the lights burning before automation was completed in 1998. We have also supported coastal communities in raising awareness of their own lighthouse heritage and are always ready to consider requests for assistance - and hope that members of similar communities reading this lovely book will become more aware of Scotland's historic lighthouse heritage of world importance and will want to raise awareness of it in their own locality.

Our very sincere thanks go to Ian for generously sharing his passion and his art with us. Robert Louis Stevenson memorably described his family's legacy in these words: "far along the sounding coast its pyramids and tall memorials catch the dying sun". What RLS did with words Ian has done with visual poetry, as we revisit these wonderful "pyramids and tall memorials".

We also thank HRH The Princess Royal for her warm and supportive foreword - which reflects her continuing interest in and enthusiasm for the work of the Northern Lighthouse Board and its Stevenson heritage, most of which she has visited over more than 20 years as its Patron.

PETER MACKAY
CHAIRMAN
NORTHERN LIGHTHOUSE HERITAGE TRUST

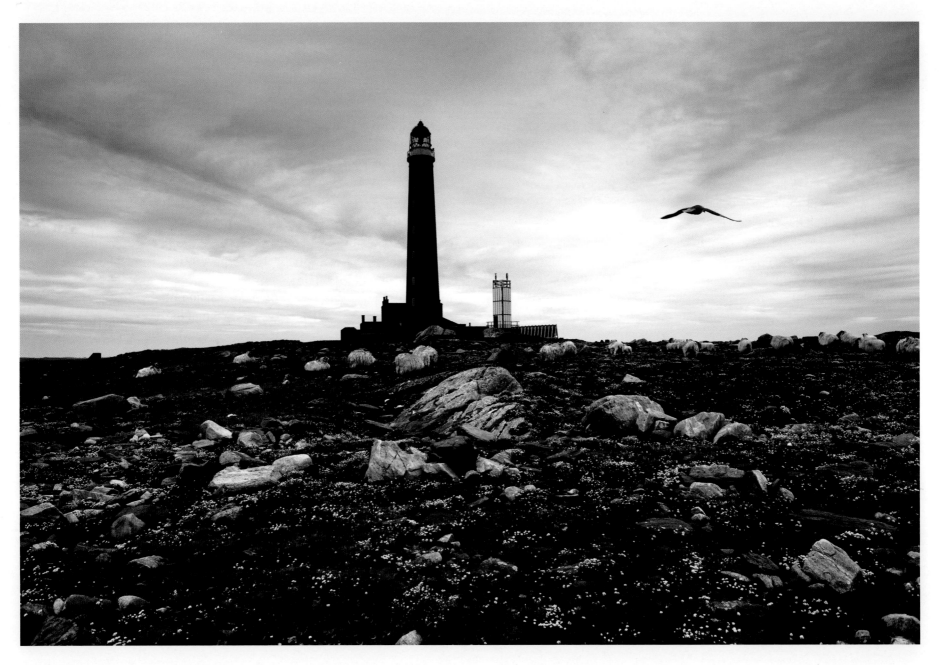

THE MONACHS LIGHTHOUSE

ACKNOWLEDGEMENTS

I would like to thank Her Royal Highness The Princess Royal for writing the Foreword to this book. I am honoured that Her Royal Highness as Patron of The Board has taken an interest in my work.

My thanks go to the Northern Lighthouse Heritage Trust, without whose support this book would not have been possible. The Trust do an excellent job of promoting the wonderful lighthouse heritage we have in Scotland and the Isle of Man. I would particularly like to thank the Trust's Chairman Peter Mackay for his very kind words in the Preface as well as his valuable advice on the text for the book during its development. Thanks also to Mike Bullock, Chief Executive of the Northern Lighthouse Board (NLB), who reviewed the text and supported the creation of this book, and his predecessor, Roger Lockwood, who championed the book in its early stages.

My appreciation goes to Lorna Hunter, who, as my main point of contact with the NLB, has helped organise trips to many of the lighthouses. This book has created a great deal of additional work for her and I am extremely grateful for the assistance she has provided.

My grateful thanks go to the NLB staff (from 84 George Street, technicians and Retained Lighthouse Keepers) who have looked after me during my lighthouse visits. Captain Sean Rathbone, Captain Eric Smith and the crew of the *NLV Pharos* extended great hospitality to me whilst I was on board the ship. Special thanks go to RLKs Fred Fox and Billy Muir who provided additional assistance during my stay on the Isle of Man and North Ronaldsay respectively.

I am indebted to my good friend David Taylor (owner of the Bell Rock website) and his wife Nessie who proof-read the text. David's excellent website has also been a great source of information.

Thanks to David Taylor of the Association of Lighthouse Keepers who provided valuable feedback of an initial draft of the book.

A special mention goes to Colin Murray who has very kindly taken me out in his boat to visit the islands of the Firth of Forth.

Finally I would like to thank my wife, Eileen, for her patience when accompanying me over numerous miles of winding roads, or being woken up as I set off to capture yet another early morning sunrise! Her help when writing the book and selecting the pictures has been immeasurable.

ONE OF MY EARLIER EXPEDITIONS
TO RATTRAY HEAD!

INTRODUCTION

I can't quite explain why, but I have probably been a lighthouse enthusiast since birth. Perhaps it is because they are located on spectacular stretches of coastline; or that they are marvels of engineering; or indeed beautiful buildings of great architectural interest. Growing up in a seafaring community on the north-east coast of Scotland, I was never far from a lighthouse and have many happy memories of pestering my folks to take me to see some of these. My father and grandfather were both trawlermen and there was always a tale to be told about the lighthouses they had seen when they returned from their trips on the open seas.

As a young boy, I loved reading the stories of the building and manning of these sentinels of the sea. There was something quite awe inspiring about the struggle in the most adverse of conditions to make our coastline a safer place for mariners.

In my twenties and early thirties I had travelled extensively around the globe. However, I was aware that there were large swathes of Scotland which I had never explored including most of the lighthouses I had read so much about in my childhood. My initial thoughts were to try and photograph some of the more famous lights on the west coast and Northern Isles. This soon grew into a quest to photograph all the lighthouses which the Stevenson family of engineers built.

The photographs you see in this book are the result of a great deal of travelling over a seven year period by foot, car, boat, plane and helicopter. There have been many early morning alarm calls to catch the dawn light and roaming in the twilight after capturing a wonderful sunset. As well as the lighthouses, I've seen some world class scenery and wildlife. I've also met some great people along the way. During this time I've built up a very good relationship with the Northern Lighthouse Board and been privileged to gain access to a number of very remote offshore lighthouses which (for obvious reasons) are normally only accessible to their own staff and contractors.

I can't take credit for being the first photographer to attempt to photograph all of the lighthouses around the Scottish coast. Of particular note are the books *At Scotland's Edge* and *At Scotland's Edge Revisited* by Keith Allardyce which provide an excellent photographic record of the Northern Lighthouse Board during the 1980s and 90s as the process of automation gathered pace. Those books concentrated on the keepers and their families while I have focused more on the actual lights and have tried to capture the drama and beauty of these wonderful buildings. This new collection offers a snapshot of Scotland's lighthouses taken since the advent of digital photography. The pictures were taken using a Nikon D300 and D600 with a variety of wide angle and zoom lenses.

In writing this book I hope to appeal to both lighthouse enthusiasts and those who are unfamiliar with the subject alike. There are already a number of excellent books on the history of Scotland's lighthouses so I have not attempted to provide detailed information on each and every lighthouse. What I have done is to recount some of the more interesting stories and facts along with my own experiences when photographing these places. I have also offered an insight into the Northern Lighthouse Board in the 21st century.

So come with me on a journey around our beautiful coastline. After an introduction to the work of the Northern Lighthouse Board and the Stevensons, we'll travel from St Abb's Head on the east coast of Scotland all the way round to Chicken Rock off the Isle of Man.

My hope is that you'll gain a greater appreciation of the rich lighthouse heritage we have here in Scotland and be inspired to discover some of these places for yourself.

IAN COWE
BALMEDIE, ABERDEENSHIRE

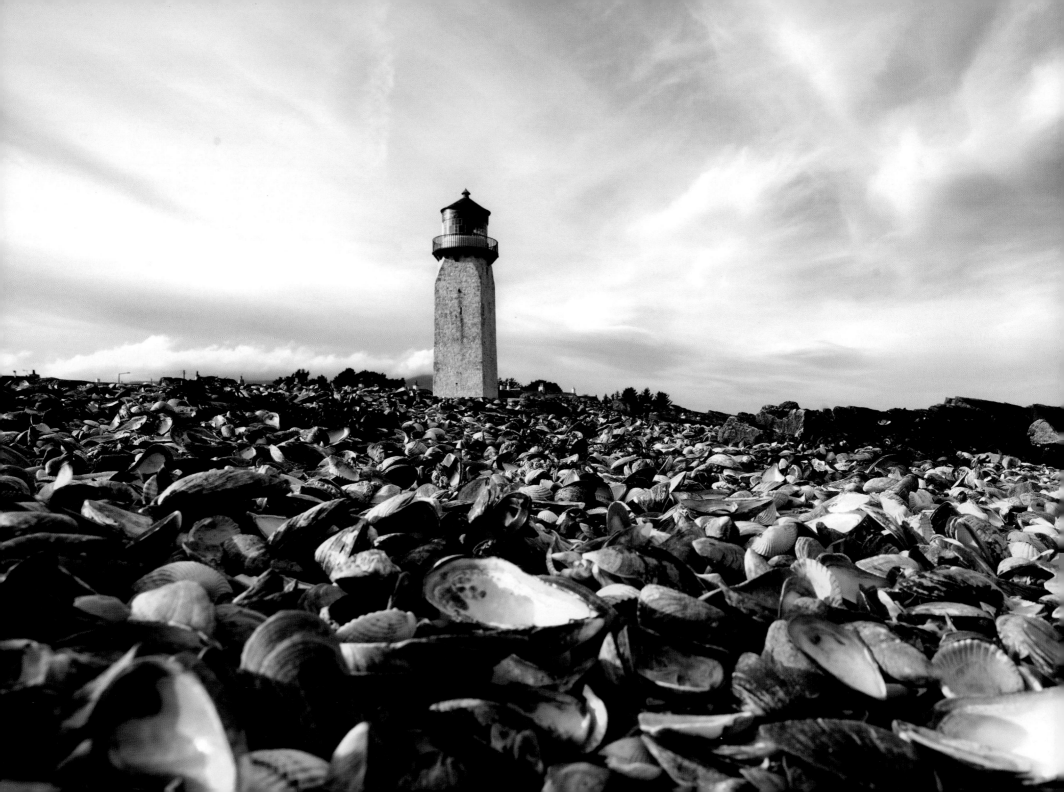

EARLY LIGHTHOUSES

The coastline of Scotland stretches for over 11,500 miles including all islands and presents some of the most treacherous conditions for shipping in Western Europe. In the 21st century the mariner has a wide range of tools at his disposal including lighthouses, buoys and satellite systems for navigating around this wild and rugged coastline. The early 17th century mariner had no such aids to help him and was faced with an extremely perilous prospect when sailing during the hours of darkness.

The first attempt at building a permanently manned lighthouse in Scotland came in 1636, when a privately owned stone tower was built on the Isle of May in the Firth of Forth.

A number of other lighthouses would be built over the next century including those at Buddon Ness on the mouth of the River Tay (1687, The Trinity House of Dundee), Southerness on the Solway Firth (1749, Dumfries Town Council) and Little Cumbrae on the Firth of Clyde (1757, Cumbrae Lighthouse Trust).

These early lighthouses all had one thing in common; they were generally rudimentary stone towers with coal braziers mounted on top which proved to be unreliable. Mariners would often find them obscured by the sea conditions or difficult to distinguish from the lights of towns and settlements on the shoreline.

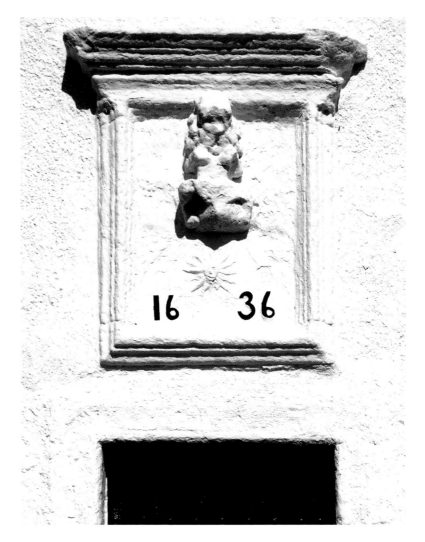

[ABOVE] DETAIL AND DATE ABOVE THE DOORWAY TO THE FIRST LIGHTHOUSE ON THE ISLE OF MAY

[OPPOSITE] THE LIGHTHOUSE AT SOUTHERNESS WAS BUILT IN 1749 TO GUIDE SHIPS IN THE SOLWAY FIRTH. THE STRUCTURE WAS ALTERED ON A NUMBER OF OCCASIONS AND FINALLY EXTINGUISHED IN 1936

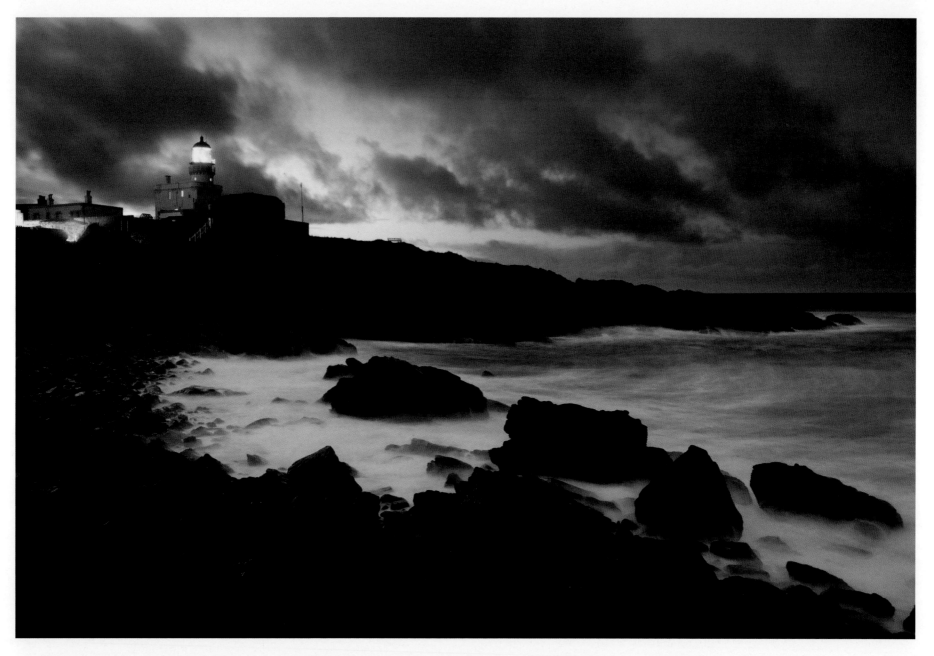

1ST DECEMBER 2012 WAS THE 225TH ANNIVERSARY OF THE ESTABLISHMENT OF KINNAIRD HEAD LIGHTHOUSE. THIS SPECIAL OCCASION WAS MARKED BY SWITCHING THE LIGHT BACK ON FOR THE EVENING

THE NORTHERN LIGHTHOUSE BOARD

As the seas around Scotland became busier in the 18ᵗʰ century, the number of ships coming to grief steadily rose and pressure mounted for action to be taken.

George Dempster, a Scottish MP, was instrumental in preparing a Bill which went before Parliament for the creation of a new Board of Trustees that would be responsible for building four lighthouses at selected locations around the Scottish coast. The resulting Act of Parliament led to the appointment in 1786 of a board of nineteen commissioners (which included the Sheriffs, Provosts and Lord Provosts from the main coastal regions) to oversee this task. These commissioners (later to become known as the Commissioners of Northern Lighthouses) had the right to collect dues from the ships which had benefited from these lights once they arrived in port. Further legislation was enacted a few years later increasing their authority to build lighthouses wherever they felt necessary around the Scottish coast.

The Commissioners appointed Thomas Smith (1752 -1815), an Edinburgh tinsmith and lamp maker, to be their first engineer. Smith had been brought to the attention of the Commissioners after showing an interest in applying his lamp technology to lighthouses. Before setting to work, he was sent to England for training in lighthouse building and illumination from a Mr Ezekiel Walker who had been responsible for lighting improvements at Hunstanton lighthouse in Norfolk.

The first lighthouse Thomas Smith established was at Kinnaird Head in the town of Fraserburgh to mark the north-east corner of Scotland where

THE HEADQUARTERS OF THE NORTHERN LIGHTHOUSE BOARD HAVE BEEN HOUSED BEHIND THE ELEGANT GEORGIAN FACADE OF 84 GEORGE STREET SINCE 1832. THE STEVENSONS' CIVIL ENGINEERING FIRM WAS ALSO LOCATED IN THE BUILDING UNTIL THE 1930s

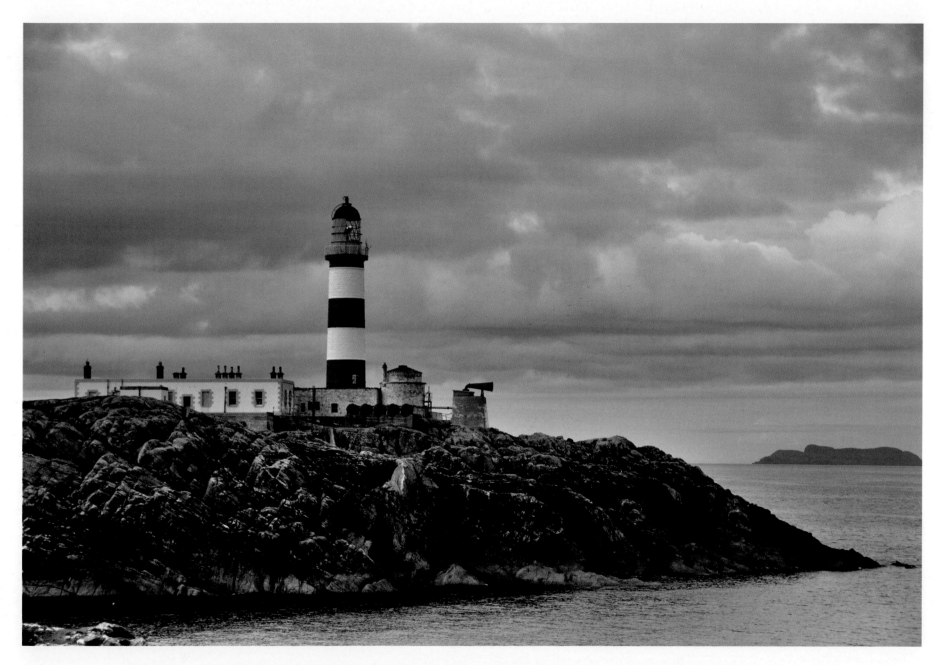

EILEAN GLAS LIGHTHOUSE. THE ORIGINAL LIGHTHOUSE OF 1789 CAN BE SEEN
IMMEDIATELY TO THE RIGHT OF ROBERT STEVENSON'S 1820s TOWER

the Moray Firth meets the North Sea. A lantern was constructed on top of the existing 16th century Kinnaird Castle. The light was produced by arrays of lamps burning whale oil, each of them backed by its curved reflector made up of small squares of silvered mirror-glass. The light first shone on 1st December 1787.

Smith's next project at the Mull of Kintyre was a much more challenging prospect. The remote site at the parting of the ways between the Firth of Clyde and the Irish Sea was located at the top of a cliff with no access road across the hilly moorland. The nearest landing point for shipping in materials was 6 miles away and everything then had to be carried on horseback. The lighthouse first shone in November 1788.

The next two lighthouses to be built were both in island locations. The lights on Eilean Glas on the island of Scalpay, marking The Minch, and North Ronaldsay, the most northerly of the Orkney Islands, were both lit in 1789. In the case of Eilean Glas, it was discovered that the local tenant had already started building a tower of his own. Smith was then forced to modify his design to complete the partially built structure.

In addition to supervising the building of these lights, Smith was also responsible for appointing and instructing lightkeepers to look after these new lights.

NORTH RONALDSAY. AN AERIAL VIEW OF THOMAS STEVENSON'S 1789 LIGHTHOUSE

[LEFT] A DETAIL FROM AN ANTIQUE TABLE WHICH WAS MADE
FOR THE STRANGER'S ROOM IN THE BELL ROCK LIGHTHOUSE.
THE TABLE IS NOW IN THE FOYER OF 84 GEORGE STREET

[RIGHT] A DETAIL FROM AN ANTIQUE CHAIR ORIGINALLY
USED IN THE ISLE OF MAY FOR COMMISSIONERS' MEETINGS.
THE MOTTO OF THE NORTHERN LIGHTHOUSE BOARD IS
'IN SALUTEM OMNIUM' (FOR THE SAFETY OF ALL)

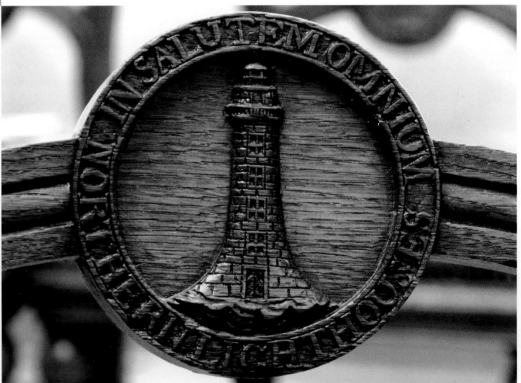

THE STEVENSON FAMILY

Thomas Smith suffered a number of personal tragedies, having the misfortune of being widowed and left with young children to bring up. Through church connections, the Smith family had met and befriended a certain Jean Stevenson. On seeing Thomas Smith's plight, she offered to look after his children whenever he had to go away on lighthouse business.

Jean's first husband had died of fever whilst on a trip to the West Indies, leaving her alone to bring up their son **Robert Stevenson (1772-1850)** who was aged just two at the time. She had married again but her second husband deserted her. She then moved to Edinburgh with Robert and enrolled him in a charity school there. Upon leaving school, Robert served an apprenticeship as a gunsmith. In 1791 Thomas Smith employed the 19-year-old Robert to provide assistance with his steadily increasing workload. Robert also attended classes in natural philosophy at Glasgow University around this time where he was guided towards an engineering career. In 1792 Thomas Smith became Robert's stepfather when he married Jean Stevenson following the death of his second wife.

Robert was entrusted with supervising the construction of the lighthouses at Little Cumbrae (1793) and Pentland Skerries (1794). By 1797 Thomas Smith had delegated most of the lighthouse work to him. In 1799 Robert married Thomas Smith's eldest daughter Jane (from his first marriage). The turn of the century saw Robert attend classes at the University of Edinburgh to further his knowledge. It was also around this

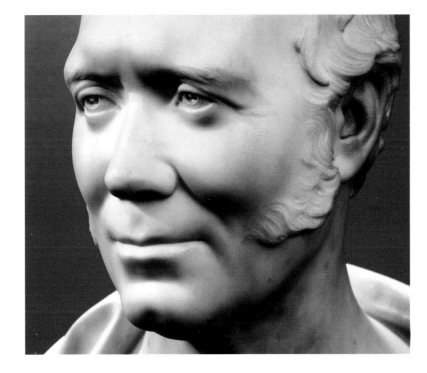

THIS MARBLE BUST OF ROBERT STEVENSON WAS MADE FOR THE STRANGER'S ROOM IN THE BELL ROCK LIGHTHOUSE. IT IS NOW KEPT IN THE FOYER AT 84 GEORGE STREET

time that his focus turned towards building a lighthouse on the notorious Bell or Inchcape Rock 11 miles off the coast of Angus. In 1806 the Northern Lighthouse Board appointed the illustrious civil engineer John Rennie as Chief Engineer with Robert Stevenson as Resident Engineer. Robert planned and executed the works on site sharing the hardships and dangers with those under his charge. He narrowly escaped with his life shortly after construction commenced when the tender used for transferring men to the rock broke from her moorings. The two small boats which were left did not have the capacity to carry all those stranded on the rock (which by this time was rapidly being covered by the incoming tide). The grave situation was only averted with the timely arrival of a ship carrying mail from Arbroath.

The completion of the Bell Rock project saw Robert Stevenson gain a reputation as one of the foremost civil engineers of the day. As well as lighthouses, he designed many bridges, railways and harbours. From 1808 he held the post of Engineer to the Northern Lighthouse Board and oversaw the construction of new lighthouses as well as the rebuilding of some of the earlier lights designed by his father-in-law.

Perhaps his greatest achievement was the founding of an engineering dynasty that would span five generations – three sons, two grandsons and one great-grandson would all follow him and become lighthouse engineers. For over one hundred and fifty years the Stevensons battled against the elements to light the Scottish coastline. They constructed wonders of engineering which have withstood the test of time, most of which continue to operate today.

Robert's eldest surviving son, **Alan Stevenson (1807–1865)**, was the first to follow in his footsteps. After serving a comprehensive apprenticeship, he was appointed as Clerk of Works to the Northern Lighthouse Board. By far and away his biggest achievement was the construction of the lighthouse on the Skerryvore reef near the island of Tiree. The building of the lighthouse in a location which is subject to the full fury of the Atlantic was considered an even greater challenge than his father had faced at the Bell Rock. Skerryvore is considered to be the most graceful rock lighthouse in the world.

THE BELL ROCK LIGHTHOUSE

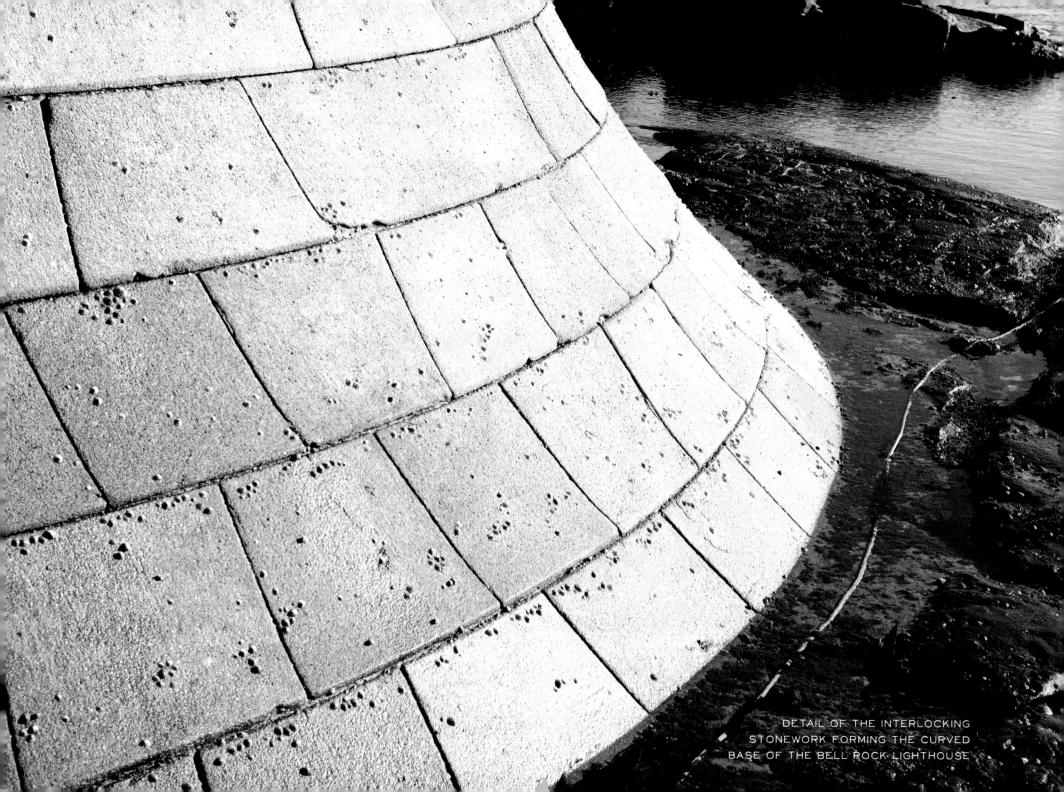

DETAIL OF THE INTERLOCKING
STONEWORK FORMING THE CURVED
BASE OF THE BELL ROCK LIGHTHOUSE

SKERRYVORE LIGHTHOUSE

Alan succeeded his father as Engineer to the Northern Lighthouse Board in 1843. Many of his lighthouse designs incorporated details influenced by the Neo-classical and Egyptian Revival architectural movements of the time. As well as building the actual towers, he was responsible for a number of lighting improvements. Alan visited France to study the work of the late Augustin Fresnel who had invented the Fresnel lens in the 1820s. He struck up a friendship with his brother, Leonor Fresnel, who continued the development of these lenses. The Fresnel Lens was a glass lens which went in front of the light source and provided a more efficient light than the polished metal reflectors being used in Scotland at that time. Under Alan's direction, Fresnel lenses were adopted in Scotland.

Alan Stevenson did not enjoy good health and his condition was probably aggravated by exposure to the elements during his many lighthouse tours. His declining health led him to resign from the post of Engineer to the Northern Lighthouse Board in 1853.

David Stevenson (1815–1886) was the next son to join the family business. He became a partner in 1838 where he was responsible for general engineering works including harbours and railways. One of the first challenges he faced upon succeeding his brother as Engineer to the Northern Lighthouse Board was the building of a lighthouse on Muckle Flugga, an exposed rocky outcrop at very top of the British Isles.

Thomas Stevenson (1818–1887), the youngest surviving son of Robert Stevenson, entered the family firm at the age of 17. He supervised the latter stages of the construction of Skerryvore lighthouse and also conducted research into the forces exerted by waves. In 1855, he took he took up a joint appointment with his brother David as Engineer to the Northern Lighthouse Board. A keen meteorologist, he was responsible for inventing the Stevenson Screen used to shelter thermometers.

In addition to their work for the Northern Lighthouse Board, David and Thomas provided advice on lighthouse construction in other countries including Japan and New Zealand.

Together they built the rock towers at Dubh Artach and Chicken Rock. Dubh Artach was a particularly daunting project. The original design had to be modified such was the ferocity of the sea in this inhospitable location.

Despite his great engineering achievements, Thomas will always be best known for being the father of the literary genius **Robert Louis Stevenson (1850 –1894)** the author of such classics as *Treasure Island, Kidnapped* and *Strange Case of Dr Jekyll and Mr Hyde.*

The relationship between father and son was a difficult one although there is no doubt that there was a deep love between the two. Thomas assumed that his only child would follow in his footsteps and design lighthouses. Whilst Robert Louis commenced training as an engineer he had neither the inclination nor the physical stamina for such a role. It was a great disappointment to his father when he announced that he would not be following this career path. He then qualified as a lawyer but immediately abandoned this in favour of writing which had always been his true passion. Another source of great tension was Robert Louis' rejection of his parents' strongly held Christian beliefs.

David's two sons **David A Stevenson (1854–1938)** and **Charles Stevenson (1855–1950)** continued in the family tradition. David A took over the post of Engineer to the Northern Lighthouse Board in 1885. Charles was the great inventor of the family and made many improvements to the lighting apparatus installed in lighthouses. He also experimented with wireless communication and the remote activation of equipment.

The lighthouses designed by David A and Charles Stevenson include those at Sule Skerry, Flannan Islands, Hyskeir and Rattray Head.

David A Stevenson held on to the post of Engineer until the ripe old age of 83. He had two daughters but no sons to succeed him in this post which may have been a factor in his reluctance to relinquish the position. On his death the Northern Lighthouse Board appointed an Engineer who was not a Stevenson ending their long association with the family.

Charles' son **D Alan Stevenson (1891–1971)** was also a lighthouse engineer. Although he was never appointed as Engineer to the Northern

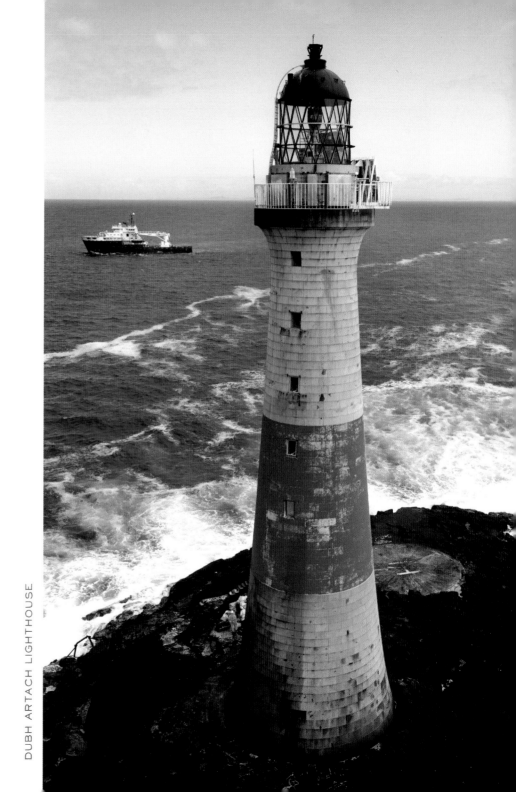

DUBH ARTACH LIGHTHOUSE

Lighthouse Board, he did continue the family association with the Clyde Lighthouses Trust by acting as their Engineer. His retirement in 1952 brought the story of the Stevenson family of engineers to a close. He would go on to become a world authority on the history of lighthouses.

"There is scarce a deep sea light from the Isle of Man to
North Berwick, but one of my blood designed it.
The Bell Rock stands monument for my grandfather;
the SkerryVhor for my uncle Alan;
and when the lights come out along the shores of Scotland,
I am proud to think that they burn more
brightly for the genius of my father."
Robert Louis Stevenson

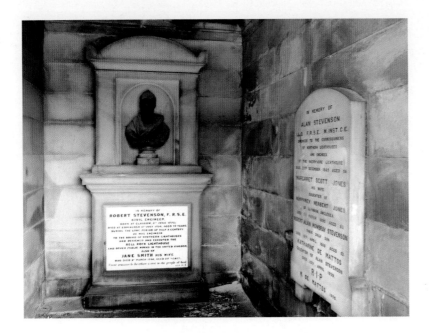

THE STEVENSON FAMILY BURIAL VAULT AT NEW CALTON CEMETERY, EDINBURGH. ROBERT, ALAN AND THOMAS STEVENSON ARE ALL INTERRED HERE

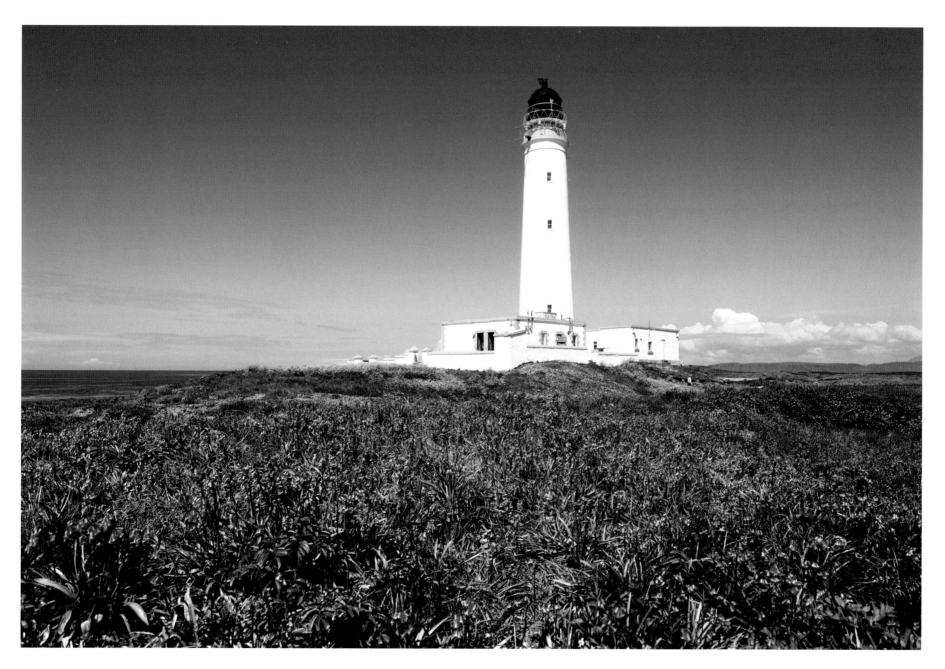

HYSKEIR LIGHTHOUSE

EAST COAST

ST ABB'S HEAD

Engineers:	David and Thomas Stevenson
Established:	1862
Automated:	1993
Character:	Flashing White every 10 seconds
Height:	9 metres
Status:	Operational
Authority:	NLB

Noss Head

Clyth Ness

Tarbat Ness

Covesea
Skerries

Kinnaird
Head

Cromarty

Rattray
Head

Chanonry

Buchan
Ness

Girdle
Ness

Tod Head

Scurdie Ness

Buddon Ness
High and Low

Bell Rock

North Carr

Elie Ness

Isle of May

Fidra

Bass Rock

Oxcars

Barns Ness

Inchkeith

St Abbs
Head

14

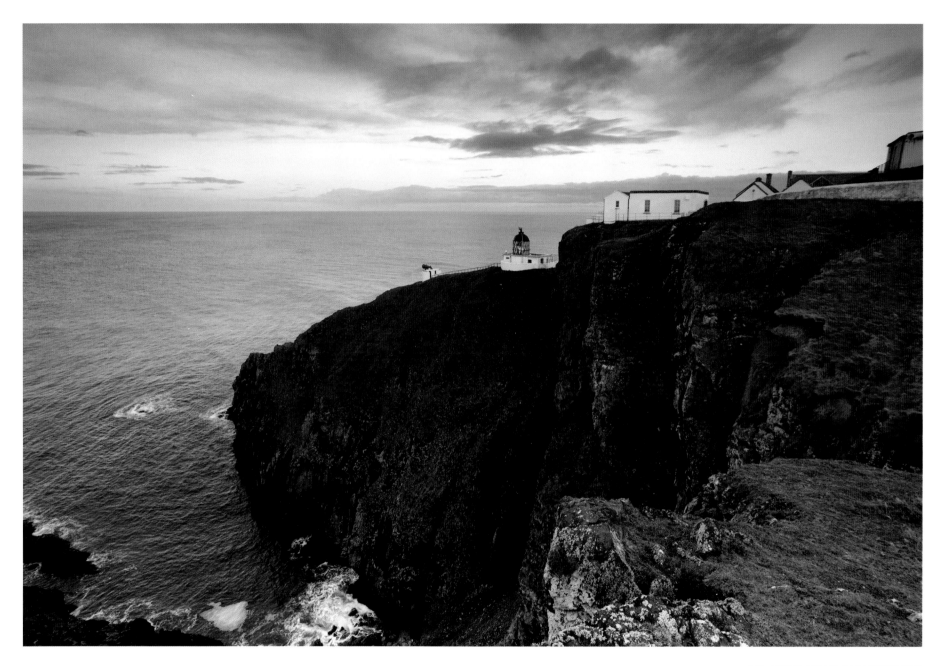

ST ABBS HEAD LIGHTHOUSE

BARNS NESS

Engineer:	David A Stevenson
Established:	1901
Automated:	1986
Character:	Isophase White every 4 seconds (Discontinued)
Height:	37 metres
Status:	Permanently discontinued with effect from 27 October 2005, now in private ownership

BASS ROCK

Every year the Bass Rock comes alive with the world's largest colony of Northern Gannets. The Bass Rock and Northern Gannet are so closely connected that the bird takes it scientific name 'Morus Bassanus' from the island.

The lighthouse sits on top of the ruins of an old prison where the unfortunate occupants (including the Covenanters) were held in terrible conditions.

The spectacle of the volcanic plug teeming with over 150,000 gannets has to be seen to be believed. The closest parallel I can make is that of bees swarming around a gigantic honeycomb.

Engineer:	David A Stevenson
Established:	1902
Automated:	1988
Character:	Flashing (3) White every 20 seconds
Height:	20 metres
Status:	Operational
Authority:	NLB

BARNS NESS LIGHTHOUSE

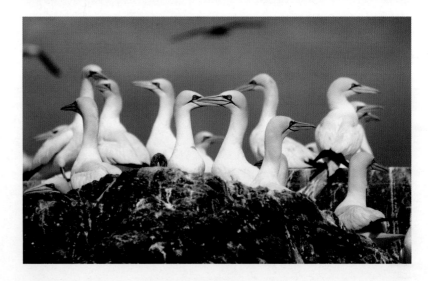

[ABOVE] GANNETS ON BASS ROCK

[OPPOSITE] BASS ROCK LIGHTHOUSE

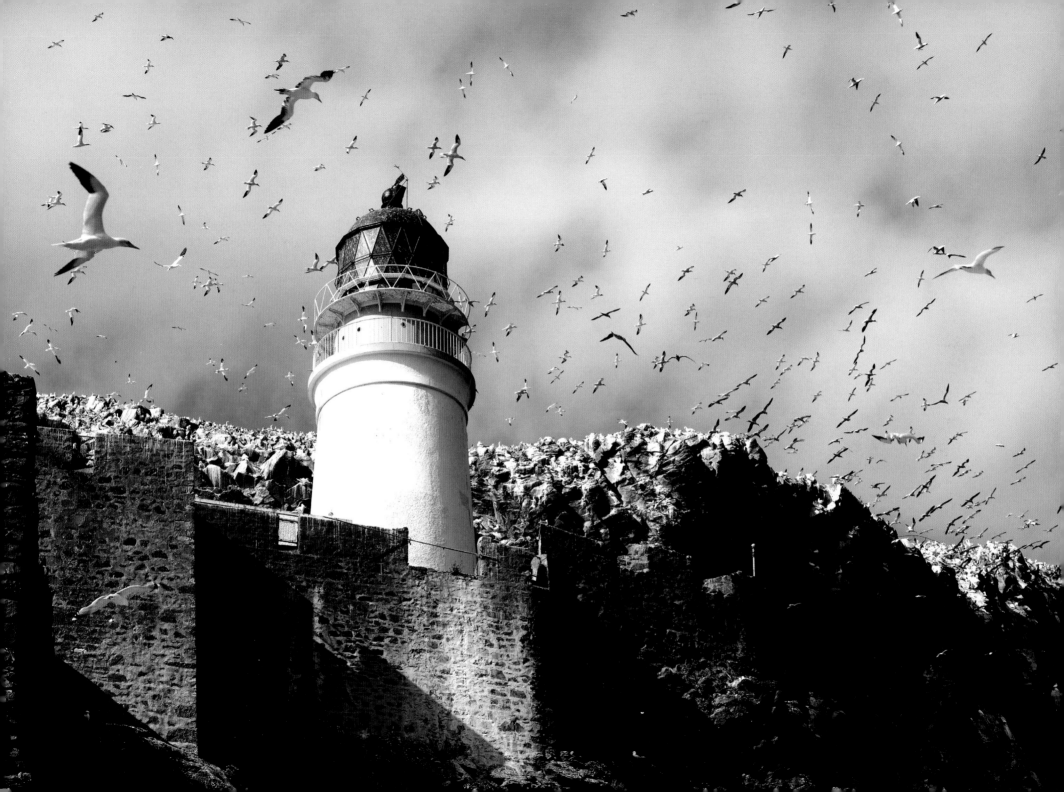

FIDRA

Engineers:	Thomas and David A Stevenson
Established:	1885
Automated:	1970
Character:	Flashing (4) White every 30 seconds
Height:	17 metres
Status:	Operational
Authority:	Transferred to Forth Ports, 2013

INCHKEITH

Over the centuries Inchkeith has served a number of uses. These include a place of quarantine for those suffering from contagious diseases and an island fortress in times of war. Legend has it that Inchkeith was also the location for a bizarre social experiment. King James IV is said to have sent a deaf-mute lady along with two infants to live there in total isolation, the reason being to find out which language the children would end up speaking. According to the 16th century historian Robert Lyndsay of Pitscottie "some say they spoke good Hebrew, but I do not know of any reliable sources for these claims".

The Firth of Forth resembles a millpond as we sail towards Inchkeith. We land at the dilapidated harbour and I gradually make my way up the path towards the lighthouse.

As I wander around the island, I get a real feeling of being in a ghost town. There are lots of military buildings and gun emplacements. These date mainly from the Second World War when Inchkeith played a key role in the defence of the Firth of Forth. The only invaders now are the wild plants and sea birds which have completely taken over the island.

The lighthouse crowns the summit of the island. It's a fine edifice. A stone plaque incorporated into the façade is inscribed with the details of

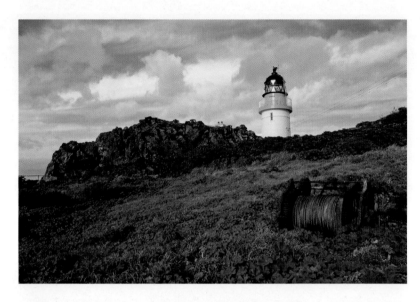

FIDRA LIGHTHOUSE AND ONE OF ITS PUFFINS

[ABOVE] WWII DEFENCES ON THE ISLAND OF INCHKEITH

[TOP] REMAINS OF THE GATEPOST FROM AN OLD FORTRESS WITH
MARY QUEEN OF SCOTS' COAT OF ARMS (1564)

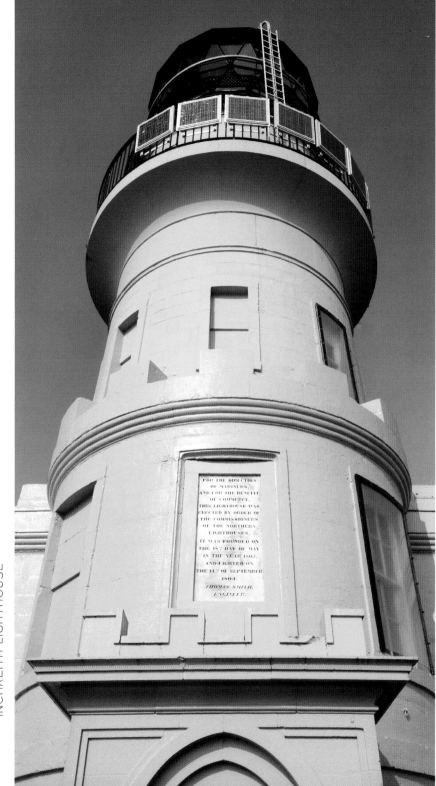

INCHKEITH LIGHTHOUSE

the lighthouse's construction. Adjacent to the tower, a much older stone gate bears the coat-of-arms of Mary Queen of Scots along with the date of 1564. It commemorates her visit to the French garrison that year. The lighthouse has just been painted and looks immaculate in stark contrast to its surroundings. A new solar powered LED light has been installed. I feel quite melancholic as I gaze around. The courtyard in front of the lighthouse is infested with weeds and the former engine room has been vandalised. This room would have been kept spotlessly clean back in the days when there were lightkeepers living on the island.

Following the automation of many lighthouses, the adjacent accommodation and outbuildings were sold into private ownership. Whilst many of these privately owned buildings are now well maintained, there are a number which have been neglected and fallen into disrepair and Inchkeith is one such example.

I can feel the wind picking up as I head down to the harbour. Unlike our journey there, we're in for a choppy ride as we sail back! I manage to get some shelter at the front of the boat but poor Colin gets a soaking at the helm! I feel a bit sick and it's quite painful on my posterior as the boat bumps up and down (I can feel the bruising the next day!) We finally reach port. It's been a great day but I'm glad to be back on dry land!

Engineers:	Thomas Smith and Robert Stevenson
Established:	1804
Automated:	1986
Character:	Flashing White every 15 seconds
Height:	19 metres
Status:	Operational
Authority:	Transferred to Forth Ports, 2013

FOR THE DIRECTION OF MARINERS, AND FOR THE BENEFIT OF COMMERCE, THIS LIGHTHOUSE WAS ERECTED BY ORDER OF THE COMMISSIONERS OF THE NORTHERN LIGHTHOUSES. IT WAS FOUNDED ON THE 18TH DAY OF MAY IN THE YEAR 1803, AND LIGHTED ON THE 14TH OF SEPTEMBER 1804. THOMAS SMITH, ENGINEER.

OXCARS

Engineers:	Thomas and David A Stevenson
Established:	1886
Automated:	1894
Character:	Flashing (2) White/Red every 7 seconds
Height:	22 metres
Status:	Operational
Authority:	Transferred to Forth Ports 1990s

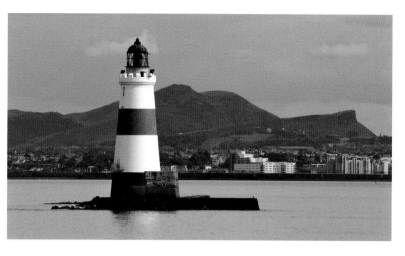

OXCARS WAS THE VERY FIRST LIGHTHOUSE TO BE AUTOMATED

ELIE NESS

Engineer:	David A Stevenson
Established:	1908
Automated:	Built as automatic
Character:	Flashing White every 6 seconds
Height:	11 metres
Status:	Operational
Authority:	Transferred to Forth Ports 2013

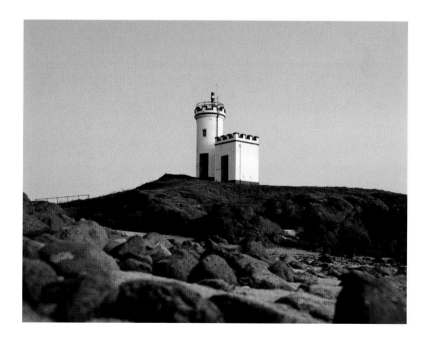

ELIE NESS LIGHTHOUSE

THE STONE WORK INSIDE THE ISLE OF MAY IS PAINTED
TO GIVE THE EFFECT OF DRESSED ASHLAR STONE

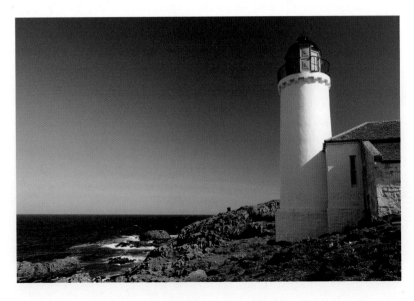

THE LOW LIGHT ON THE NORTH SIDE OF THE ISLAND

THE ISLE OF MAY

The Isle of May was one of the next building projects Robert Stevenson tackled following his success constructing the Bell Rock Lighthouse. Great attention was paid to the exterior and interior details of the lighthouse and it was often used for meetings of the Commissioners of Northern Lighthouses.

Stevenson wanted to completely demolish the earlier coal-fired beacon (Scotland's first lighthouse) as it would obstruct the light from his new tower. However, Sir Walter Scott (who sailed as a guest of the Commissioners in 1814) persuaded him to preserve the lower levels of the beacon for posterity and it remains to this day.

In 1844, Alan Stevenson constructed a low light on the north side of the island to warn ships away from North Carr Rocks. This tower became redundant when a lightship was stationed at the North Carr.

In 1885 an electric lamp was installed in the main tower, the first of its kind in Scotland. This installation required additional keepers so new accommodation had to be constructed along with the large engine room to house the coal-fired steam generators which provided the electricity. This arrangement proved too expensive to run and the light later reverted back to an oil-fired one.

The island is now owned by Scottish Natural Heritage and is popular with day trippers during the summer months hoping to spot one of the island's many puffins and hundreds of grey seals.

Engineer:	Robert Stevenson
Established:	1816
Automated:	1989
Character:	Flashing (2) White every 15 seconds
Height:	24 metres
Status:	Operational
Authority:	NLB

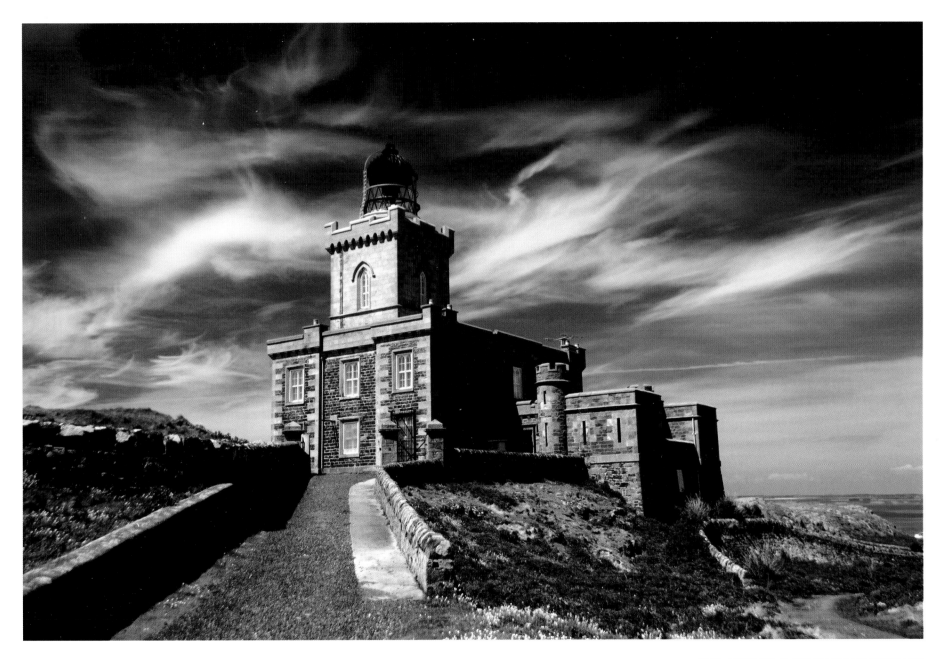

THE 1816 ISLE OF MAY LIGHTHOUSE

NORTH CARR

Following his success at the Bell Rock, Robert Stevenson turned his attention to the nearby North Carr reef which had also claimed a number of ships over the years. This dangerous reef extends over a mile and a half from the headland of Fife Ness out into the North Sea. Previous attempts at marking the reef with a buoy had failed with the buoy breaking adrift on several occasions.

The location was extremely challenging for a number of reasons. The rock was completely submerged most of the time and was only sufficiently exposed two or three times a fortnight for any work to be carried out. The area was also subject to strong currents, being the turning point between the waters of the Firth of Tay and Firth of Forth. One of the main difficulties was the actual size of the rock which was too small to build a lighthouse upon.

Stevenson decided to build a smaller stone beacon approximately 40ft high with a bell mounted on top. He also devised a system for ringing the bell which took the form of a tidal machine operated by the sea as it entered a narrow opening in the base of the tower.

Construction of the stone beacon commenced in 1813 and continued over the next few years. The building of a new lighthouse on the nearby Isle of May made the North Carr project economically viable as those involved in its construction could be diverted to the work on the Isle of May whenever conditions at the North Carr were poor.

The stone beacon had almost been completed when a storm in November 1817 washed away most of it, leaving only the bottom courses of stonework in place. Stevenson subsequently changed his design for a cast iron structure mounted on top of the remaining stones. This structure served as a daymark only and was completed in 1821.

Other attempts were made over the years to mark the North Carr. In the 1840s a low light was constructed on the Isle of May. This was superseded by a lightship moored off the reef. In 1975 the lightship was replaced by a lit buoy on location and a new lighthouse on Fife Ness.

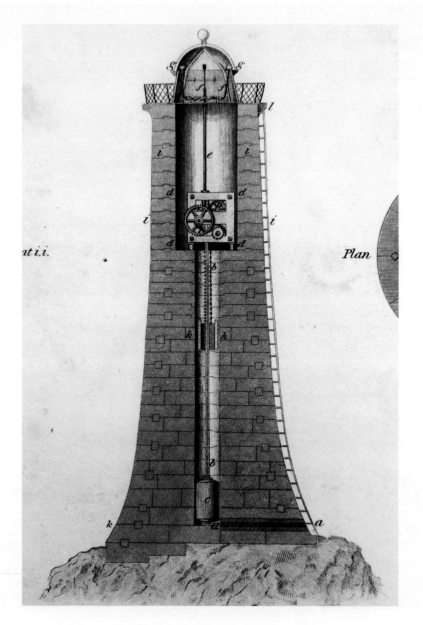

THE ORIGINAL PROPOSAL FOR A STONE BEACON AND TIDAL OPERATED BELL

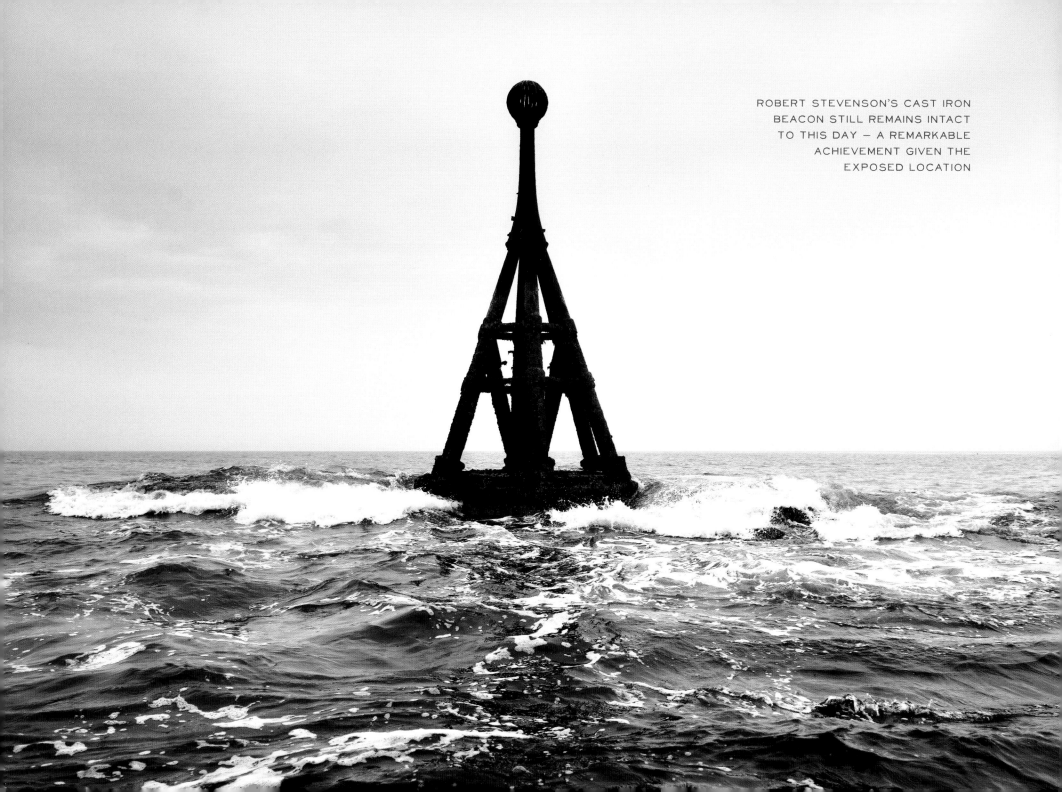

ROBERT STEVENSON'S CAST IRON
BEACON STILL REMAINS INTACT
TO THIS DAY — A REMARKABLE
ACHIEVEMENT GIVEN THE
EXPOSED LOCATION

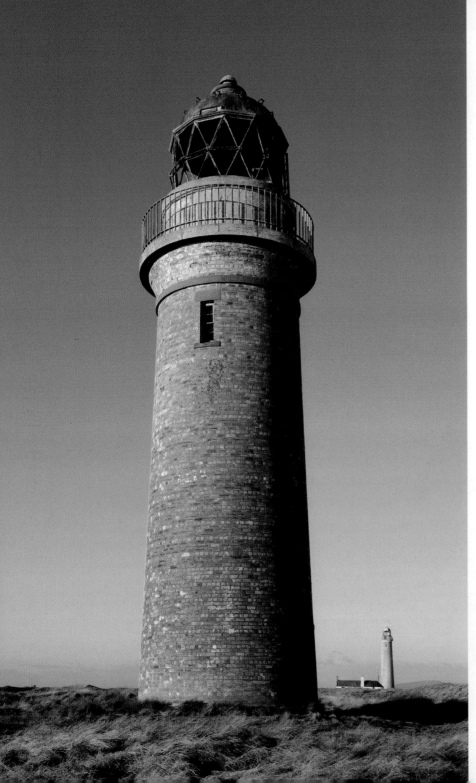

BUDDON NESS

The sandbanks at the mouth of the River Tay have always posed a hazard for shipping and there were two leading lights to give shipping a safe passage as far back as the 17th century. The idea was that when the two lights lined up a ship could safely navigate their course.

The lower and higher lighthouse towers seen here were designed by David and Thomas Stevenson for Trinity House of Dundee and first lit in 1867. The constantly moving sandbanks meant that the lower light was eventually in the wrong place. It was moved in 1885 around 200ft on a system of rails to its current location (an engineering feat at the time!).

The lighthouses were eventually abandoned in 1943 and are now part of the Barry Buddon Training Camp used by the Ministry of Defence.

BELL ROCK

The Bell or Inchcape Rock is a dangerous reef lying 11 miles off the coast of Angus which claimed many ships heading for the Firths of Forth and Tay prior to the construction of the lighthouse.

The Northern Lighthouse Board appointed the eminent civil engineer John Rennie as Chief Engineer for the project and Robert Stevenson as the on-site resident Engineer for the works. Stevenson was until recently given the main credit for the design of the lighthouse itself. However, research has suggested that he downplayed John Rennie's influence in the design. What cannot be disputed is that Stevenson arranged and supervised the actual building works and endured the many hardships experienced by the workmen during the construction period.

The design of the lighthouse was heavily influenced by the one which John Smeaton had built 50 years earlier on the Eddystone Rocks off the coast of Devon. Smeaton pioneered the use of the 'oak tree' shape for offshore lighthouses (which provided less resistance to waves) and

BUDDON NESS LIGHTHOUSE

interlocking granite blocks (much like a giant jigsaw puzzle) for additional strength.

Construction of the Bell Rock Lighthouse began in 1807. As the rock was fully submerged twice a day, Stevenson designed a special barracks for housing the workmen so that the men could remain on the rock at high tide (and work on the lighthouse could continue regardless of tide once the construction works had risen above the high water mark). Stevenson experienced considerable resistance at the start of the works when he asked the workmen to work on Sundays. Most were eventually won over by Stevenson's argument that the speedy construction of the lighthouse and the need to save sailors' lives would be a more godly pursuit than keeping the Sabbath in this case. Shortly after work on the rock started, Stevenson suffered great personal tragedy and lost three of his children to disease within the space of a year. His dogged determination to continue overseeing the project further gained the respect of his men.

The lighthouse was first lit on 1st February 1811 making it the oldest continually operating seawashed lighthouse in the world (i.e. its foundations are completely covered at high tide).

There have been a number of dramatic events at the Bell Rock since it was first lit. During WWI the Royal Navy cruiser *HMS Argyll* ran aground on the rock. Miraculously not a single life was lost. In 1955 a RAF helicopter collided with the tower killing all those on board, and in 1987 the lighthouse had to be evacuated after a fire broke out causing damage to the upper levels of the lighthouse.

The Bell Rock is arguably the most famous of all the Scottish lights and I'm keen to land there to see the lighthouse up close. Up to this point I've had to make do with viewing this magnificent structure from a boat. Much to my disappointment a planned trip with the NLB a few years earlier had been cancelled due to the fog which often shrouds this part of the east coast.

Conditions for my visit today could not be better. It's a beautiful spring morning with calm seas and clear blue skies - just perfect for photography!

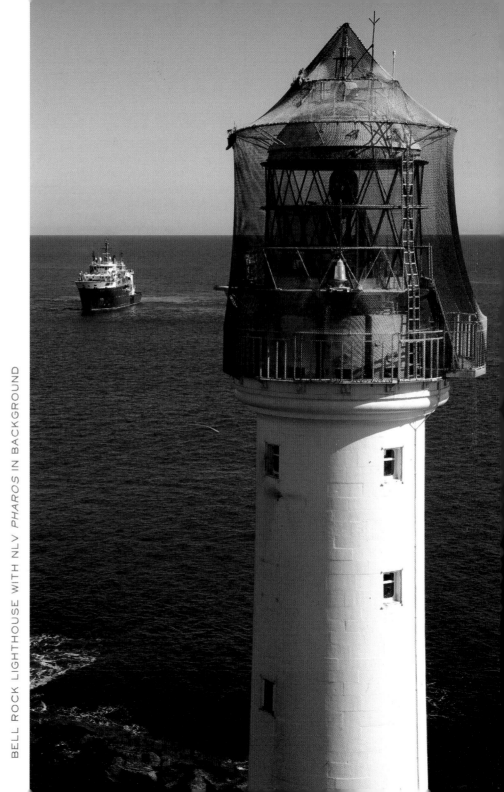

BELL ROCK LIGHTHOUSE WITH NLV *PHAROS* IN BACKGROUND

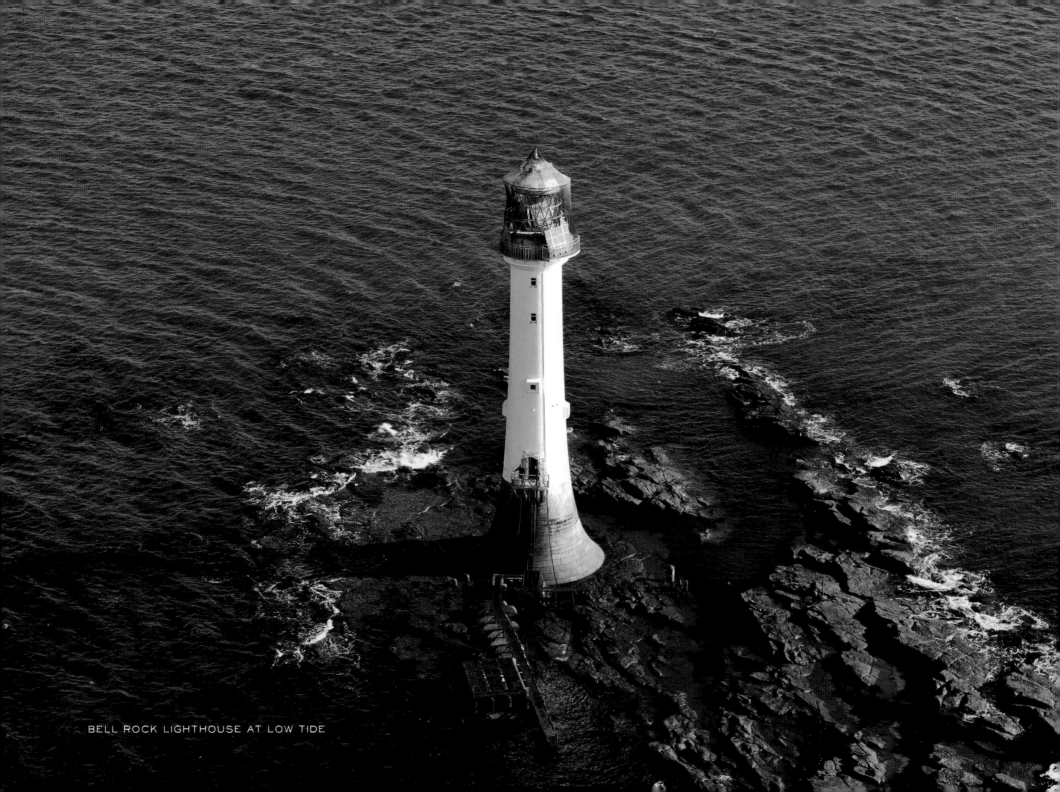

BELL ROCK LIGHTHOUSE AT LOW TIDE

After landing on the seaweed covered helipad, I make my way carefully along the old cast iron railway. The design of the railway dates back to the early days of the lighthouse, although it's been repaired many times since. I don the obligatory harness and clip myself in to the fall arrest system before climbing up to the platform outside the entrance doorway. Tucked away behind the top rung of the ladder, I can see the date of 1809 inscribed in the stonework. This marks the year the solid base of the tower was completed.

The writer RM Ballantyne provides a fascinating description of the original lighthouse interiors during a two week stay in 1865. He describes each floor in detail starting with a narrow stone spiral staircase leading up to the first floor. Reference is made to the fine oak fittings in each room and a library or Strangers Room near the top of the tower which is furnished with a handsome table, fine Turkish carpet and a marble bust of Robert Stevenson (the table and bust are now in the foyer of 84 George Street). One hundred and fifty years later, the interior bears absolutely no resemblance to this! The Bell Rock feels the most cramped of all the pillar rock towers I've seen. The spiral stone staircase to the first floor has been removed to create more space and the lower rooms are now packed with engines, tanks and electrical equipment. Each floor is connected by a vertical ladder and it's a tight squeeze getting through the fire rated hatches with my camera equipment.

One floor is divided into two (very) small bedrooms each with three tier bunk beds much like you would find in a ship. It must be quite a challenge to spend extended periods of time in such close proximity to others particularly if they snore! The floor above once housed the library but now has a modern kitchen curved to fit the profile of the walls. Looking up, I admire the outlines of the dovetailed stones on the domed ceiling. The balcony is on the next level and I have a look outside. The giant hairnet installed after automation to keep birds away from the solar panels does not appear to have prevented them from doing their business on them!

I go back inside and have a look in the lightroom. There are a few dents and signs of repairs on the underside of the dome, probably the result of the helicopter accident in 1955.

THE DATE 1809 IS INSCRIBED BEHIND THE TOP RUNG OF THE LADDER

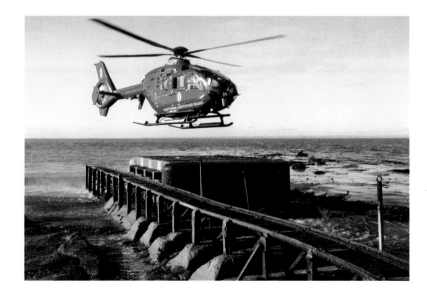

BELL ROCK HELIPAD AND WALKWAY

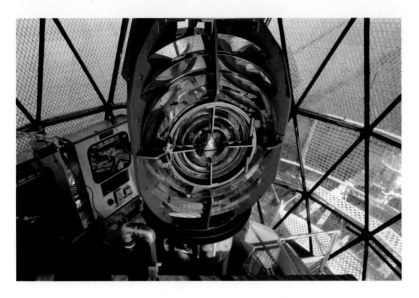

BELL ROCK LENS

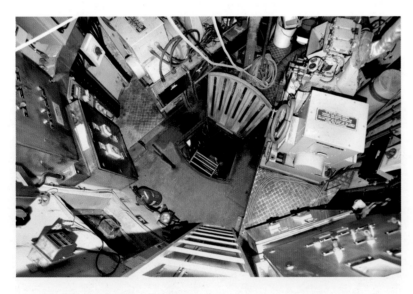

THE ENGINE ROOM

The tide is well out by the time I make my way back down the tower and explore the rock below. I can see the holes in the sandstone where the posts for the wooden barracks were sunk. Robert Louis Stevenson's description of the sandstone reef as a "pleasant assemblage of shelves, and pools, and creeks, about which a child might play for a while summer without weariness" feels very apt. On a day like this, it's difficult to imagine what is must be like out here during a storm or the terror that sailors would have felt whilst journeying up the east coast in the days before the lighthouse was built. However, a further glance around the rock provides evidence that conditions are not normally as benign as this. The green slime on one side of the tower reminds me of the waves that crash against the structure at high tide. The storms of the past winter have also carried away some of the heavy gratings from the railway track. Beyond the helipad I can see what appears to be part of the engine of a ship.

Before boarding the helicopter I take one final look at the intricately carved stones which make up the elegantly curved base of the lighthouse. There's a young seal playing in the water next to the helipad, it seems to be oblivious to the downdraught of the helicopter.

The dark clouds appear as we head back towards the coast; a hailstorm starts soon after we touch down at Dundee Airport. The timing of my visit could not have been better!

Engineer:	Robert Stevenson
Established:	1811
Automated:	1988
Character:	Flashing White every 5 seconds
Height:	36 metres
Status:	Operational
Owner:	NLB

BELL ROCK LIGHTHOUSE AT HIGH TIDE.

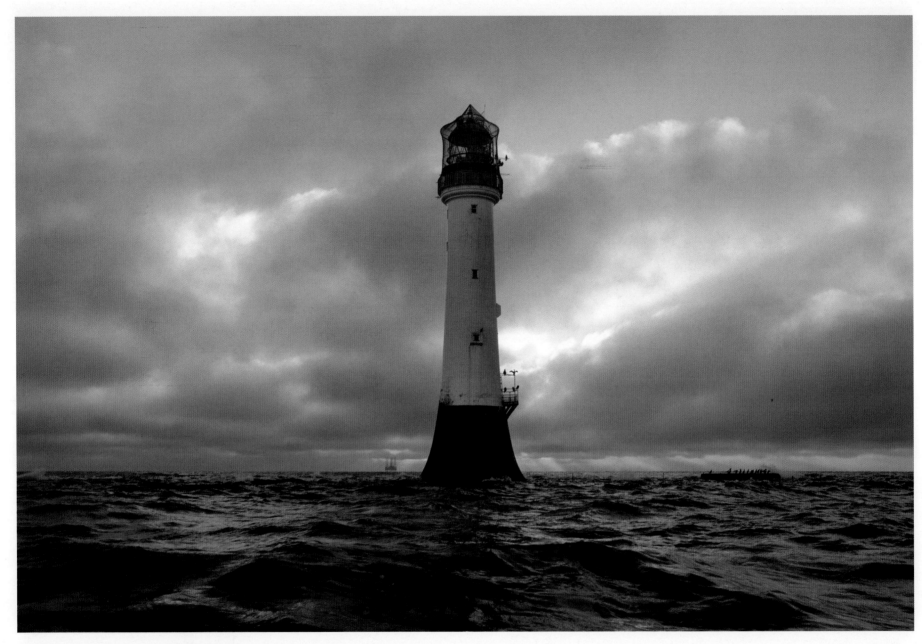

WINTER SUNRISE AT THE BELL ROCK

BELL ROCK SIGNAL TOWER

The Signal Tower at Arbroath was built in 1813 shortly after the completion of the Bell Rock Lighthouse and housed the keepers' families and the master of the tender who serviced the lighthouse. The building's other purpose was to communicate between the shore and lighthouse - this was done via telescope, flagstaff and a copper signal ball.

The Signal Tower is now a museum about the Bell Rock Lighthouse and tells the story of Arbroath's fishing and maritime industries.

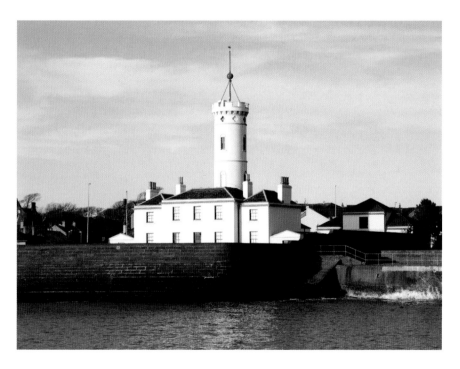

[ABOVE] BELL ROCK SIGNAL TOWER, ARBROATH

[RIGHT] BELL ROCK SIGNAL TOWER STAIRCASE

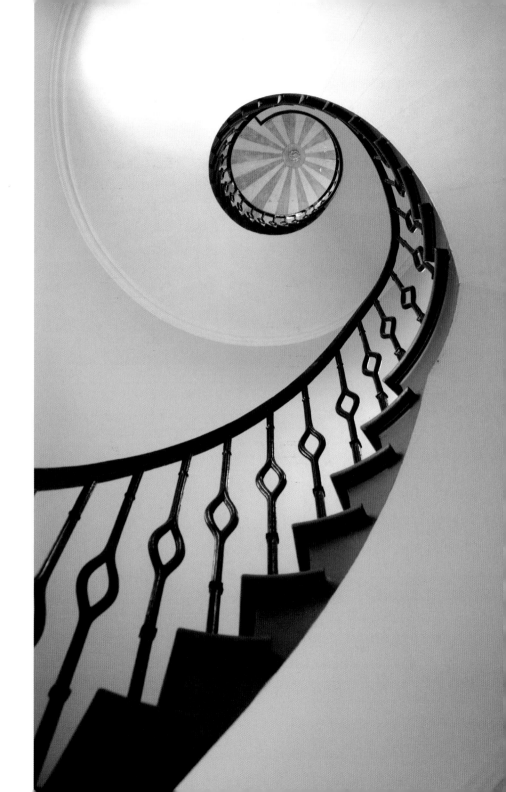

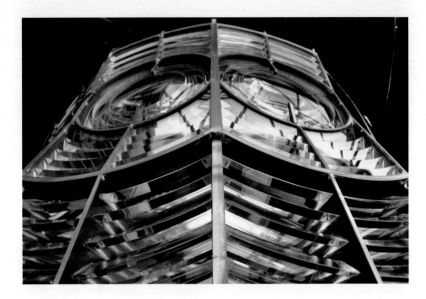

TOD HEAD LENS PRIOR TO REMOVAL

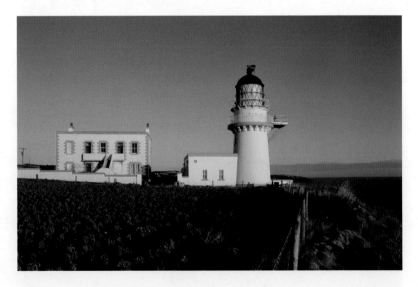

TOD HEAD LIGHTHOUSE

SCURDIE NESS

Engineers:	David and Thomas Stevenson
Established:	1870
Automated:	1987
Character:	Flashing (3) white every 20 seconds
Height:	39 metres
Status:	Operational
Authority:	NLB

TOD HEAD

Following a review of aids to navigation, the light at Tod Head was discontinued on 11th July 2007. I visited the lighthouse with Retained Lighthouse Keeper (RLK) Donald Cameron back in 2009 and photographed the first order lens prior to its removal and the sale of the lighthouse. Tod Head has since been converted into a unique family home. The lens is now in the care of the National Museum of Scotland.

Engineer:	David A Stevenson
Established:	1896
Automated:	1988
Character:	Flashing White (4) every 30 seconds (Discontinued)
Height:	13 metres
Status:	Discontinued 2007, now in private ownership

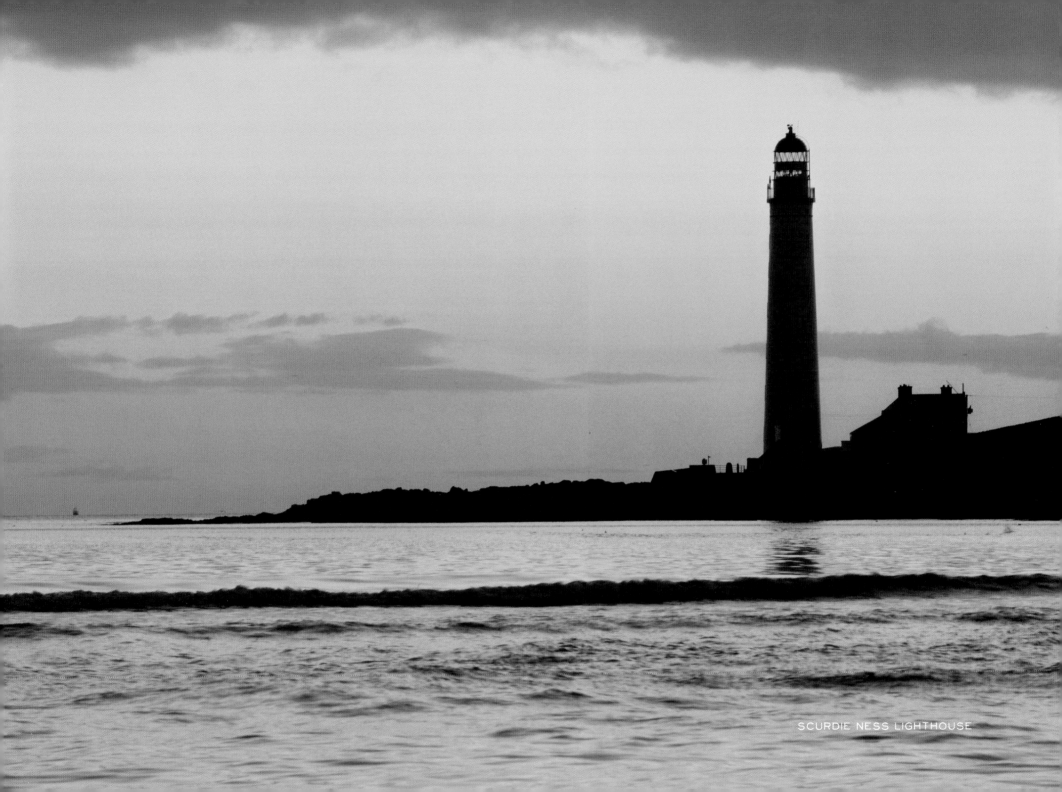

SCURDIE NESS LIGHTHOUSE

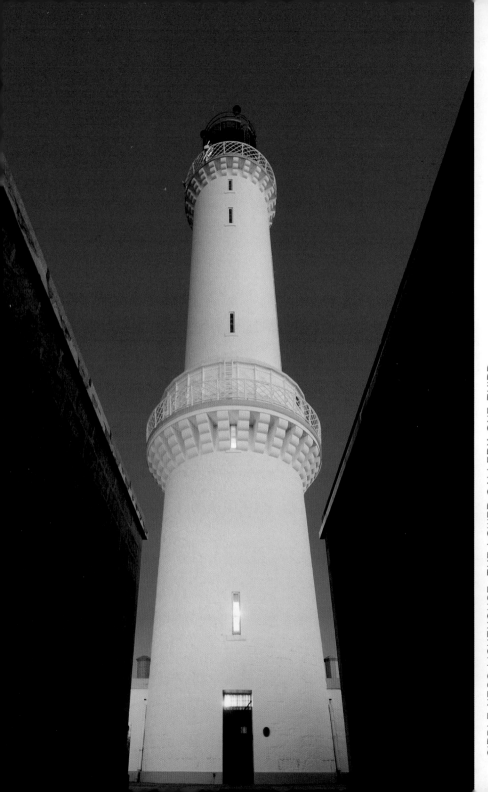

GIRDLE NESS LIGHTHOUSE, THE LOWER GALLERY ONE THIRD OF THE WAY UP USED TO HOUSE THE LOW LIGHT

GIRDLE NESS

Girdle Ness Lighthouse originally displayed two lights (which accounts for the unusual shape of the tower). The lower light was later discontinued.

It's an extremely cold day in November 2010. The road leading to the lighthouse is covered in ice and it takes a few attempts to drive the car up to the entrance gate. There's a biting wind and I can hardly feel my hands as I try to take some pictures. As the sun sets behind me the light reflects off the snow laden clouds coming in from the North Sea to give them an other-worldly orange glow.

Engineer:	Robert Stevenson
Established:	1833
Automated:	1991
Character:	Flashing (2) White every 20 seconds
Height:	37 metres
Status:	Operational
Owner:	NLB

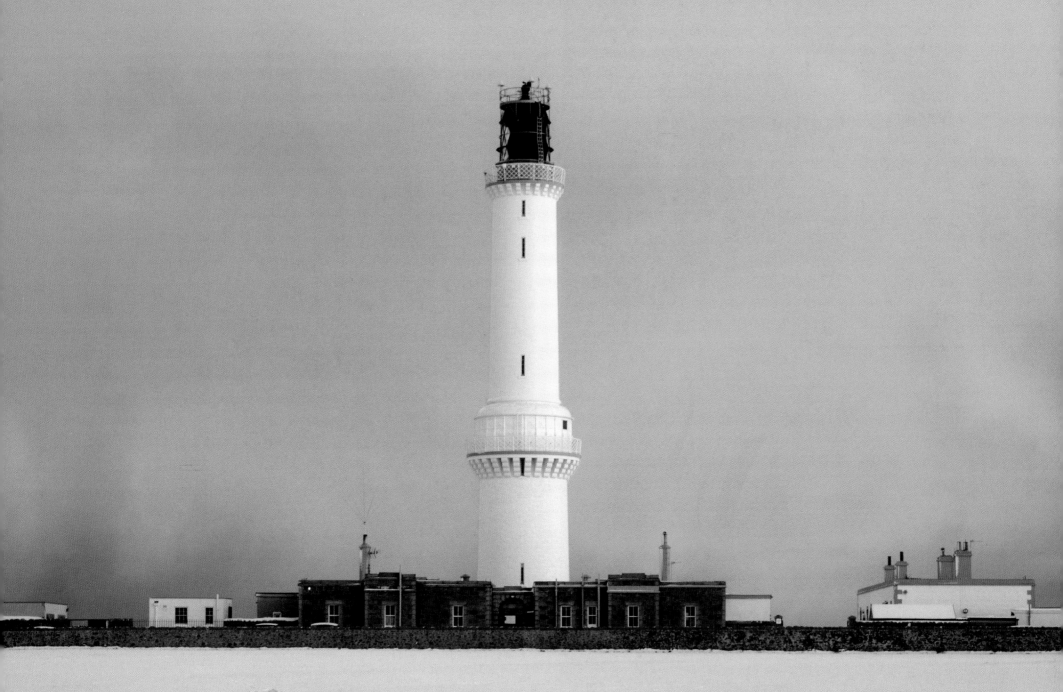

GIRDLE NESS LIGHTHOUSE

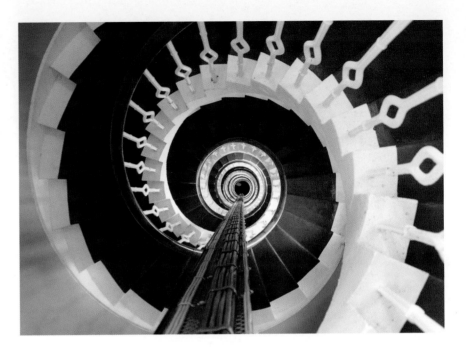

[ABOVE] BUCHAN NESS STAIRCASE

[LEFT] GIRDLE NESS WINDOW ASTRAGAL DETAIL
DATING FROM 1847 WHEN THE ORIGINAL LANTERN
WAS REPLACED BY ALAN STEVENSON

BUCHAN NESS

Buchan Ness has always been one of my favourite lighthouses and a place I visited frequently during my childhood as I knew the Principal Lightkeeper.

It's nearly 25 years since I last set foot in the tower. It's a busy place as various folk are inspecting the lighthouse ahead of refurbishment works. The tower is a classic Stevenson design with many interesting architectural features including a corbelled balcony and decorative cast iron features around the lantern housing. I take some shots of the wonderful spiral staircase, one of the finest in Scotland. It's a bit of a challenge to keep the camera steady in the relatively low lighting conditions and avoid blurry shots. Once in the lightroom I photograph the large bullseye lens panels. These were removed from Out Skerries Lighthouse after it was automated and have been used at Buchan Ness since the late 1970s producing distinctive sweeping rays during the hours of darkness. I feel a little bit sad that these will shortly be removed and replaced by the 'blink' of a modern LED light.

Engineer:	Robert Stevenson
Established:	1827
Automated:	1988
Character:	Flashing White every 5 seconds
Detail:	The red band was added in 1907
Height:	35 metres
Status:	Operational
Authority:	NLB

THE VIEW FROM THE TOP OF BUCHAN NESS LIGHTHOUSE

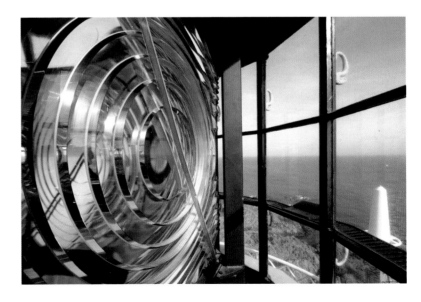

BUCHAN NESS LENS WHICH WAS INSTALLED
IN THE TOWER FROM 1978 TO 2012

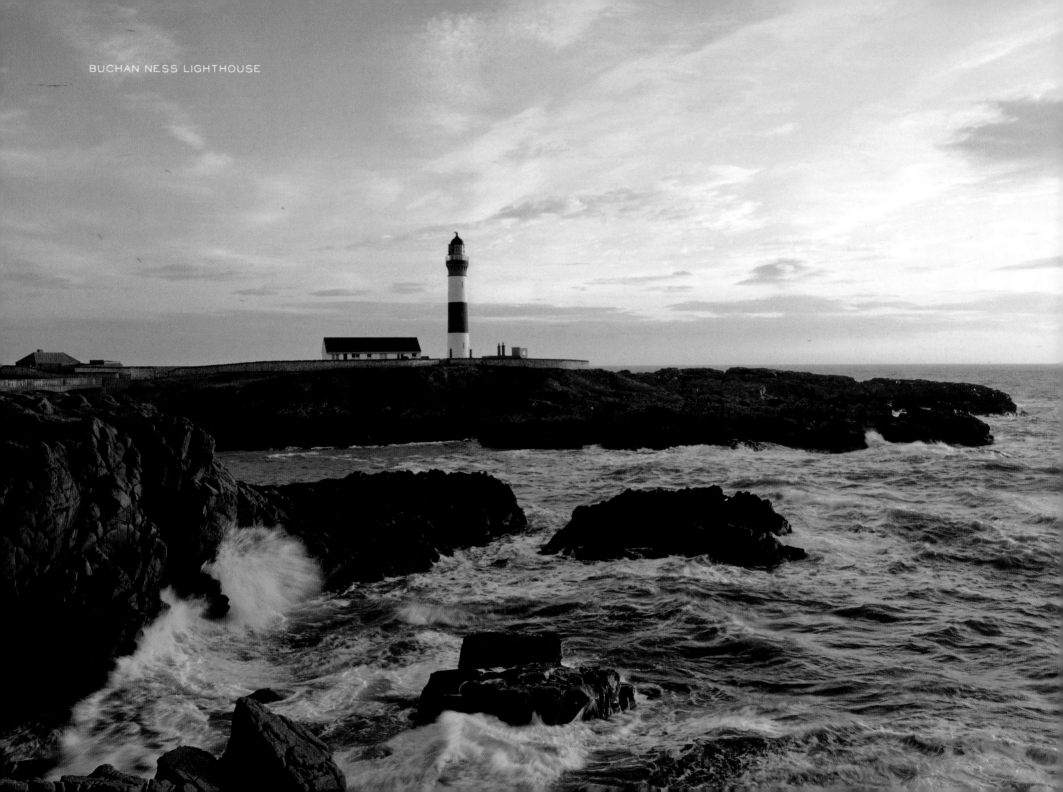

BUCHAN NESS LIGHTHOUSE

RATTRAY HEAD

There was a local saying in the days before Rattray Head Lighthouse was built *"Keep Mormond Hill a handspike high, and Rattray Briggs you'll not come nigh"*. Strong currents and shallow water have always made this stretch of coastline particularly hazardous to shipping. The timbers of several wrecks protruding above the sand at low water testify to this.

The lighthouse stands on Ron Rock about half a mile offshore at high tide but reachable by tractor when the tides are at their lowest. As the location is regularly fog bound, the Stevensons decided that this necessitated a first class fog siren. Installing such a device in a rock tower had never been attempted before. The alternative of building a foghorn onshore was considered to be ineffective. This choice accounts for the unique design; the lower section of the tower is made of granite and originally housed the engines and equipment for the foghorn. The upper portion is brick and housed the keepers' accommodation as well as the lighting apparatus. One can only sympathise with the poor keepers having to live in such close proximity to the foghorn!

Rattray Head is a place which instantly brings back childhood memories of walks along the beach with my family. As a youngster I was always impressed by the unusual looking rock tower lying offshore as well as the air of loneliness about the place.

The first time I saw inside the lighthouse was a summer evening back in 1986 on the very day I started secondary school. Upon retiring, my grandfather had taken up a part time job mending fishing nets and one of the elderly gentlemen he worked with just happened to be the Attendant for the light. Knowing of my enthusiasm for all things pertaining to lighthouses, my grandfather asked if we could have a look around. This happened to coincide with a visit by the Commissioners during their annual inspection. I can still remember the excitement as we sat on the back of the trailer and were towed out by tractor with these rather important looking fellows! Once there, I didn't particularly relish the climb up the steep ladder. However, I wasn't going to let

VEHICLE FOR DRIVING OUT TO RATTRAY HEAD

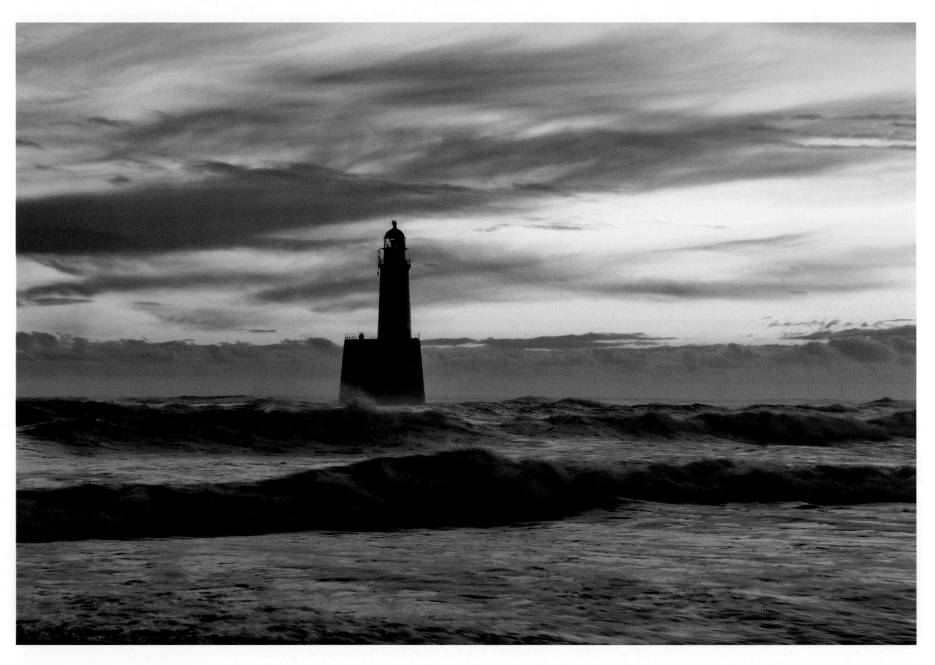

RATTRAY HEAD LIGHTHOUSE

this stop me! Inside, the interior was sadly a little the worse for wear with the unchecked effects of dampness taking their toll. At the top of the lighthouse, the Attendant went outside and cleaned the lantern windows without wearing any sort of harness - something you wouldn't get away with nowadays!

Autumn 2011

On this latest visit I'm accompanying a group of NLB staff on a site survey. It is a beautiful autumn morning and there has just been a lovely sunrise. Gordon Stewart, the Retained Lighthouse Keeper (RLK) for the area drives us all out in a Land Rover. I have to put on a harness before climbing up the ladder. The interior is in much better condition these days having benefited from a recent paint job. The rooms which once housed the engines and compressed air receivers for the foghorn are now mostly empty although the Victorian glazed wall tiles are a reminder that it was once an engine room. Upstairs the existing sealed beam light is being checked. This will soon be replaced by a new LED light which is more efficient and requires less maintenance.

After an hour or so, there's a shout from downstairs telling me it's time to go. The tide is rushing in and the patches of sand and rocks which were visible on the way out are now completely submerged. Gordon expertly negotiates the Land Rover through the water and we're soon back on dry land, relieved that the engine didn't stall!

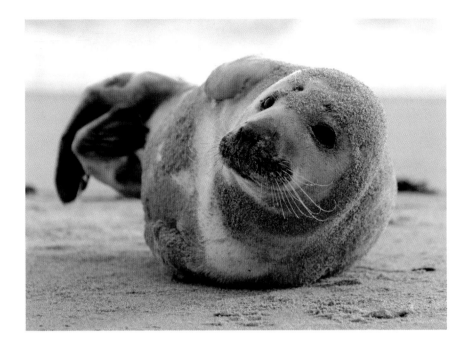

SEAL AT FORVIE NATURE RESERVE

Engineer:	David A Stevenson
Established:	1895
Automated:	1982
Character:	Flashing (3) White every 30 seconds
Height:	34 metres
Status:	Operational
Authority:	NLB

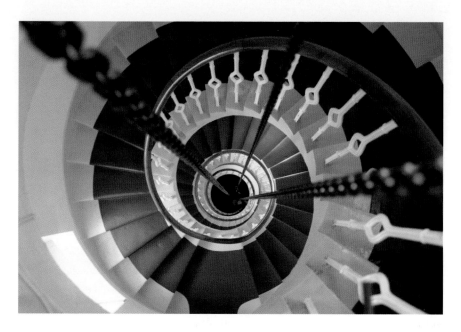

[ABOVE] KINNAIRD HEAD LIGHTHOUSE — THE ORIGINAL CLOCKWORK
WEIGHT CHAINS RUN DOWN THE CENTRE OF THE TOWER

[LEFT] KINNAIRD HEAD LIGHTHOUSE

KINNAIRD HEAD

Successive generations of the Stevensons have left their imprint on the lighthouse at Kinnaird Head since it was first lit on 1st December 1787.

In 1824 Thomas Smith's stepson, Robert Stevenson, decided that the lantern atop the old castle was no longer fit for purpose. His original proposal was to demolish the castle and replace it with a purpose-built structure. The story goes that he was persuaded to save the castle by the writer Sir Walter Scott and designed a new tower within the castle's outer walls which remains to this day.

David A Stevenson (Robert Stevenson's grandson) made further changes in 1902 when a larger lantern and hyper-radial lens were installed on top of the tower.

Kinnaird Head Lighthouse would escape the fate of most other lighthouses as it was withdrawn from service in 1991, rather than being automated, leaving the equipment and layout untouched. It is now in the care of Historic Scotland and forms the centrepiece of the Museum of Scottish Lighthouses. The museum contains many artefacts connected with the Stevensons and Northern Lighthouse Board including a large collection of lenses. Visitors to the museum can take a tour around the lighthouse to see an example of how lighthouses operated before lightkeepers were replaced by technology.

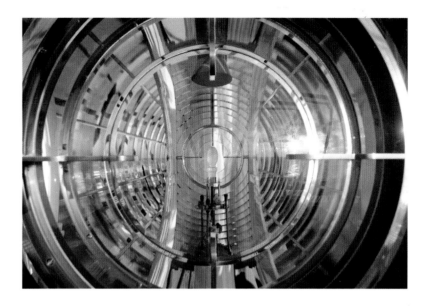

KINNAIRD HEAD LENS

Engineer: Thomas Smith
Established: 1787
Character: Flashing White every 15 seconds
Height: 23 metres
Status: Discontinued in 1990, now part of the
 Museum of Scottish Lighthouses

ON 4TH JUNE 2012, A BEACON WAS LIT ON TOP OF KINNAIRD HEAD LIGHTHOUSE TO CELEBRATE THE DIAMOND JUBILEE OF HM QUEEN ELIZABETH II. THE LIGHTHOUSE LAMP WAS ALSO SWITCHED ON FOR A FEW HOURS TO MARK THIS SPECIAL OCCASION

COVESEA SKERRIES

Covesea Skerries Lighthouse provided over 165 years service before being switched off in March 2012 and replaced by a lit buoy at the nearby Halliman Skerries. The Covesea Community Company Limited was set up with local support so that the lighthouse and adjacent land could be purchased and developed as a tourist attraction. The complex documents the history of the lighthouse and nearby RAF Lossiemouth.

Engineer: Alan Stevenson
Established: 1846
Automated: 1984
Character: Flashing White/Red every 20 Seconds (Discontinued)
Height: 36 metres
Status: Discontinued 2012, now owned by The Covesea
 Lighthouse Community Company

COVESEA SKERRIES — A DETAIL OF ONE OF THE BRASS VENTILATORS INSTALLED IN THE WATCH ROOM

COVESEA SKERRIES LIGHTHOUSE

CHANONRY

Engineer:	Alan Stevenson
Established:	1846
Automated:	1984
Character:	Occulting white every 6 seconds
Height:	13 metres
Status:	Operational
Authority:	NLB

CHANONRY POINT

CROMARTY

The tower at Cromarty was purchased by the University of Aberdeen in 2009 following its decommissioning. It forms part of their Lighthouse Field Station where research into marine mammals and seabirds is carried out including the local bottlenose dolphin population.

Engineer:	Alan Stevenson
Established:	1846
Automated:	1985
Character:	Occulting White and Red every 10 Seconds (Discontinued)
Height:	13 metres
Status:	Discontinued 2006, now owned by the University of Aberdeen

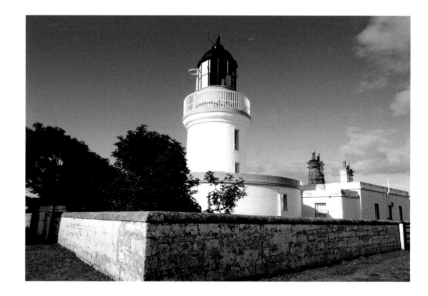

CROMARTY LIGHTHOUSE

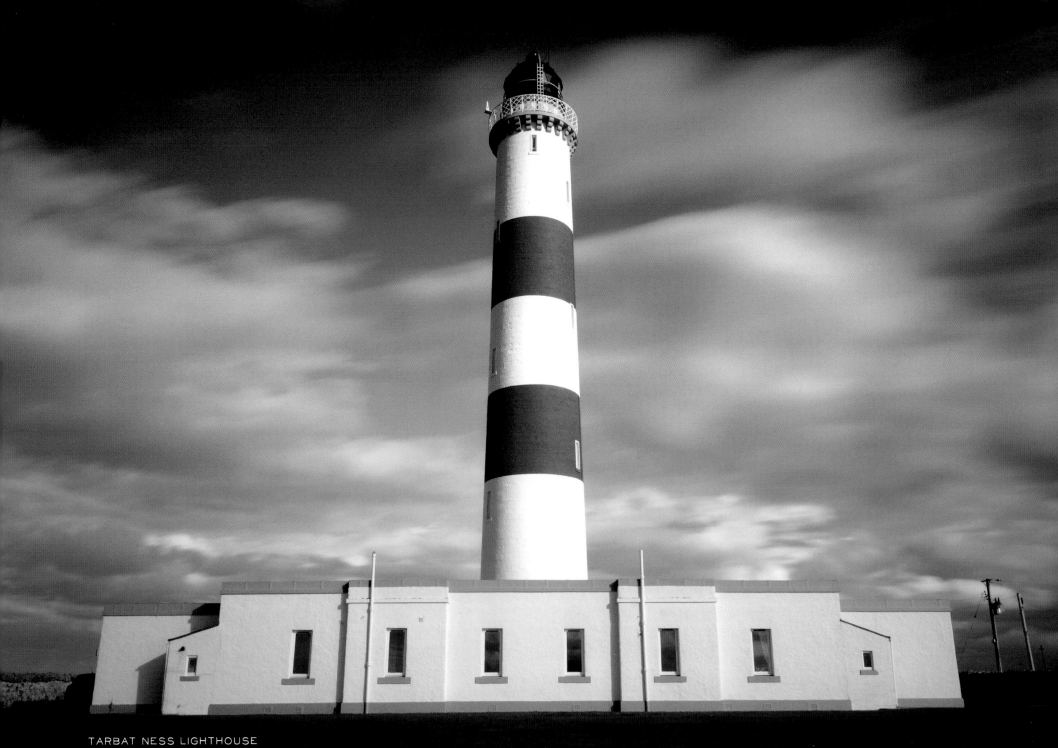

TARBAT NESS LIGHTHOUSE

TARBAT NESS

Tarbat Ness is the third tallest lighthouse in Scotland (after Skerryvore and North Ronaldsay).

Engineer:	Robert Stevenson
Established:	1830
Automated:	1985
Character:	Flashing (4) white every 30 seconds
Detail:	The two red bands were added in 1915
Height:	41 metres
Status:	Operational
Authority:	NLB

TARBAT NESS – LOOKING DOWN

CLYTH NESS

Engineer:	David A Stevenson
Established:	1916
Automated:	1964
Character:	Flashing White every 30 seconds (Discontinued)
Height:	13 metres
Status:	Discontinued 2010, in private ownership

CLYTH NESS LIGHTHOUSE

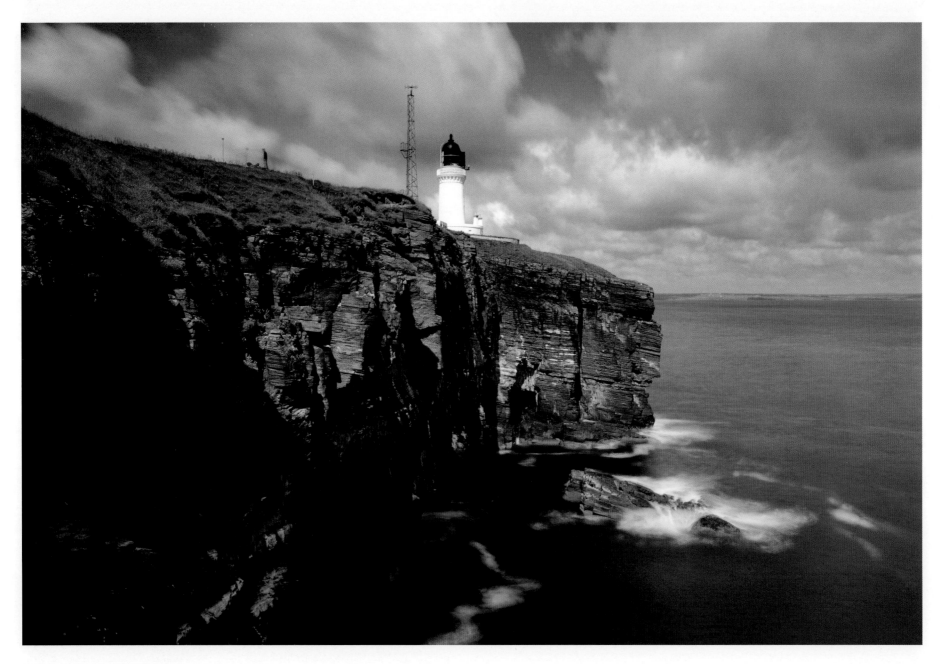

NOSS HEAD LIGHTHOUSE

NOSS HEAD

Engineer: Alan Stevenson
Established: 1849
Automated: 1987
Character: Flashing White/Red every 20 seconds
Height: 18 metres
Status: Operational
Authority: NLB

NOSS HEAD – THE VIEW FROM THE BALCONY. THE KEEPERS'
HOUSES NOW FORM PART OF THE CLAN SINCLAIR STUDY CENTRE

LIGHTKEEPERS

James Park, a retired sea captain, was the first lightkeeper to be appointed by Thomas Smith in 1787 when the lighthouse at Kinnaird Head was established. He was paid a shilling a night and given the right to stay in the castle as well as graze a cow on the lighthouse grounds. This was on condition that he had someone else with him whom he had instructed in maintaining the light. He was to be the first in line of a tradition which lasted for over two centuries.

The life of a Paraffin Oiler (the nickname for lightkeepers in Scotland) was not for everyone. However, those that had the right disposition for the job loved it. Indeed it was not unusual to find several generations from the same family who had served as lightkeepers. This tradition is still alive in the 21st century with a number of employees being the second, third and even fourth generation to have worked for the NLB.

During the hours of darkness each keeper kept a watch below the lightroom to ensure the light source was kept supplied with fuel and the clockwork mechanism which rotated the lens (used to magnify the light and produce the unique flash pattern for that particular lighthouse) was wound up at regular intervals. Failure to keep the lamp lit or allowing the lens to become stationary would usually result in instant dismissal. Duties during the daytime included polishing the lens, cleaning the lantern panes (for which a good head for heights was needed!), maintaining the engines and equipment for fog signals, painting, completing various logbooks as required by 84 George Street (the NLB's Edinburgh headquarters), and, showing any visitors around if the station was on the mainland.

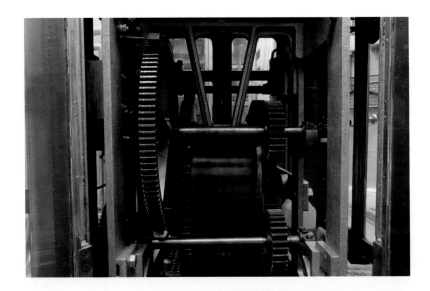

[ABOVE] THE CLOCKWORK MECHANISM AT NORTH RONALDSAY WHICH HAD TO BE WOUND UP AT REGULAR INTERVALS BY THE KEEPER ON WATCH IN ORDER TO KEEP THE LENS TURNING

[OPPOSITE] BILLY MUIR MBE. BILLY WAS A LONG-SERVING LIGHTKEEPER AT NORTH RONALDSAY LIGHTHOUSE PRIOR TO ITS AUTOMATION AND CONTINUES TO LOOK AFTER THE LIGHTHOUSE AS THE RETAINED LIGHTHOUSE KEEPER (RLK)

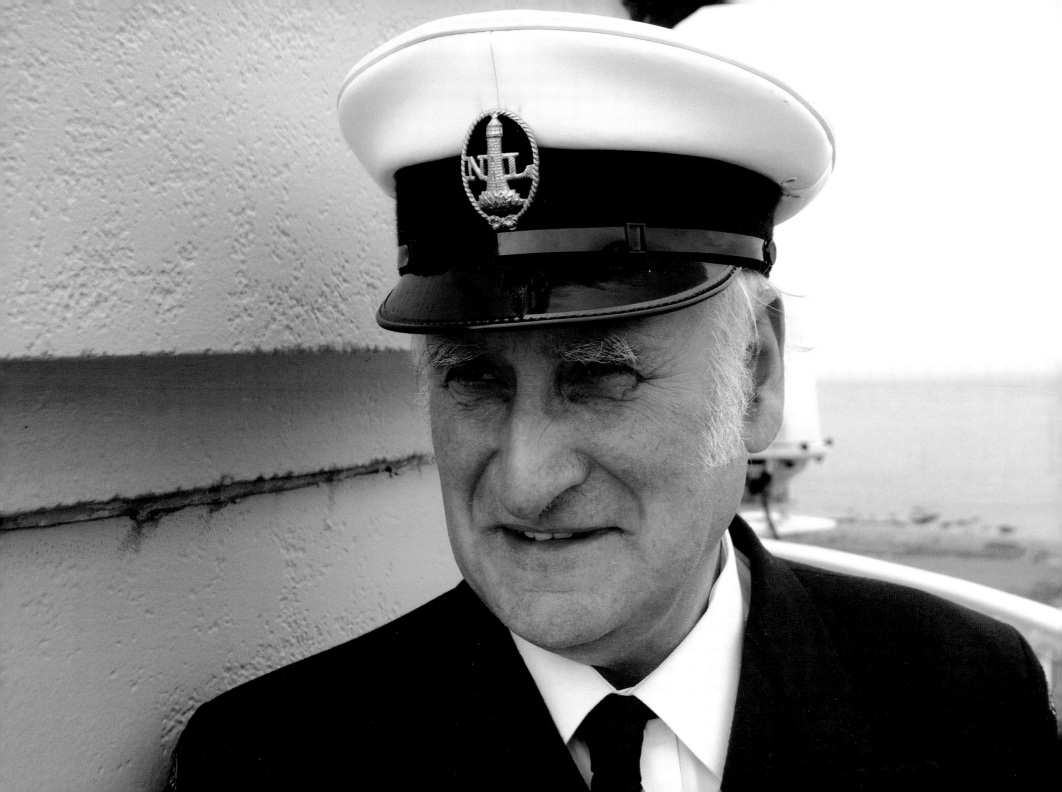

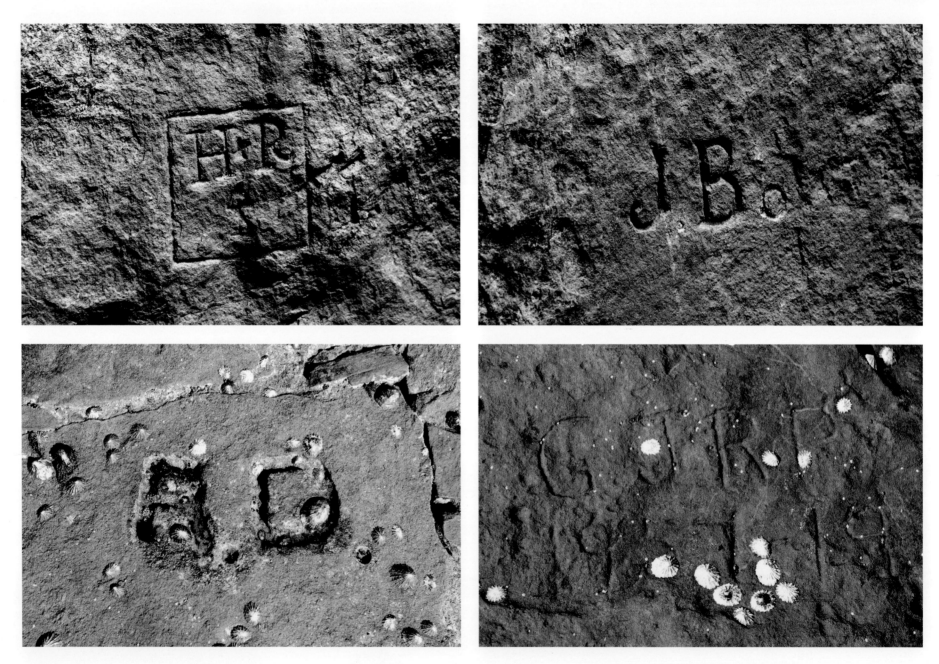

THE INITIALS OF LIGHTKEEPERS CARVED IN THE ROCK AT SKERRYVORE (TOP ROW) AND THE BELL ROCK (BOTTOM ROW)

The offshore stations would be manned at all times by three keepers. They worked two months offshore and a month ashore. This rota was later changed to a month on and a month off. On some of these stations, the keepers not only faced complete isolation away from loved ones for extended periods but also the problem of living in an extremely confined space with two other men. There was little room for exercise, minimal recreational facilities and primitive sanitary conditions (although home comforts such as electricity, TV and flushing toilets would come later with advances in technology). Getting on and off the rocks could also be extremely tricky and reliefs by boat were often delayed because of bad weather. On the positive side, there was plenty of free time to indulge in hobbies with bird-watching, painting, model making and fishing being amongst the more popular pastimes. Gardening and golf were also a favourite on some of the islands where more space was available.

THE MV WINDSOR CASTLE (FORMERLY MV FINGAL) WAS THE LAST SHIP TO BE BUILT BY THE BLYTHSWOOD SHIPPING COMPANY OF GLASGOW. SHE SERVED THE NORTHERN LIGHTHOUSE BOARD BETWEEN 1963 AND 2000 AND WAS USED TO CARRY SUPPLIES AND TRANSFER LIGHTKEEPERS TO AND FROM THE OFFSHORE LIGHTHOUSES. IN 2014 THE ROYAL YACHT BRITANNIA TRUST BOUGHT THE VESSEL WITH THE PURPOSE OF CONVERTING HER INTO A LUXURY FLOATING HOTEL WHICH WILL BE PERMANENTLY MOORED IN LEITH

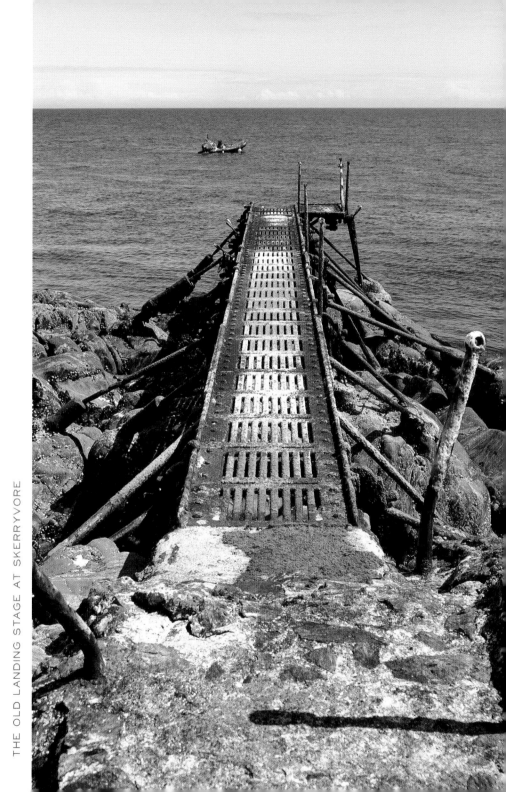

THE OLD LANDING STAGE AT SKERRYVORE

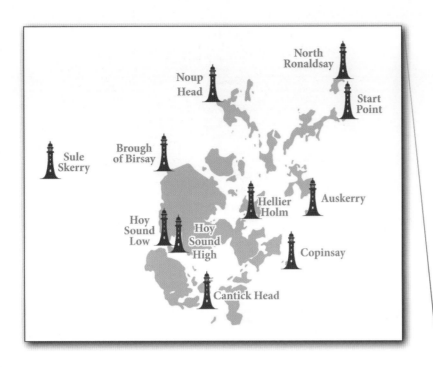

Sule Skerry

Noup Head

North Ronaldsay

Start Point

Brough of Birsay

Hellier Holm

Auskerry

Hoy Sound Low

Hoy Sound High

Copinsay

Cantick Head

ORKNEY

CANTICK HEAD

Engineers:	David and Thomas Stevenson
Established:	1858
Automated:	1991
Character:	Flashing White every 20 seconds
Height:	22 metres
Status:	Operational
Authority:	NLB

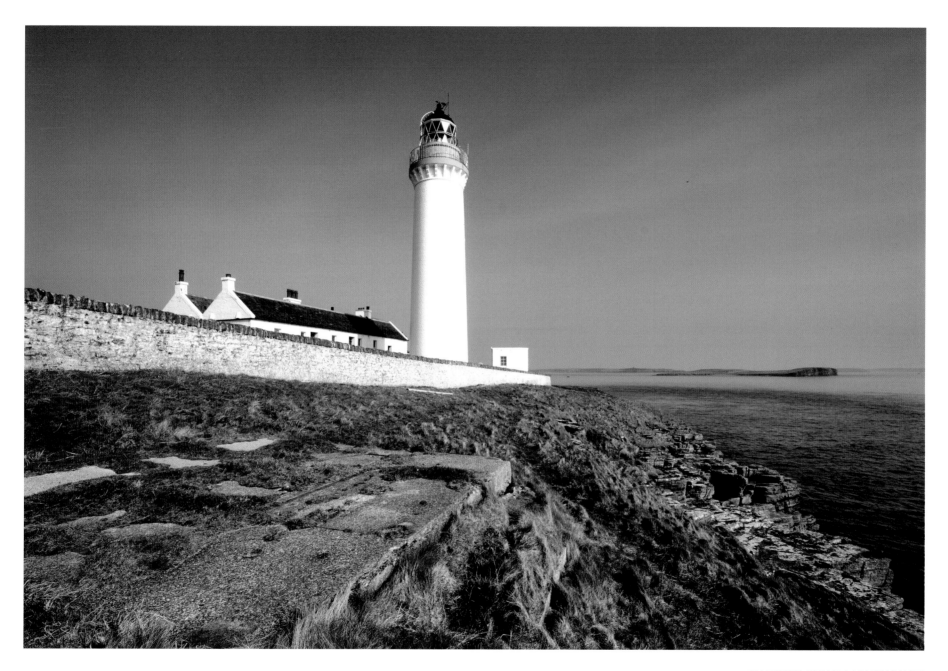

CANTICK HEAD LIGHTHOUSE

HOY HIGH LIGHTHOUSE

HOY HIGH

Engineer:	Alan Stevenson
Established:	1851
Automated:	1978
Character:	Occulting White/Red every 8 seconds
Height:	33 metres
Status:	Operational
Authority:	NLB

HOY LOW LIGHTHOUSE

HOY LOW

Engineer:	Alan Stevenson
Established:	1851
Automated:	1966
Character:	Isophase White every 3 seconds
Height:	12 metres
Status:	Operational
Authority:	NLB

COPINSAY LIGHTHOUSE

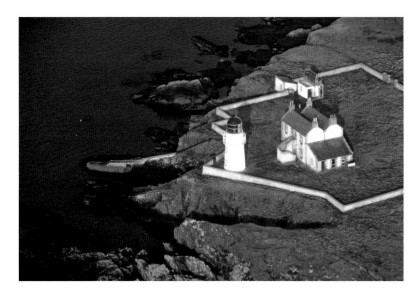

HELLIAR HOLM LIGHTHOUSE

COPINSAY

Engineer:	David A Stevenson
Established:	1915
Automated:	1991
Character:	Flashing (5) White every 30 seconds
Height:	16 metres
Status:	Operational
Authority:	NLB

HELLIAR HOLM

I'm on the 9 am flight back to Kirkwall after an overnight visit to Westray. The first leg of the journey is the flight to the neighbouring island of Papa Westray. It's the world's shortest scheduled flight at approximately 2 minutes long. There are two tourists from the south of England on the flight and they ask the pilot what attractions there are to see on Papa Westray. The pilot recommends that they take a walk to see the Neolithic settlement at the Knap of Howar. Their next question, "Is there anywhere where we can go for a drink around there?" shows that they obviously haven't appreciated the remoteness of the place!

On the second leg of the flight I notice that we're flying over the island of Shapinsay and I manage to get the camera out for one aerial shot of the lighthouse on Helliar Holm before coming in to land.

Engineer:	David A Stevenson
Established:	1893
Automated:	1967
Character:	Flashing White/Red/Green every 10 seconds
Height:	13 metres
Status:	Operational
Owner:	Transferred to Orkney Islands Council 2014

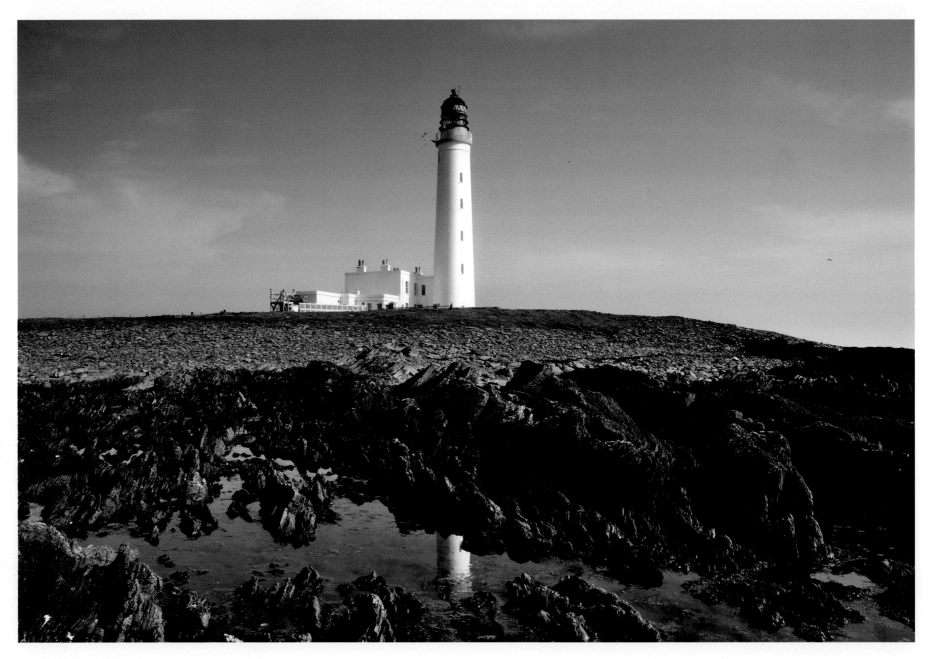

AUSKERRY LIGHTHOUSE

AUSKERRY

Auskerry is one of the most difficult islands to reach in the Orkneys and can only be accessed by chartering a boat. The slender lighthouse which stands proudly at the southern tip of the island was one of the first offshore lighthouses to be automated.

The island is now inhabited by a couple who sell a range of woollen products made from the seaweed-eating North Ronaldsay sheep they rear there.

The rocky foreshore near the lighthouse is littered with the wreckage of the *Hastings County*, a steam ship which ran aground on a foggy evening in June 1926.

Engineers:	David and Thomas Stevenson
Established:	1867
Automated:	1961
Character:	Flashing White every 20 seconds
Height:	34 metres
Status:	Operational
Authority:	NLB

AUSKERRY LIGHTHOUSE

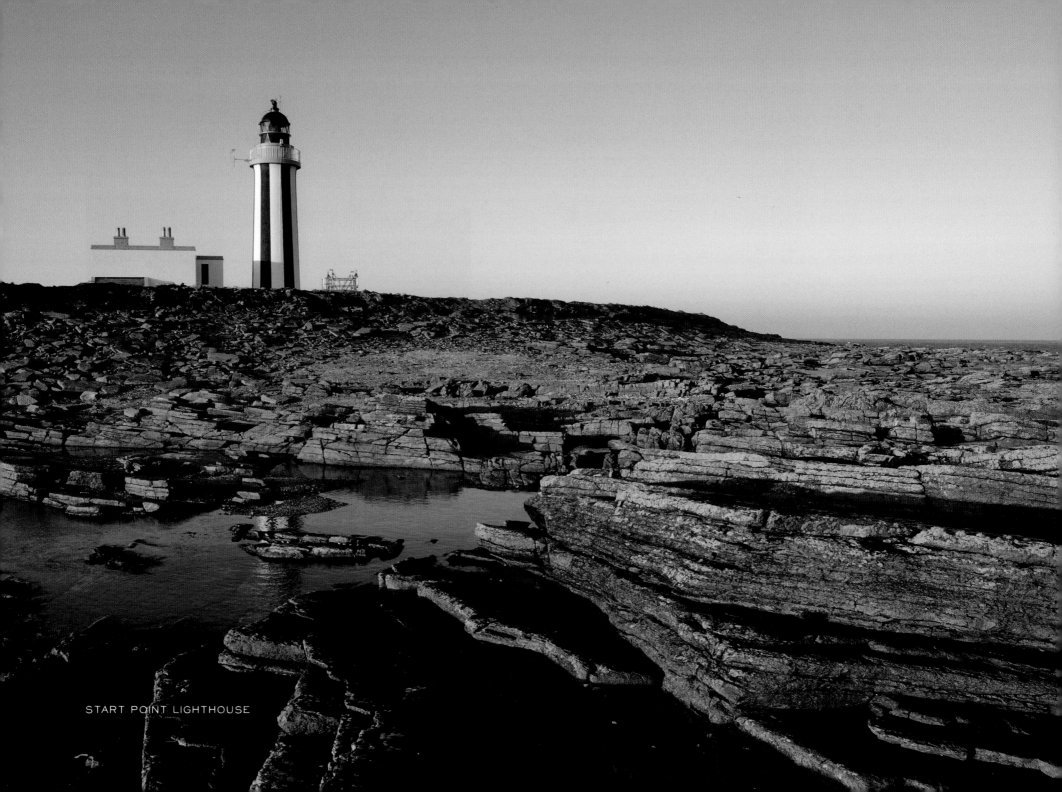
START POINT LIGHTHOUSE

BROUGH OF BIRSAY

Engineer:	David A Stevenson
Established:	1925
Automated:	Built as automatic
Character:	Flashing (3) White every 25 seconds
Height:	11 metres
Status:	Operational
Authority:	NLB

START POINT

Start Point Lighthouse sits on a small tidal island marking the eastern extremity of Sanday. An unlit stone beacon was erected in 1802 to provide a daymark for sailors. Robert Stevenson oversaw the conversion of the beacon into a lighthouse in 1806. The lighting equipment installed had the distinction of being the first revolving light in Scotland giving the lighthouse its own unique character.

The 1806 lighthouse was demolished in 1870 and replaced with the current lighthouse. The unusual paint scheme first appeared in 1915.

In conjunction with the Sanday Ranger and Sanday Development Trust, the lighthouse is open to the public on a limited number of days during the summer months.

Engineers:	Thomas Smith and Robert Stevenson
Established:	1806 (Rebuilt 1870 by David Stevenson)
Automated:	1962
Character:	Flashing (2) White every 20 seconds
Detail:	The black & whites vertical stripes were added around 1915
Height:	23 metres
Status:	Operational
Authority:	NLB

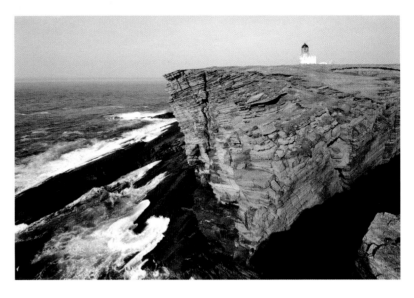

BROUGH OF BIRSAY LIGHTHOUSE

START POINT LIGHTHOUSE

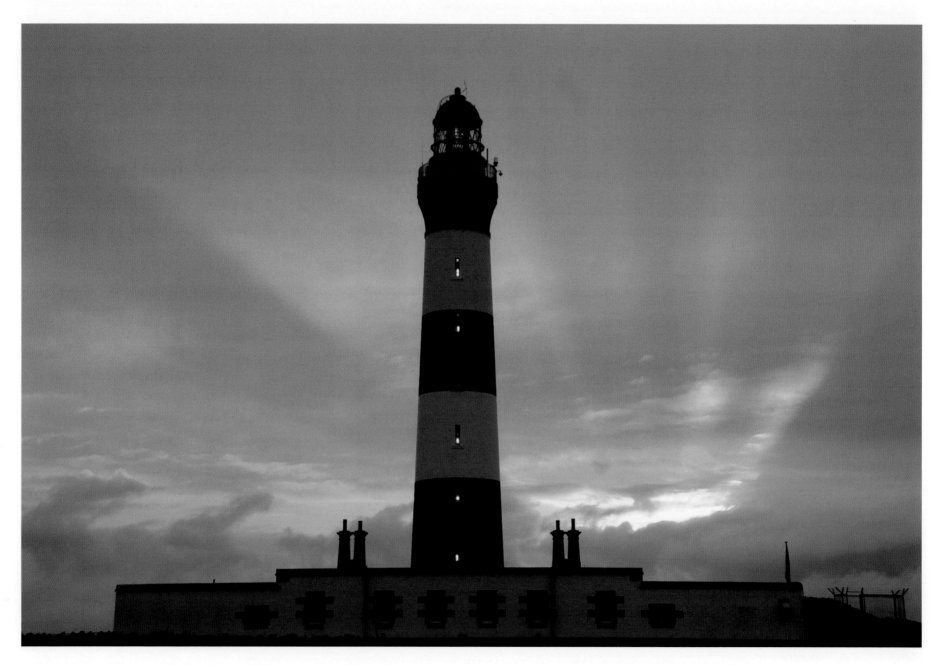

NORTH RONALDSAY LIGHTHOUSE – THE TWO WHITE BANDS WERE ADDED IN 1889 TO DISTINGUISH IT AS A DAY MARK

NORTH RONALDSAY

The island of North Ronaldsay was the location for one of the first four lighthouses built by the Northern Lighthouse Board. The beacon at Dennis Head was lit in 1789. Its position proved to be a poor one and it was discontinued in 1809 following the construction of a lighthouse at Start Point on the nearby island of Sanday. The lantern was then removed and the tower capped with a large masonry ball.

Several decades later it became apparent that a lighthouse was still required to warn ships away from the dangerous shoals and reefs around the island. Alan Stevenson designed a tall tower which would be visible for miles around and it still holds the record for being the tallest land-based lighthouse in the UK.

There was no suitable stone available on the island so it was decided to use brick for construction rather than quarrying stone elsewhere. The project turned out to be an expensive one even with the use of this cheaper material due to the remote location.

The lens was designed by Thomas Stevenson. It was the first ever all-glass revolving optic to be installed in a lighthouse. This impressive piece of engineering remains in use today.

North Ronaldsay was one of the last lighthouses to be automated. The keepers' cottages and outbuildings are now owned by the North Ronaldsay Trust. These house an exhibition, café and self-catering accommodation. The lighthouse is also open to the public and well worth a visit.

Engineer:	Alan Stevenson
Established:	1854 (Original beacon established 1789 by Thomas Smith)
Automated:	1998
Character:	Flashing White every 10 seconds
Detail:	The two white bands were added in 1889
Height:	42 metres
Status:	Operational
Authority:	NLB

ALAN STEVENSON PAID GREAT ATTENTION TO DETAIL. EVEN THE DOOR HANDLE IS INSCRIBED WITH THE INITIALS N.L. FOR NORTHERN LIGHTHOUSES

THE CLOCKWORK MACHINERY WAS MADE BY MILNE & SON OF EDINBURGH

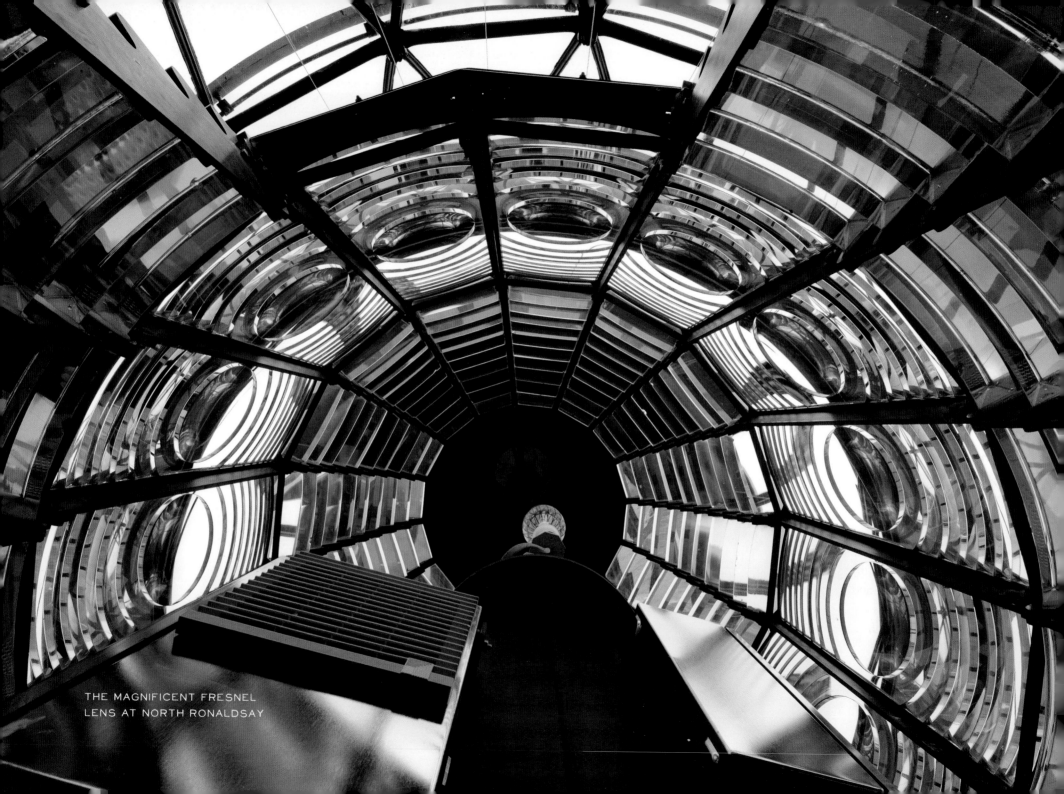

THE MAGNIFICENT FRESNEL
LENS AT NORTH RONALDSAY

NOUP HEAD

The drive up to Noup Head from Pierowall (Westray's main settlement) passes by the 16th century Noltland Castle and eventually turns into a rough track at Noup Farm. I carefully negotiate the potholes and large rocks along the track and manage to reach the lighthouse with the suspension still intact!

The RSPB reserve at Noup Head is Orkney's largest seabird colony. It's early Spring and the cliffs are still relatively quiet. In a few weeks they will come alive with the sounds (and smells!) of thousands of seabirds.

It's a marvellous scene as the sun sets over the Atlantic. I'm not the only one enjoying the view as there is a colony of seals hauled out on the rocks just below the lighthouse.

I wait for twilight so that I can get a shot of the lighthouse with the lamp turned on. The lighthouse sits in a splendid location at the top of a cliff overlooking the Atlantic Ocean. In order to capture the whole scene I have to get down onto my hands and knees and crawl towards the edge of the cliff. I'm keenly aware that any sudden movement could send my camera hurtling down into the ocean as I perch it on the ledge. I put the camera strap around my neck just in case. With some difficulty I get one shot I'm pleased with and then decide to quit while the going is good.

Engineer:	David A Stevenson
Established:	1898
Automated:	1964
Character:	Flashing White every 30 seconds
Height:	24 metres
Status:	Operational
Authority:	NLB

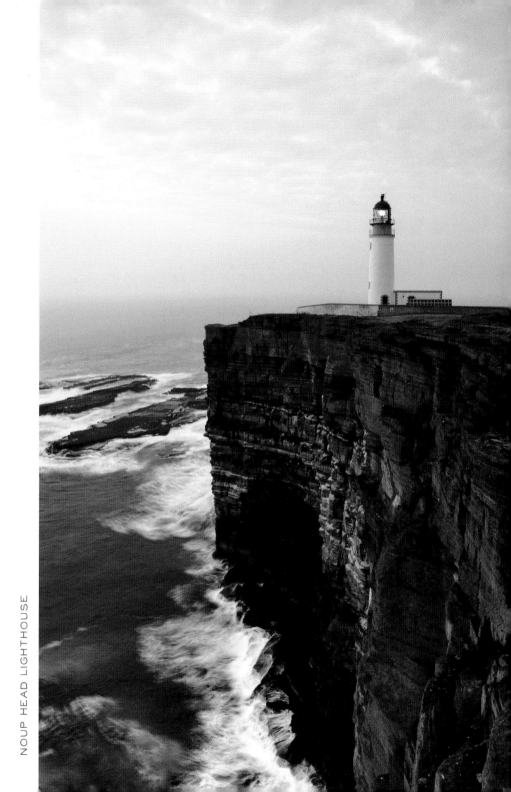

NOUP HEAD LIGHTHOUSE

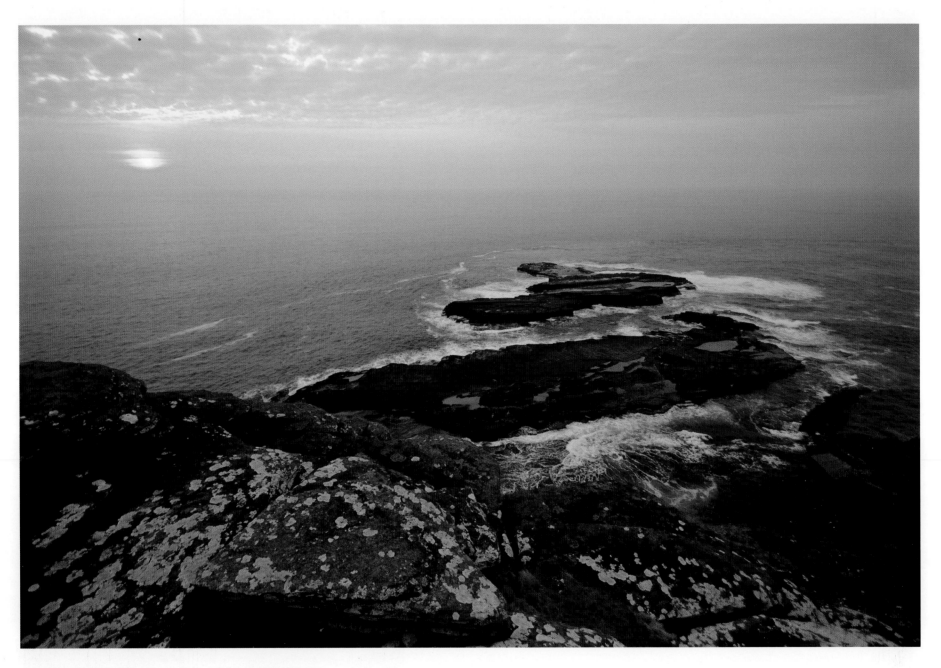

SUNSET OVER THE ATLANTIC FROM NOUP HEAD

SULE SKERRY

Situated out in the Atlantic Ocean almost 40 miles west of Orkney, Sule Skerry is one of the most difficult-to-reach lighthouses in Scotland. In the days when lighthouses were still manned, Sule Skerry was listed in the Guinness Book of Records as the most remote lighthouse in the UK.

My trip to Sule Skerry starts with a flight from Kirkwall airport. I'm accompanying two NLB staff (Craig Field and Craig Pake) on the helicopter – they form a good double act and will provide much of the entertainment for the duration of the trip!

As I get out of the helicopter after landing on Pharos, one of the crew shouts to tell me that I've dropped my camera. I fear the worst as I don't have a spare camera body and there are no camera shops nearby! Fortunately the camera still works although some of the functionality has been lost (it later costs me a few hundred pounds to get it fixed!)

We're anchored just off Sule Skerry – this place really does feel remote. The only other land to be seen is the neighbouring Sule Stack a few miles to the south west.

Once I've flown over to the island, I try to go for a wander but there are limited places to walk as the ground is strewn with old puffin burrows. It's late March and a colony of gannets have established themselves on the island. In a few weeks they'll be joined by thousands of pairs of puffins. Around the island there are several landing stages and the remains of two tramways which were used in days gone by to transport heavy goods up to the lighthouse. These have long since been abandoned and are rapidly decaying in the harsh environment.

Three technicians have made Sule Skerry their home for the past week. It's quite basic inside but they seem to enjoy the relative spaciousness of being on an island compared to that of a rock tower. Inside, much of the original interior finishes are gone (these were stripped out prior to automation in the early 1980s). However, some nice woodwork survives in the old watch room at the top of the tower. At the very top is one of the largest lantern rooms the Stevenson family ever designed, built to house a hyper-radial lens (now in

THE OLD LANDING STAGE AT SULE SKERRY

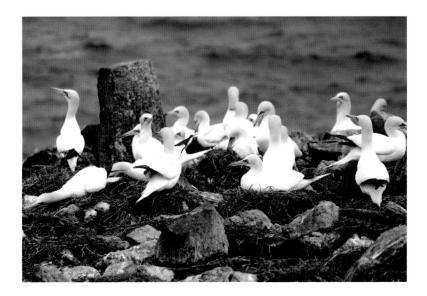

SULE SKERRY IS HOME TO A COLONY OF GANNETS

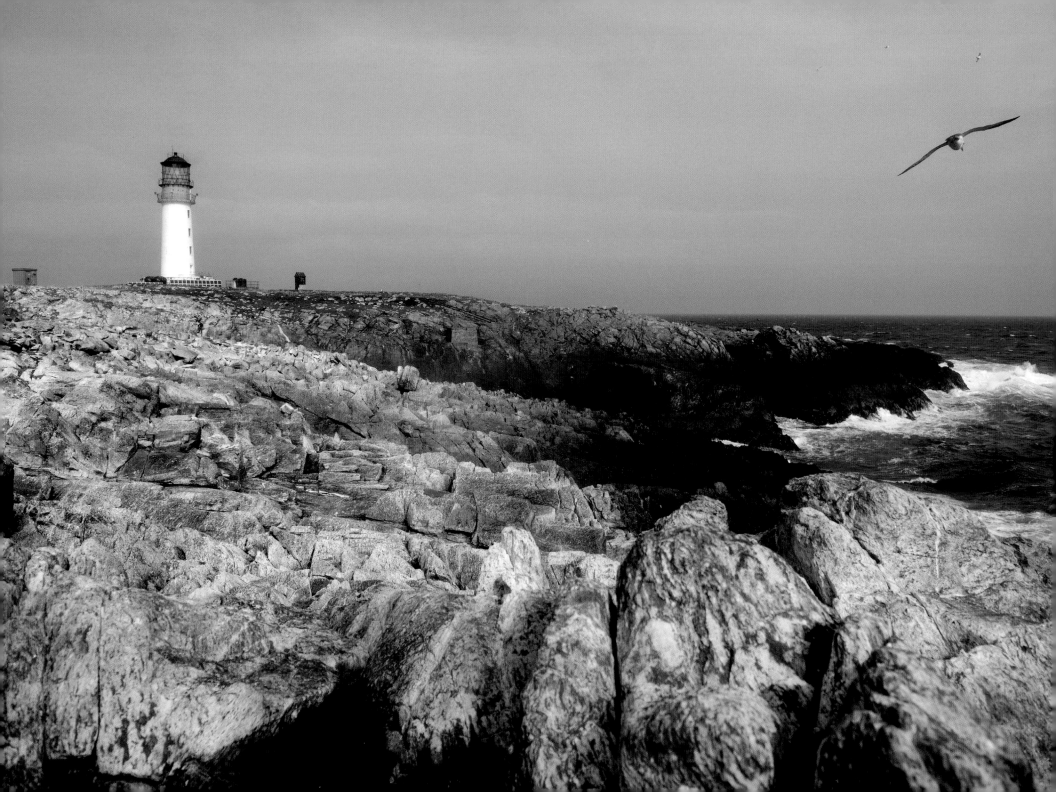

storage in the National Museum of Scotland). The space looks even bigger with the current automatic light.

The station has recently been converted to run on solar power. Much of the work going on outside involves removing materials and equipment used during the installation works.

Back on Pharos I enjoy a lovely tea followed by a highly enjoyable quiz night. A good ending to a memorable day!

Engineer:	David A Stevenson
Established:	1895
Automated:	1982
Character:	Flashing (2) White every 15 seconds
Height:	27 metres
Status:	Operational
Authority:	NLB

SULE SKERRY WATCH ROOM

[ABOVE] SULE SKERRY LANTERN ROOM

[OPPOSITE] SULE SKERRY LIGHTHOUSE

WORLD WAR TWO

During the two world wars, the lighthouses were often switched off and only turned on at the request of the Admiralty.

The Luftwaffe strafed and bombed a number of lighthouses around the coast of Scotland during the Second World War. The lights along the east coast were particularly vulnerable.

Fair Isle South Lighthouse was to suffer more than any other. During an air attack in December 1941, the wife of the Assistant Lightkeeper was killed whilst standing at the kitchen window and her infant daughter was slightly hurt. Six weeks after this attack the wife and daughter of the Principal Lightkeeper were killed when a second air attack produced a direct hit on the main accommodation block. To this day, the scars can still be seen on the side of the tower along with a bomb crater just outside the boundary wall.

Further north, an attack on the shore station for Out Skerries Lighthouse resulted in the boatman's mother sustaining fatal injuries.

At Scurdie Ness Lighthouse, the keepers had to paint the tower black after the RAF complained that it could become a daymark for German bombers and put the nearby town of Montrose at risk.

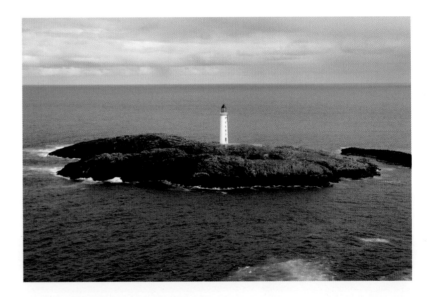

OUT SKERRIES LIGHTHOUSE

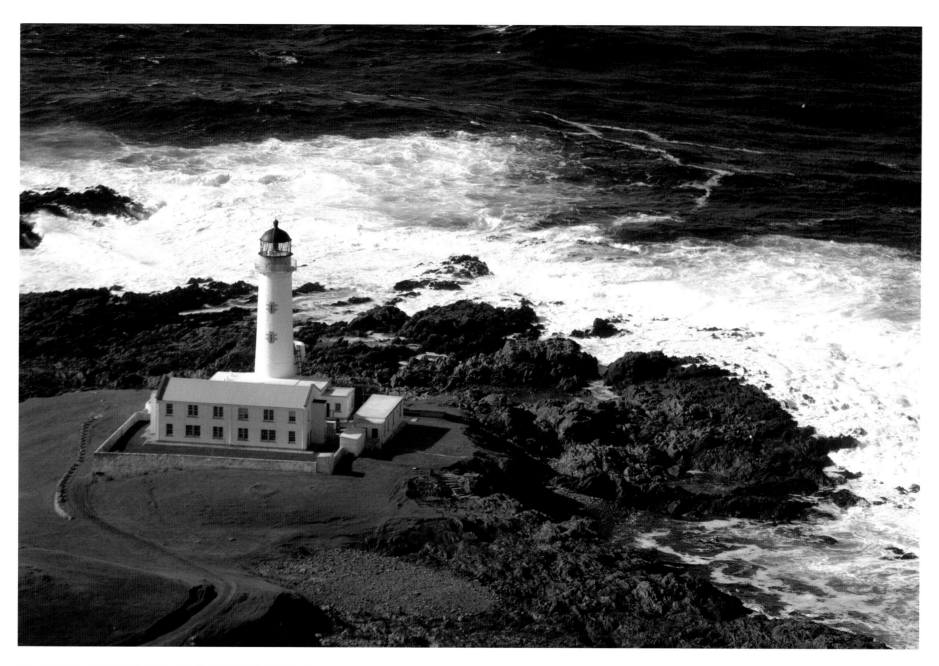

AN AERIAL VIEW OF FAIR ISLE SOUTH LIGHTHOUSE. A BOMB CRATER IS STILL VISIBLE JUST OUTSIDE THE BOUNDARY WALL

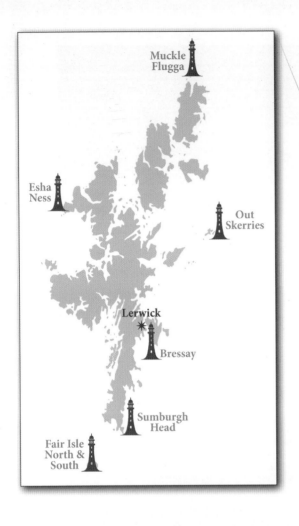

SHETLAND

FAIR ISLE SOUTH

Engineer:	David A Stevenson
Established:	1892
Automated:	1998 (Scotland's last manned lighthouse)
Character:	Flashing (4) white every 30 seconds
Height:	26 metres
Status:	Operational
Authority:	NLB

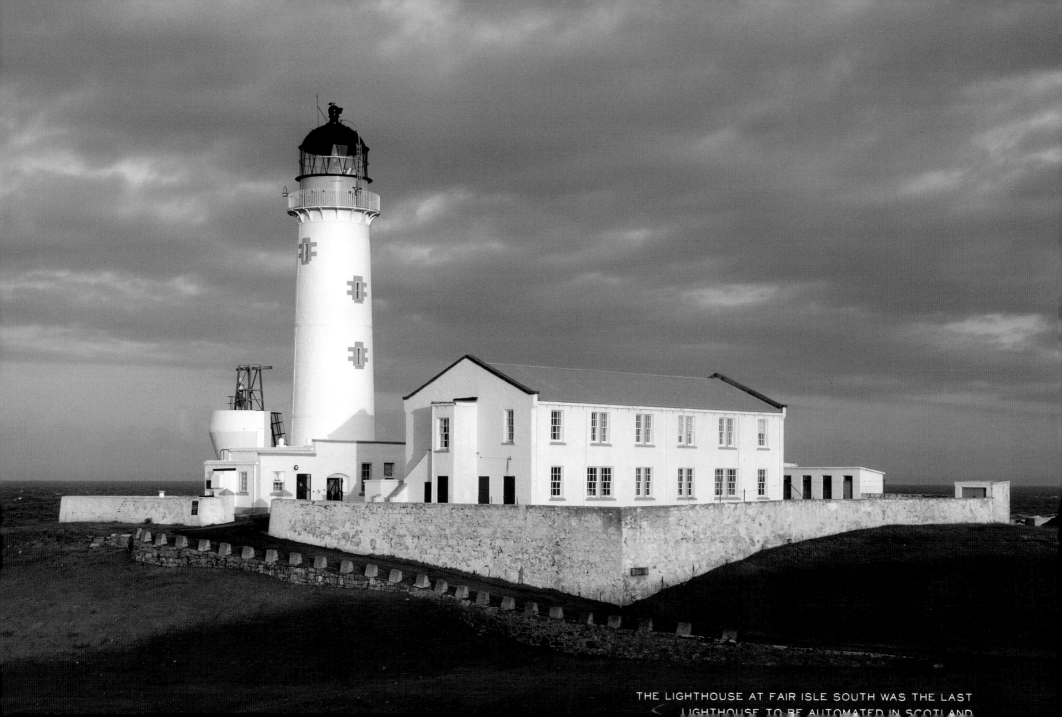

THE LIGHTHOUSE AT FAIR ISLE SOUTH WAS THE LAST
LIGHTHOUSE TO BE AUTOMATED IN SCOTLAND

FAIR ISLE SOUTH

FAIR ISLE NORTH

Engineer:	David A Stevenson
Established:	1892
Automated:	1983
Character:	Flashing (2) white every 30 seconds
Height:	14 metres
Status:	Operational
Authority:	NLB

A FULMAR IN FLIGHT

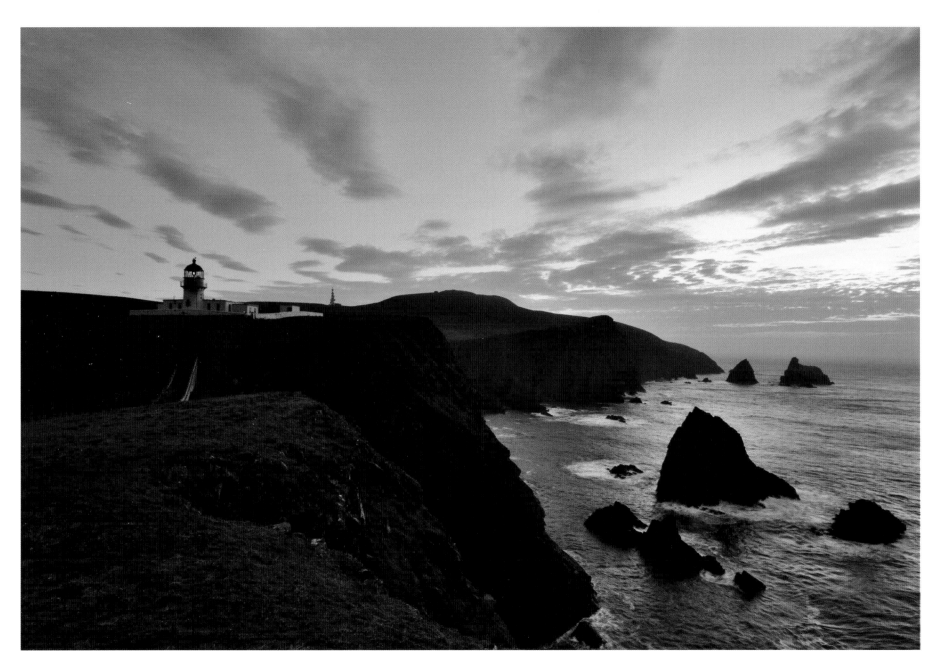

FAIR ISLE NORTH LIGHTHOUSE

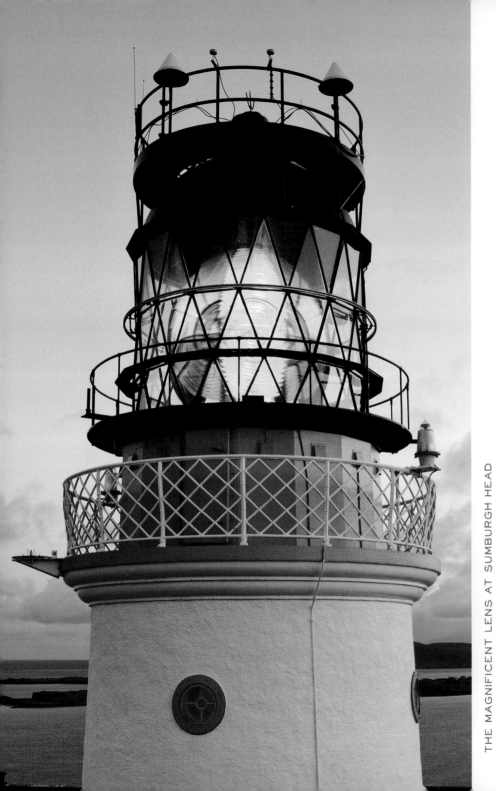

THE MAGNIFICENT LENS AT SUMBURGH HEAD

SUMBURGH HEAD

It's 4am and I've driven up to Sumburgh Head to take some pictures before sunrise. I climb up to the top of the foghorn to get the best view of the lighthouse tower and the light from the old Fresnel lens which thankfully survived the automation process.

From my elevated vantage point I can see that the surrounding buildings are suffering from years of neglect. However, this is not the end of the story as I can see a number of contractors' vehicles on site. They are about to start work on the multi-million project which will turn Sumburgh Head into a major tourist attraction.

The new Sumburgh Visitor centre was officially opened by HRH The Princess Royal on 3rd June 2014.

Engineer:	Robert Stevenson
Established:	1821
Automated:	1991
Character:	Flashing (3) white every 30 seconds
Height:	17 metres
Status:	Operational
Authority:	NLB

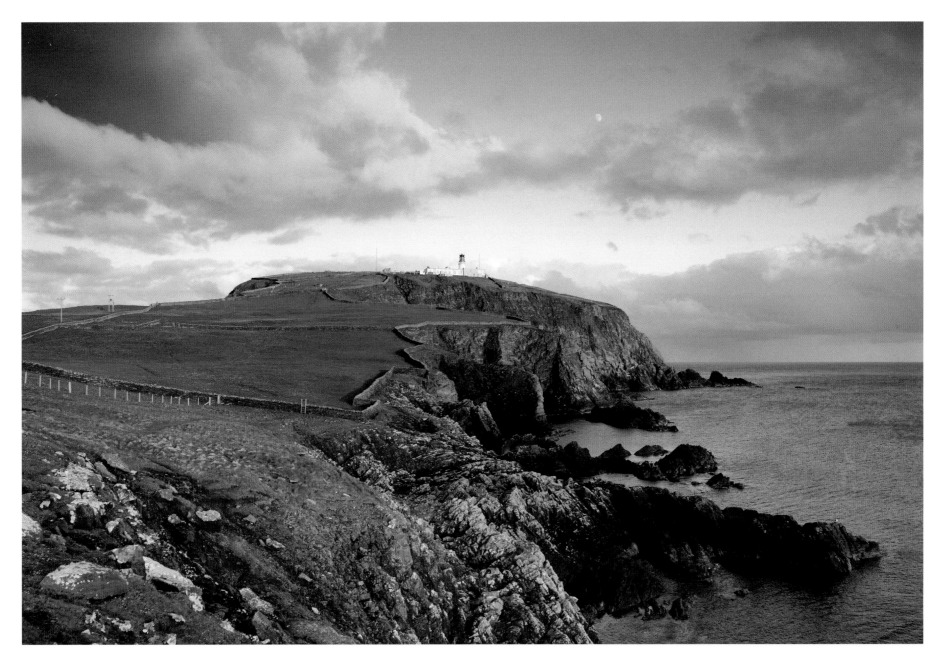

SUMBURGH HEAD LIGHTHOUSE

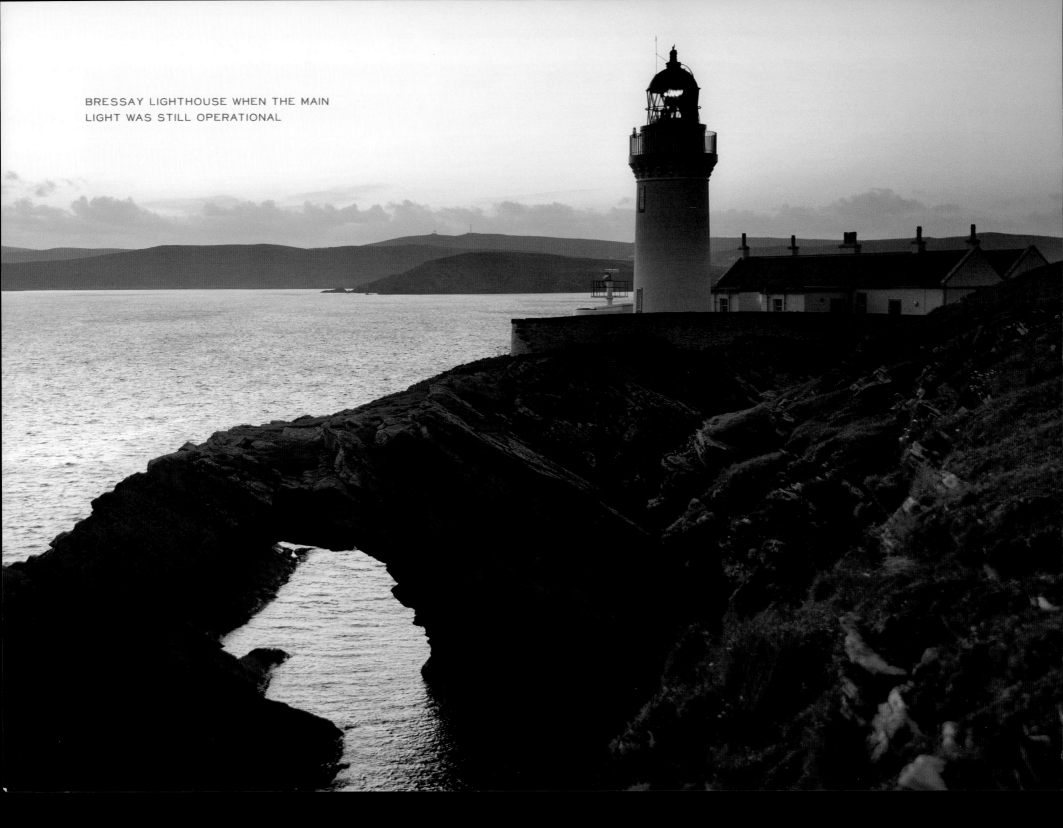

BRESSAY LIGHTHOUSE WHEN THE MAIN
LIGHT WAS STILL OPERATIONAL

BRESSAY

Engineers:	David and Thomas Stevenson
Established:	1858
Automated:	1989
Character:	Flashing (2) White every 20 Seconds
Height:	16 metres
Status:	Original light discontinued 2012, now owned by Shetland Amenity Trust
Authority:	New minor light structure established by Lerwick Port Authority (2012)

OUTSKERRIES LIGHTHOUSE

OUT SKERRIES

After flying to Out Skerries in the afternoon, a local boatman kindly takes me out for a sail to see the lighthouse on Bound Skerry. This rocky outcrop is Scotland's easternmost extremity.

We're planning to land but the swell gets progressively worse as we get nearer. We decide that it might not be such a good idea. Moments later a large wave engulfs the landing stage - confirmation that we made the right choice!

Engineer:	David Stevenson
Established:	1854 (rebuilt 1858) with Thomas Stevenson
Automated:	1972
Character:	Flashing white every 20 seconds
Height:	30 metres
Status:	Operational
Authority:	NLB

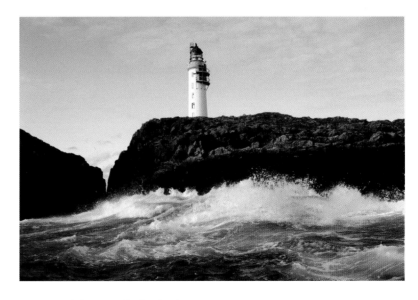

OUTSKERRIES LIGHTHOUSE

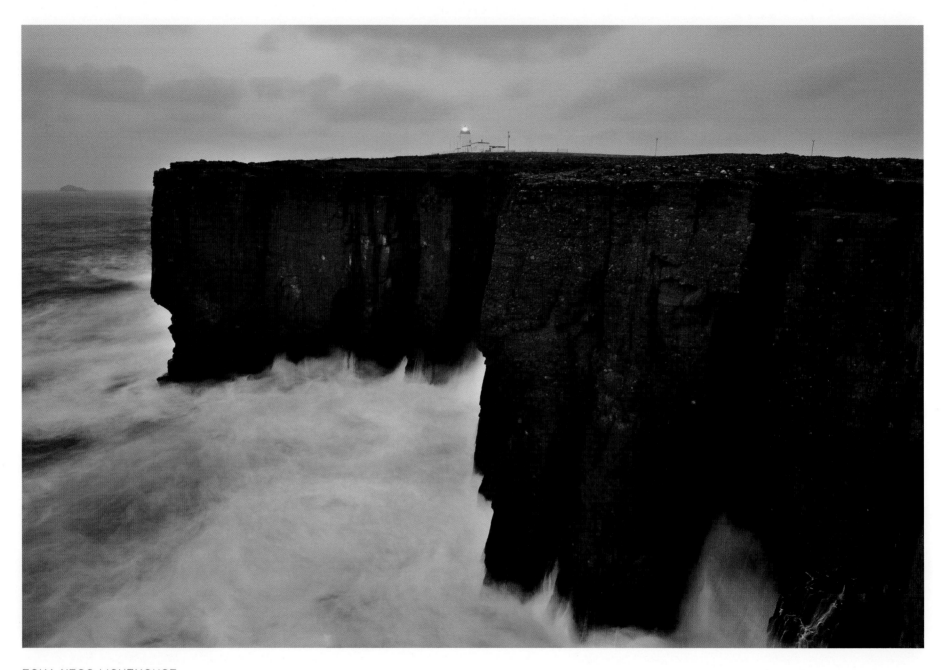

ESHA NESS LIGHTHOUSE

MUCKLE FLUGGA

Muckle Flugga lighthouse sits on a rocky outcrop at the very northern tip of the British Isles off the island of Unst. The lighthouse was built as a result of pressure from the British government as the route around the top of Shetland had experienced an increase in shipping due to the Crimean War. David Stevenson, the Northern Lighthouse Board's engineer at the time, did not believe that it would be possible to build a light in such an exposed location. However, the government insisted that a light be established as a matter of urgency and a temporary light was built under Stevenson's direction in 1854.

Although this temporary light was 200ft above sea level, the following winter saw the heavy seas causing damage to the living quarters (the sea smashed open the door to the living quarters, soaking and terrifying those inside). David Stevenson then designed a more substantial permanent lighthouse along with his brother Thomas. The lighthouse is made of brick - an innovation at the time for lighthouse engineering to reduce manual handling of the building materials up the steep sides of rock.

My trip to take some shots of Muckle Flugga before sunrise starts in the darkness at 2am. As I approach Burrafirth I can see a solitary camper van in the car park and I switch the hire car headlights off so that I don't wake those inside. Unfortunately my best attempts at being considerate are completely undone when I accidentally set the car alarm off whilst locking the car - probably giving the poor residents of the camper van the fright of their lives!

Moving swiftly on, I start my walk across the Hermaness Reserve. The reserve is well known as a breeding ground for the Bonxie (Great Skua). Bonxies are the pirates of the seabird world, stealing food from other birds and even killing smaller birds. I feel the sudden rush of air above my head as I'm dive-bombed several times and put my camera tripod above my head to provide some protection.

I finally reach my destination at the very tip of Unst. It's an awesome sight with towering cliffs and Muckle Flugga Lighthouse lying a mile or so offshore. I scramble down a grassy slope to get as low a viewpoint as possible. There's little room for manoeuvre as I fumble with the camera and struggle to get it to focus properly in the poor light. I manage to take a few pictures. There's a gloomy atmospheric feel to the scene.

Making my way back up the hill, I walk along the clifftop and the sun comes out. I take one last picture of Muckle Flugga bathed in the morning sunlight before heading back to face the Bonxies and a well earned sleep!

Engineer:	David Stevenson
Established:	1854 (rebuilt 1857) with Thomas Stevenson
Automated:	1995
Character:	Flashing (2) White every 20 seconds
Height:	20 metres
Status:	Operational
Authority:	NLB

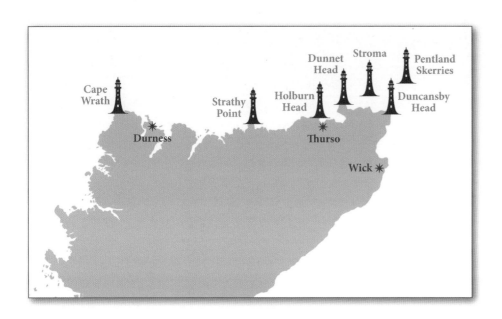

NORTH COAST

DUNCANSBY HEAD

Engineer:	David A Stevenson
Established:	1924
Automated:	1997
Character:	Flashing White every 12 seconds
Height:	11 metres
Status:	Operational
Authority:	NLB

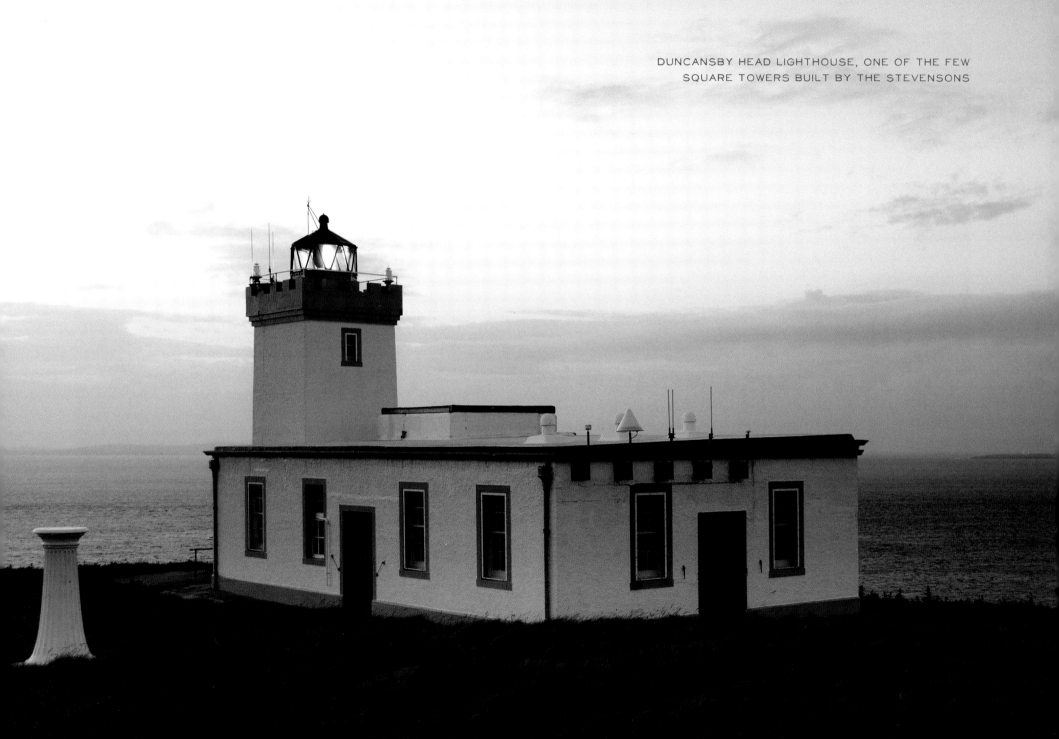

PENTLAND SKERRIES LIGHTHOUSE

PENTLAND SKERRIES

Thomas Smith gave Robert Stevenson the task of supervising the construction of two towers on the island of Muckle Skerry in the Pentland Skerries. These twin towers enabled two fixed lights to be displayed reducing the likelihood of sailors mistaking the lights for something else.

Pentland Skerries was Robert Stevenson's first work for the Northern Lighthouse Board. Following one site visit he boarded the Stromness registered sloop *Elizabeth* which was bound for Leith. The *Elizabeth* proceeded as far as the coast near Fraserburgh where lack of wind prevented her sailing any further. Robert Stevenson was rowed ashore and continued his journey to Edinburgh by land. He was the only passenger to do so. Had Stevenson decided to remain on board, he would have lost his life. When the wind picked up, it blew the *Elizabeth* northwards again where she was wrecked with the loss of all on board.

In 1895 a flashing light was installed in the taller of the two towers and the lower light extinguished.

On neighbouring Little Skerry lies the wreck of the Aberdeen registered trawler *Ben Barvas* which ran aground on 3rd January 1964. Some crew were rescued by a trawler; the rest were rescued by the Longhope Lifeboat *TGB*.

Tragically, *TGB* would be lost five years later on 17th March 1969 with all eight of her crew whilst responding to a distress call from the *SS Irene* which had got into difficulties.

Engineer:	Thomas Smith
Established:	1794, New lights established by Robert Stevenson in 1830.
Automated:	1994
Character:	Flashing (3) White every 30 seconds
Height:	36 metres
Status:	Operational
Authority:	NLB

THE WRECK OF THE BEN BARVAS ON LITTLE SKERRY

A FULMAR CHICK OUTSIDE THE LIGHTHOUSE BOUNDARY WALL

STROMA LIGHTHOUSE

A SEA CAVE ON STROMA

STROMA

Engineer:	David A Stevenson
Established:	1896
Automated:	1996
Character:	Flashing (2) White every 20 seconds
Height:	23 metres
Status:	Operational
Authority:	NLB

DUNNET HEAD

Dunnet Head Lighthouse marks the most northerly point of the British mainland.

Engineer:	Robert Stevenson
Established:	1831
Automated:	1989
Character:	Flashing (4) White every 30 seconds
Height:	20 metres
Status:	Operational
Authority:	NLB

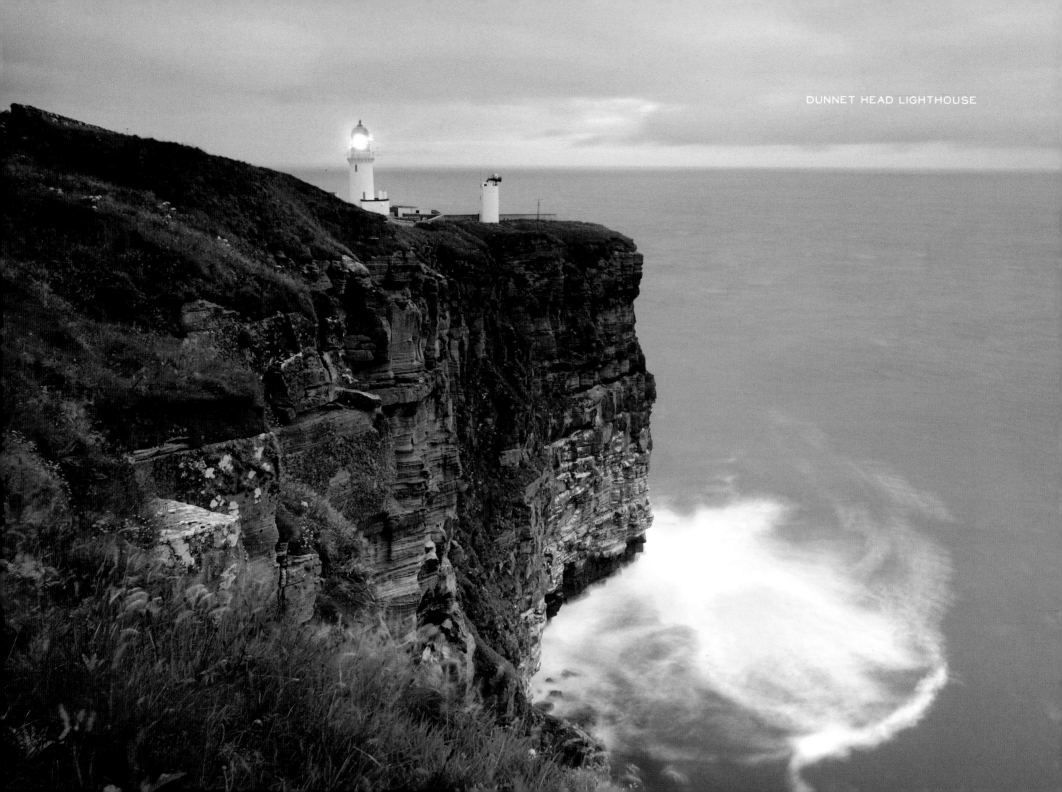

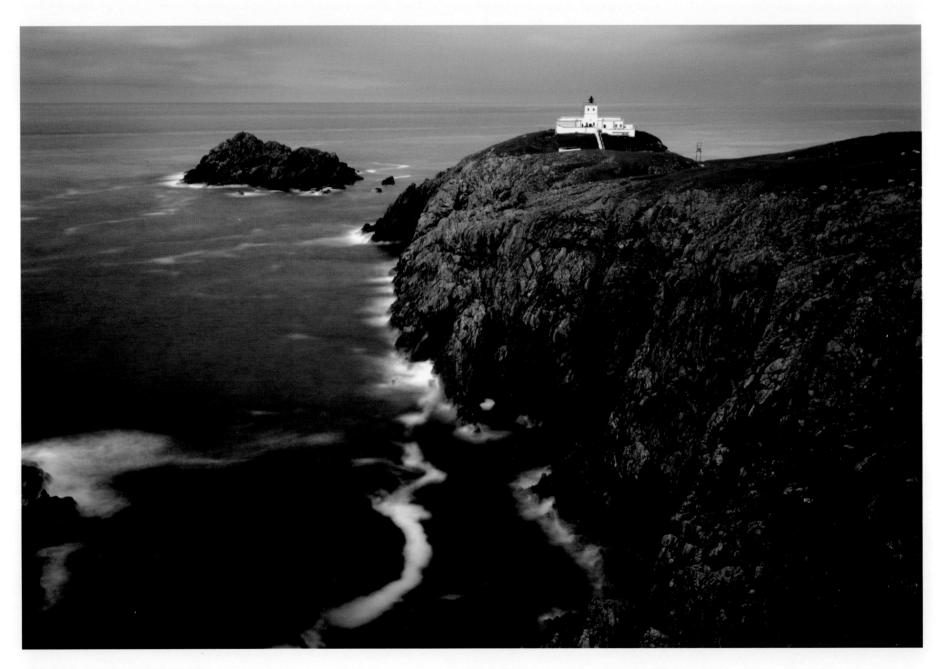

STRATHY POINT LIGHTHOUSE

HOLBURN HEAD

Engineers: David and Thomas Stevenson
Established: 1862
Automated: 1988
Character: Flashing White/Red every 10 Seconds (Discontinued)
Height: 17 metres
Status: Discontinued 2003, now in private ownership

STRATHY POINT

Strathy Point was both the first all-electric station in Scotland and the last manned lighthouse to be built in Scotland.

It is not a Stevenson designed light although some of the architectural features clearly show a Stevenson influence.

Engineer: P H Hyslop
Established: 1958
Automated: 1997
Character: Flashing White every 20 seconds (Discontinued)
Height: 14 metres
Status: Discontinued 2012, now in private ownership

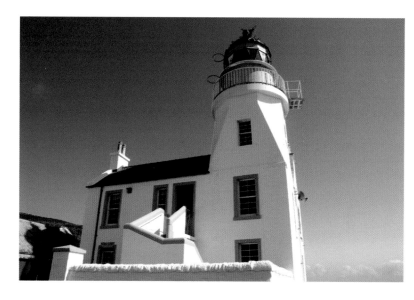

HOLBURN HEAD LIGHTHOUSE

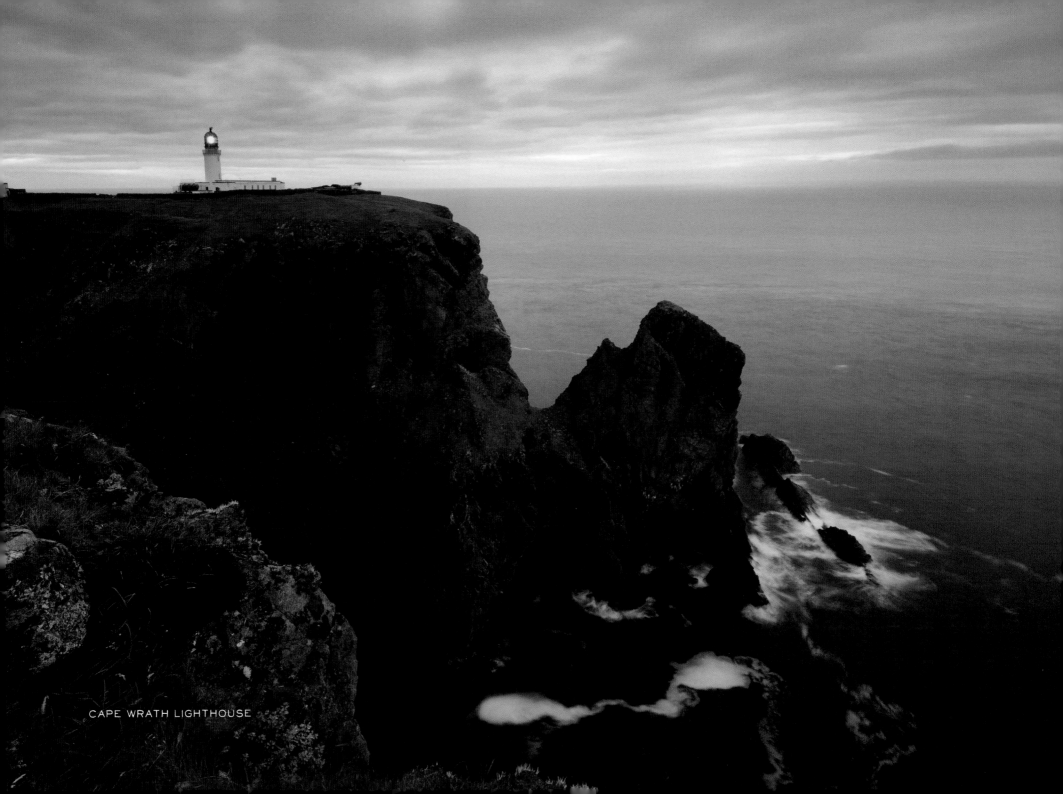

CAPE WRATH LIGHTHOUSE

CAPE WRATH

A spectacular and wild place, Cape Wrath is one of the remotest places on the British mainland.

A visit to Scotland's most north-westerly point on the mainland involves a ferry trip across the Kyle of Durness followed by an eleven mile journey by minibus, cycle or foot along a rough track. The surrounding moorland is used by the Military of Defence for training exercises.

I'm visiting the Cape with David Hird who drives the minibus and is also the Retained Lighthouse Keeper. David has written a book 'A Light in the Wilderness' about the history of the lighthouse and surrounding area.

Although it's July, the weather is cold, damp and misty for most of my visit. There's only a very brief sunny spell later in the day when I manage to take some pictures along the cliffs opposite the lighthouse. I stay overnight in the former keepers` accommodation and get up early to see if there is going to be a nice sunrise. Unfortunately it's not to be.

CAPE WRATH FOGHORN

The lighthouse on Cape Wrath is frequently obscured by low level cloud because of its elevated position at the top of a cliff. In 1913 David A Stevenson came up with an ambitious scheme to build a lighthouse at a lower position on the outermost rock at the Cape. The plans required the construction of a deep vertical shaft and covered walkways out to the lighthouse. A contractor constructed part of the shaft but later left the work. A new contractor could not be found and the onset of World War I led to the abandonment of this costly project.

Engineer:	Robert Stevenson
Established:	1828
Automated:	1998
Character:	Flashing (4) White every 30 seconds
Height:	20 metres
Status:	Operational
Authority:	NLB

FOGHORNS

An early example of a fog warning device was installed at the Bell Rock when it was first lit in 1811. This device consisted of two bells which were struck by hammers operated by a clockwork mechanism. The device would ring the bells at preset intervals so that mariners would know where they were.

The United States Lighthouse Board led the development of fog sirens operated by compressed air. In 1865, the Cumbrae Lighthouse Trust had a US designed fog siren installed at Little Cumbrae Lighthouse on the Clyde. The Northern Lighthouse Board installed their first fog siren at St Abb's Head in 1876.

These devices were either switched off or replaced by electrically powered fog signals in the 1980s during the modernisation and automation programme.

The development of radio aids to navigation has meant that foghorns, which were expensive to operate and not very efficient, are no longer required in most cases. The Northern Lighthouse Board no longer operates any fog signals, the last one at Skerryvore being switched off in October 2005. The other General Lighthouse Authorities in Great Britain and Ireland have followed suit. The Commissioners of Irish Lights decommissioned the last of their fog signals in 2011. In England and Wales, Trinity House still operate a few fog signals, however the number of these is steadily declining each year.

On a positive note, the old fog siren at Sumburgh Head Lighthouse sounded again in February 2015 after a period of inactivity of almost 30

THE FOGHORN AT ST ABBS HEAD WAS DECOMMISSIONED IN 1987

years. This followed a painstaking restoration by Brian Johnson, a former lighthouse technician and current Retained Lighthouse Keeper for Shetland. There is also a fully functioning fog siren at North Ronaldsay Lighthouse. This is a more modern design than the Sumburgh one. The blasts from these foghorns are now for the benefit of tourists rather than navigation.

THE FOGHORN AT GIRDLE NESS, AFFECTIONATELY
KNOWN AS THE 'TORRY COO'

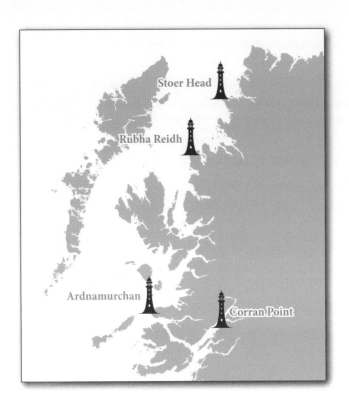

WEST COAST

STOER HEAD

Engineers:	David and Thomas Stevenson
Established:	1870
Automated:	1978
Character:	Flashing White every 15 seconds
Height:	14 metres
Status:	Operational
Authority:	NLB

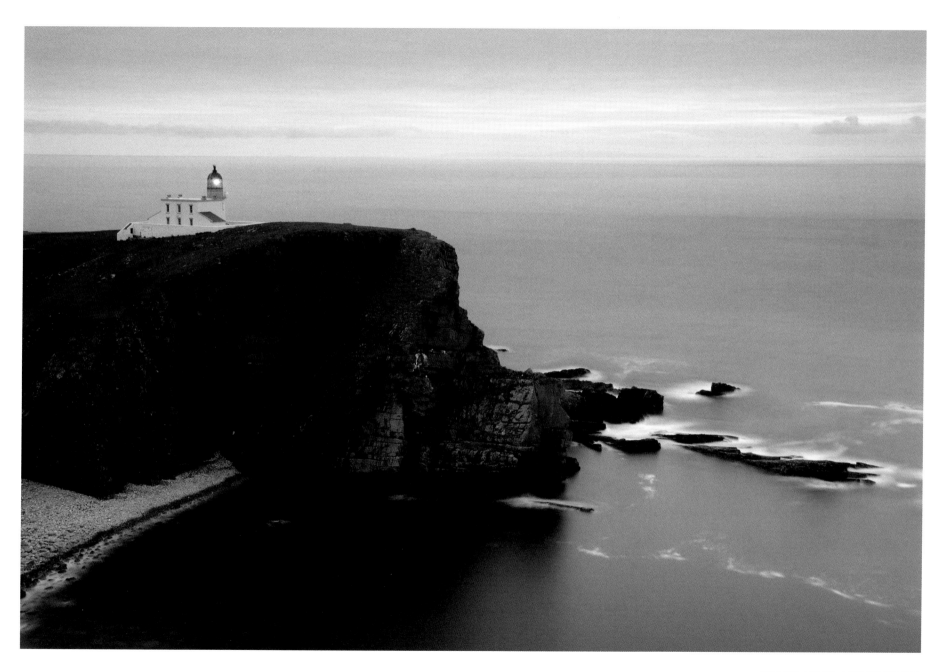

STOER HEAD LIGHTHOUSE

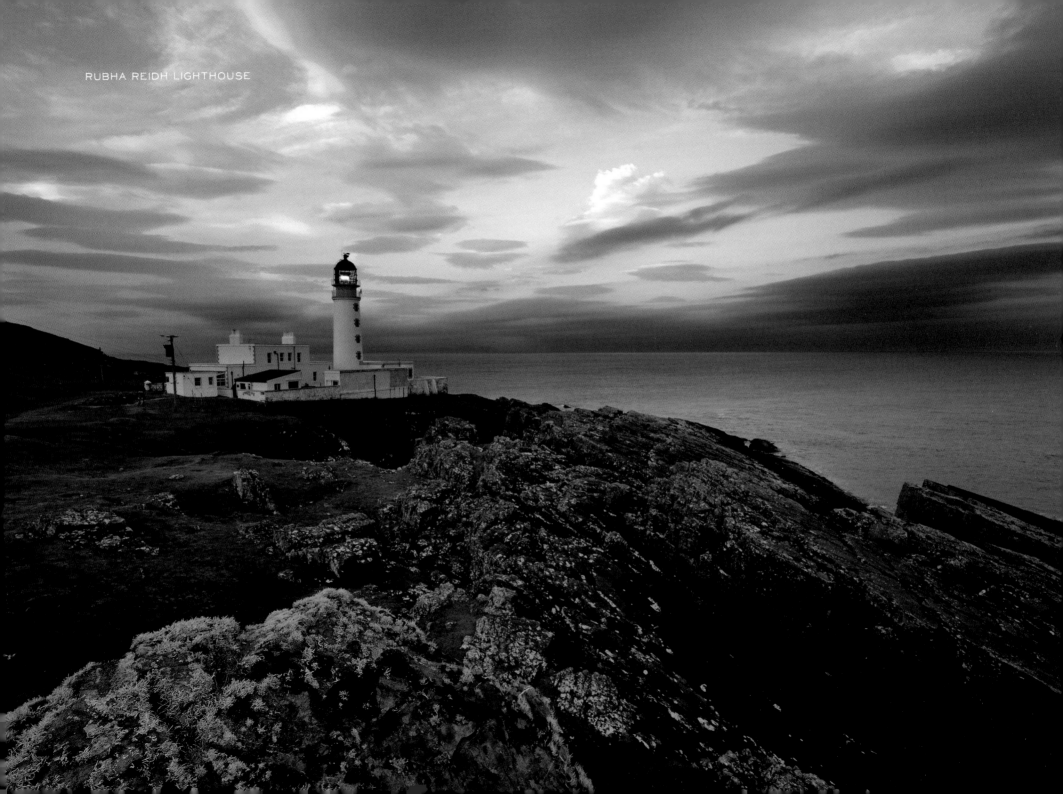

RUBHA REIDH LIGHTHOUSE

RUBHA REIDH

Engineer:	David A Stevenson
Established:	1912
Automated:	1986
Character:	Flashing (4) White every 15 seconds
Height:	25 metres
Status:	Operational
Authority:	NLB

ARDNAMURCHAN

Ardnamurchan Lighthouse stands on the most westerly point of the British mainland and is reached by what must be one of the most winding roads in Scotland.

The lighthouse is built from granite quarried from the Ross of Mull. Alan Stevenson incorporated a number of details inspired from the architecture of ancient Egypt.

Some of the buildings have been turned into a lighthouse exhibition, self-catering accommodation and a café. The lighthouse is open to the public during the summer months.

The most illustrious visitor to the lighthouse was Her Majesty Queen Elizabeth II who climbed to the top of the tower on 11th August 1986. Her visit coincided with the 200th anniversary of the founding of the Northern Lighthouse Board.

Engineer:	Alan Stevenson
Established:	1849
Automated:	1988
Character:	Flashing (2) White every 20 seconds
Height:	36 metres
Status:	Operational
Authority:	NLB

ARDNAMURCHAN LIGHTHOUSE

A PAINTING OF THE NORTHERN LIGHTHOUSE BOARD'S
CREST INSIDE THE ENTRANCE OF ARDNAMURCHAN

CORRAN POINT

Engineers:	David and Thomas Stevenson
Established:	1860
Automated:	1970
Character:	Isophase White/Red/Green every 4 seconds
Height:	13 metres
Status:	Operational
Authority:	NLB

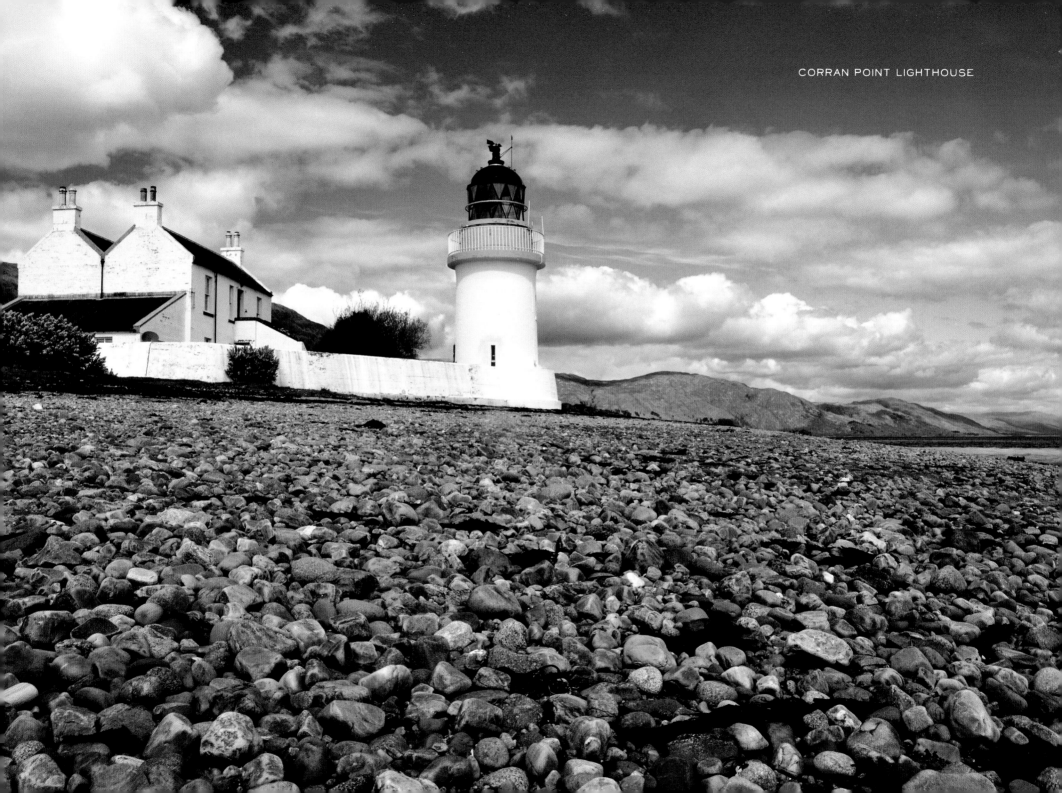

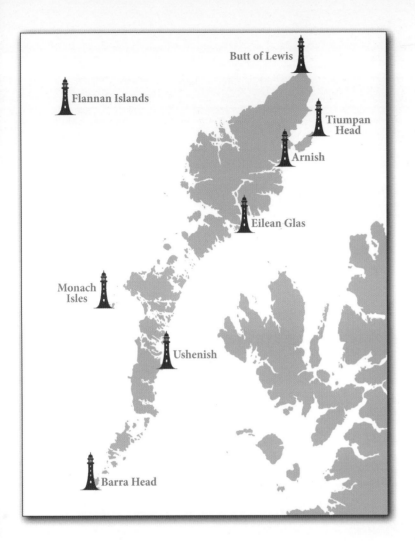

OUTER HEBRIDES

BUTT OF LEWIS

Engineers:	David and Thomas Stevenson
Established:	1862
Automated:	1998
Character:	Flashing White every 5 seconds
Height:	37 metres
Status:	Operational
Authority:	NLB

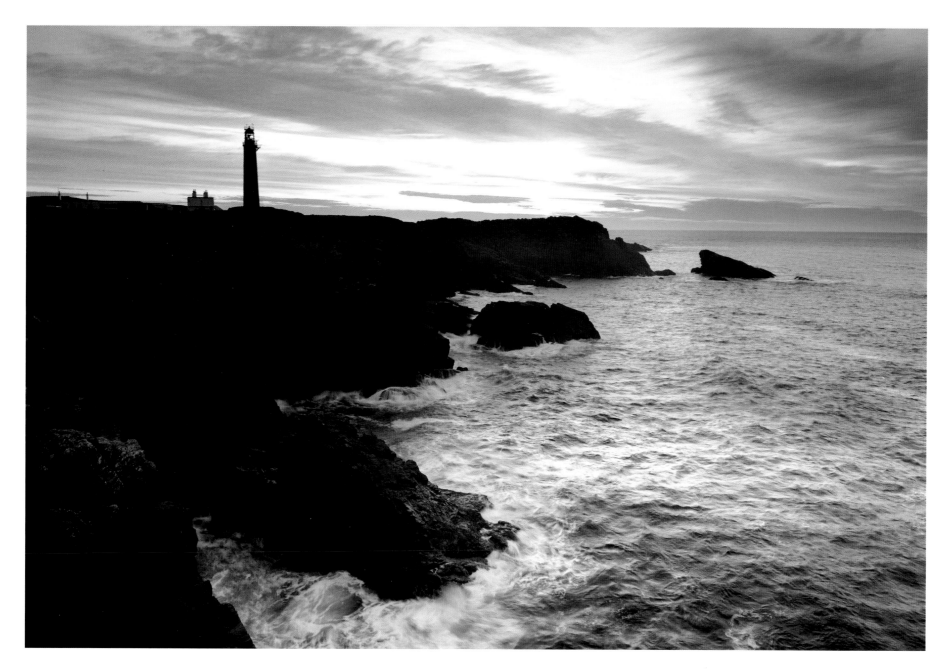

BUTT OF LEWIS LIGHTHOUSE

FLANNAN ISLANDS

THE FLANNAN ISLANDS LIGHTHOUSE

THE FLANNAN ISLE SHORE STATION AT BREASCLETE
WAS HOME TO THE FAMILIES OF THE FLANNAN
ISLAND'S KEEPERS UNTIL 1971

The Flannan Isles are a group of seven islands 21 miles west of the Isle of Lewis. The lighthouse sits at the top of Eilean Mor, the largest of these islands.

Flannan Islands would have gone down in history as just another Stevenson lighthouse (albeit in a very remote and wild location) had it not been for the events of December 1900 just a year after the station was established.

On 15th December 1900 a passing ship reported that the light was not operational. The Northern Lighthouse Board relief boat was delayed due to poor weather and did not reach the island until December 26th. Once ashore, the visiting party could find no trace of the three lighthouse keepers (Ducat, Marshall and McArthur). The lamp had been trimmed and was ready to be lit and the only sign that something may have been amiss was an upturned chair in the living room. The fate of the three keepers was a source of great speculation in the press at the time. The most likely scenario is that the keepers were washed off one of the lower parts of the island by a huge wave. The mystery remains to this day.

Flannan Islands Lighthouse was one of the first offshore lighthouses to be automated in 1971.

Engineer:	David A Stevenson
Established:	1899
Automated:	1971
Character:	Flashing (2) White every 30 seconds
Height:	23 metres
Status:	Operational
Authority:	NLB

DETAIL ABOVE ENTRANCE DOOR AT SHORE STATION

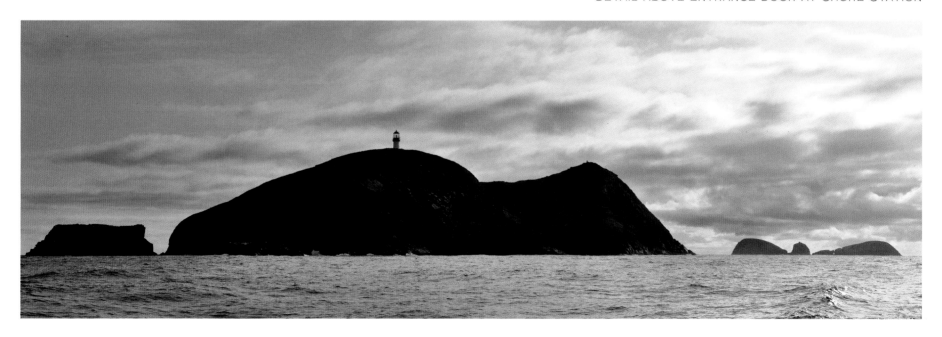

FLANNAN ISLES

TIUMPAN HEAD LIGHTHOUSE

ARNISH POINT LIGHTHOUSE

ARNISH POINT LIGHTROOM

TIUMPAN HEAD

Engineer: David A Stevenson
Established: 1900
Automated: 1985
Character: Flashing (2) White every 15 seconds
Height: 21 metres
Status: Operational
Authority: NLB

ARNISH POINT

Arnish Point lighthouse has guarded the entrance to Stornoway Harbour since 1852. It was the last lighthouse which Alan Stevenson was responsible for as Engineer to the Northern Lighthouse Board.

The lighthouse is unusual in that it is made of iron, rather than stone, and was the Stevensons' first attempt at a prefabricated lighthouse. The steel panels for the lighthouse were cast in Renfrew. The lighthouse interior was said to be very cold in winter!

Engineer: Alan Stevenson
Established: 1853
Automated: 1963
Character: Flashing White/Red every 10 seconds
Height: 14 metres
Status: Operational
Authority: Transferred to Stornoway Harbour Authority 2003

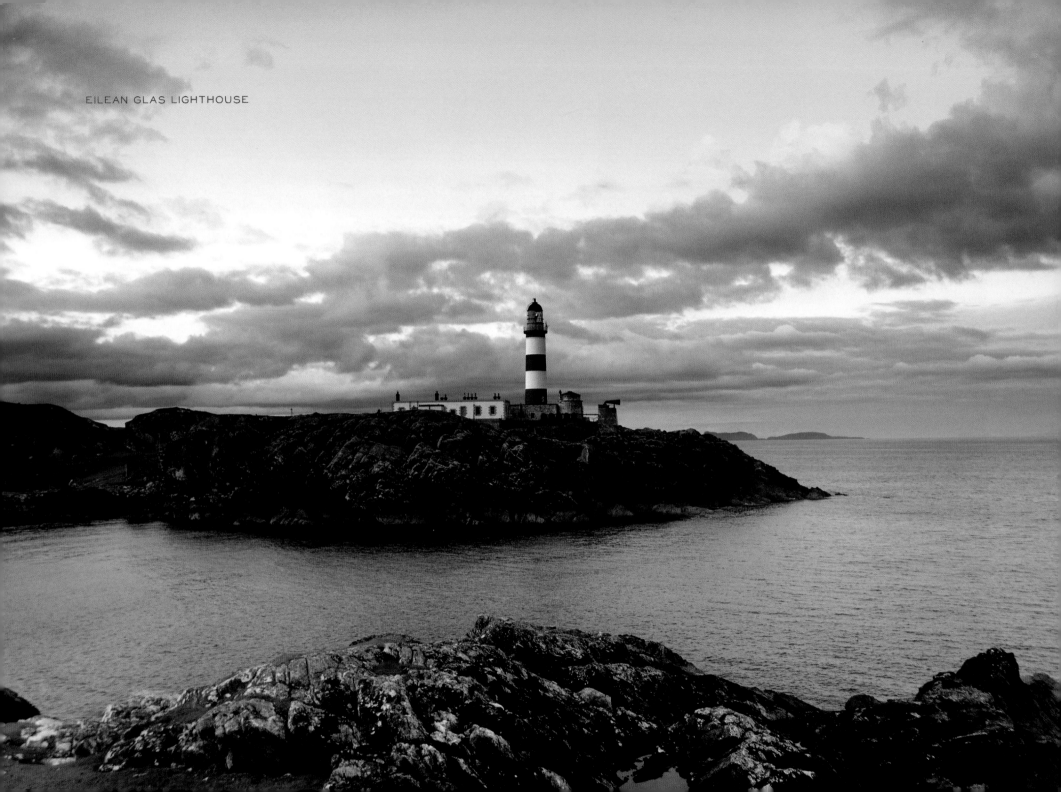

EILEAN GLAS LIGHTHOUSE

EILEAN GLAS

Eilean Glas lighthouse was one of the first four lighthouses to be established by the Northern Lighthouse Board and sits on a small peninsula on the east coast of the island of Scalpay. The lighthouse was built to guide ships sailing along The Minch.

Each generation of the Stevenson family has left its mark on this remote lighthouse. Thomas Smith's original tower of 1789 is dwarfed by the current lighthouse built by Robert Stevenson in 1824. The former keepers' houses dating from the 1840s incorporate the Egyptian Revival style details which were so highly favoured by Alan Stevenson. The foghorn and engine room were added by David A and Charles Stevenson in the early 1900s.

There is no road to Eilean Glas and the only access is by foot or by boat. A footpath has recently been laid to make public access easier. Whilst the lighthouse is still maintained by the Northern Lighthouse Board, the keepers' houses and outbuildings were sold after automation and have regrettably deteriorated over the years. There have been some attempts in recent years by the local community to halt the decline of this picturesque and architecturally significant site. However, a significant investment will be required to restore the site to its former glory.

Engineer:	Thomas Smith
Established:	1789 (New light established 1820s by Robert Stevenson)
Automated:	1978
Character:	Flashing (3) White every 20 seconds
Height:	30 metres
Status:	Operational
Authority:	NLB

SUNRISE OVER THE ISLAND OF SCALPAY

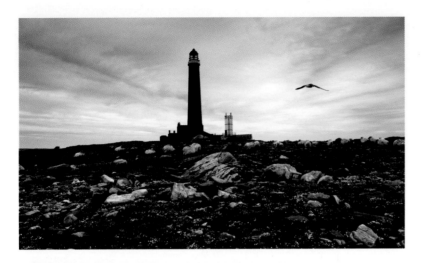

THE 1864 MONACHS LIGHTHOUSE WITH THE 1997
MODERN STRUCTURE POSITIONED TO THE RIGHT

THE VIEW OUT TOWARDS THE ATLANTIC FROM CEANN EAR

MONACH ISLES

The remote lighthouse on Shillay, the most westerly of the Monach Islands, was first lit in 1864. Tragedy occurred in 1936 when two of the keepers drowned whilst rowing back from the neighbouring island having gone there to collect mail.

The Second World War saw the lighthouse being switched off in 1942. The keepers never returned as the decision to abandon the lighthouse for good was made in 1948.

In 1997, a governmental review of the routes to be used by oil tankers around the west coast led to the establishment of a small modern light next to the old tower. It was later decided to increase the range of this light which meant a taller structure was required - things came full circle when a new light was installed in the old lighthouse in 2008 after a period of inactivity for 60 years.

This is my third time on North Uist and I'm determined to make it out to view the lighthouse on Shillay, the outermost of the Monach Islands. On previous trips I've had to settle for a long distance view due to time constraints or poor weather. The Monachs first captivated my imagination as a boy when my grandfather drew me a sketch of the abandoned lighthouse after one of his fishing trips over on the West Coast.

Conditions are favourable this time so I join a group on a boat trip out to the islands. We land on Ceann Ear first which is the largest of the islands. I take a walk round some of the island and have a quick look at the old schoolhouse there.

It's not possible to dock the boat at the seaweed covered pier on Shillay so everyone is ferried ashore in a rubber dinghy. The sun disappears for the day so I have to make do as best I can with the dull lighting conditions. I decide to go for some moody black and white shots. It's an interesting place to explore. In addition to the imposing red brick tower, there are the twisted remains of a shipwreck lying far back from shoreline. A flock of sheep are grazing on the wild grass, the only inhabitants of this remote and lonely place.

Engineers: David and Thomas Stevenson
Established: 1864, Discontinued 1942, Brought back into service 2009
Character: Flashing (2) White every 15 seconds
Height: 41 metres
Status: Operational
Authority: NLB

USHENISH

Ushenish is one of the most isolated land-based lighthouses in Scotland. There's no road access so I park the car at Loch Skipport in the morning. It takes two and a half hours to walk the five miles over moorland which is boggy in places. There is no marked path for the greater part of the route.

I eventually reach the old landing point and storehouse. From this point there is a proper path which makes the walk much easier. I pass by an old well and reach the boundary wall where there is an information board giving the history of the lighthouse - I'm not sure that many people will read it given the remote location! The actual lighthouse is a short one and the neighbouring keepers' houses were sadly demolished in the early 1970s leaving only their foundations. The location is quite spectacular however, with great views across The Minch to Skye and the mountains of South Uist behind me.

After taking some pictures and resting for a while I somewhat reluctantly begin the long walk back to Loch Skipport again.

Engineers: David and Thomas Stevenson
Established: 1857
Automated: 1970
Character: Flashing White every 20 seconds
Height: 12 metres
Status: Operational
Authority: NLB

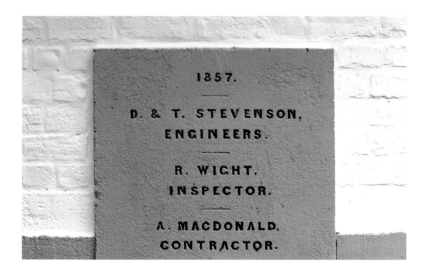

USHENISH LIGHTHOUSE DETAIL ABOVE ENTRANCE

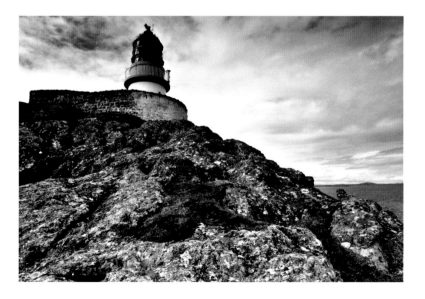

USHENISH LIGHTHOUSE

BARRA HEAD — GRAVES OF KEEPERS FAMILIES

BARRA HEAD

Barra Head Lighthouse is located on the island of Berneray, the southernmost island in the Outer Hebrides. It holds the record for being the highest lighthouse above sea level in the UK at 208 metres.

It's a steep walk of about a mile from the pier to the top of the island where the lighthouse is situated. I make a detour past a small walled enclosure containing the graves of several keepers' children, a reminder that families lived here for many years before it was designated a rock station. I have the whole island to myself and admire the views from the huge cliffs near the lighthouse. On one side is the neighbouring island of Mingulay, elsewhere there is only the vast blue expanse of the Atlantic with the next landfall being North America. When it was manned, the keepers reported finding small fish at the top of these cliffs, such is the power of the sea in this place.

Engineer:	Robert Stevenson
Established:	1833
Automated:	1980
Character:	Flashing White every 15 seconds
Height:	18 metres
Status:	Operational
Authority:	NLB

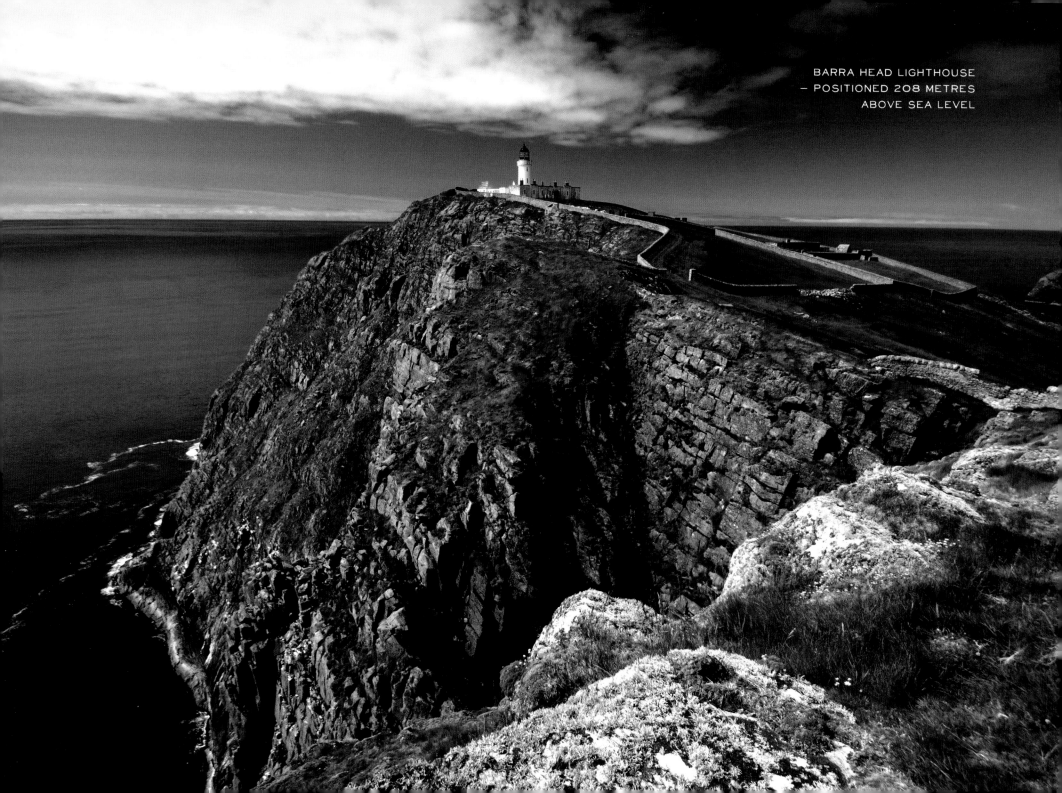

BARRA HEAD LIGHTHOUSE
– POSITIONED 208 METRES
ABOVE SEA LEVEL

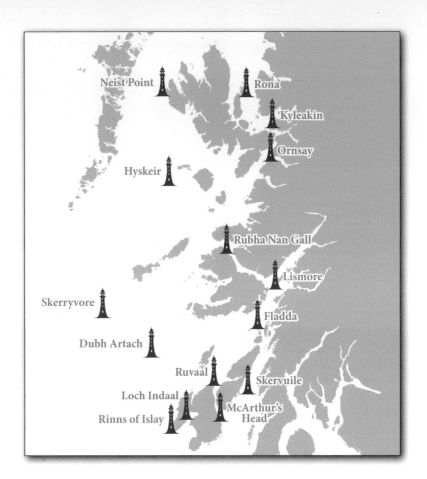

INNER HEBRIDES

RONA

Engineer:	David and Thomas Stevenson
Established:	1857
Automated:	1975
Character:	Flashing White every 12 seconds
Height:	13 metres
Status:	Operational
Authority:	NLB

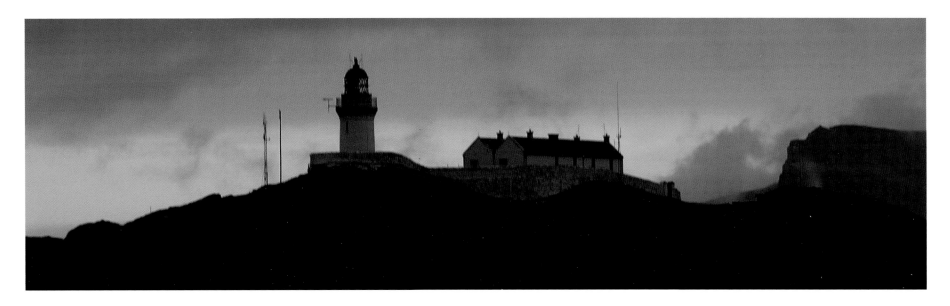

RONA LIGHTHOUSE

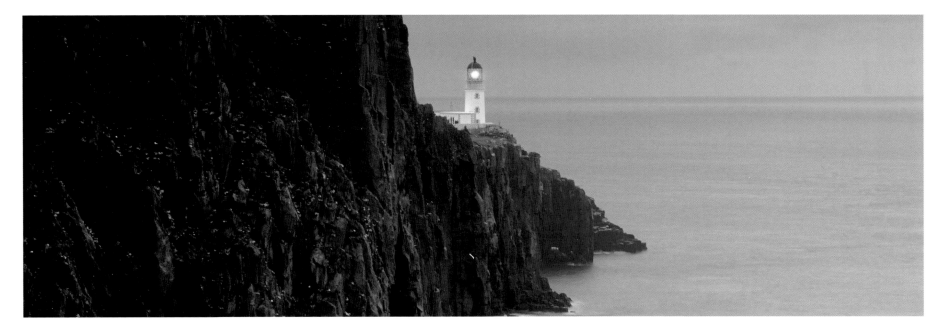

NEIST POINT LIGHTHOUSE

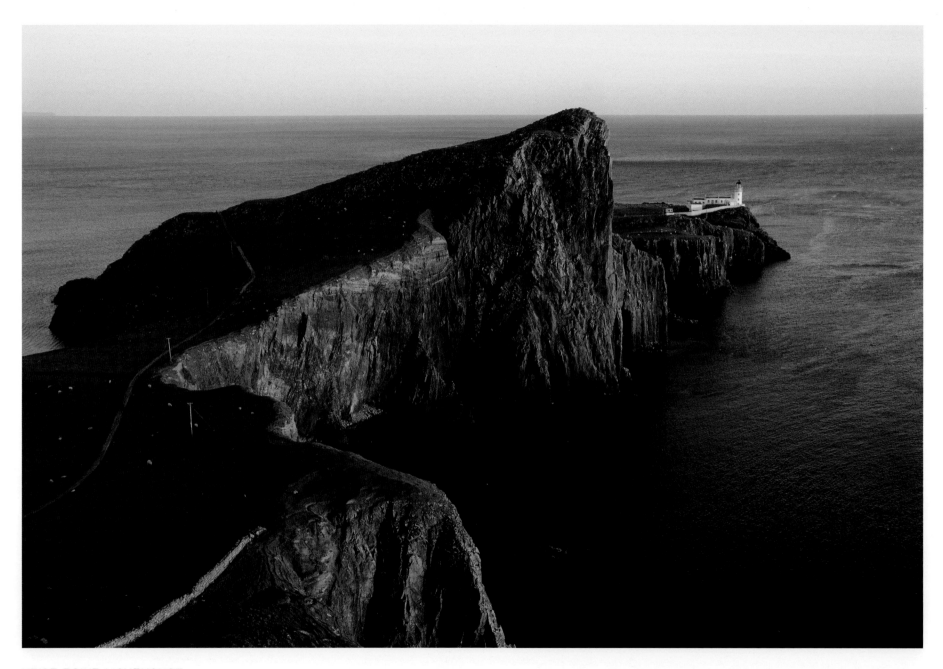

NEIST POINT LIGHTHOUSE

NEIST POINT

Engineer:	David A Stevenson
Established:	1910
Automated:	1990
Character:	Flashing White every 5 seconds
Height:	19 metres
Status:	Operational
Authority:	NLB

KYLEAKIN

The lighthouse on Eilean Ban is famous for its association with Gavin Maxwell, the naturalist and author of 'Ring of Bright Water'. Maxwell purchased the keepers' cottages after the automation of the lighthouse in 1960.

The lighthouse was discontinued due to the construction of the Skye Bridge and a new light was established at Eileanan Dubha. It is now owned by Eilean Ban Trust and can be visited as part of a tour of the island.

Engineers:	David and Thomas Stevenson
Established:	1857
Automated:	1960
Character:	Isophase White, Red, Green every 4 seconds (Discontinued)
Height:	21 metres
Status:	Discontinued 1993, now owned by Eilean Ban Trust

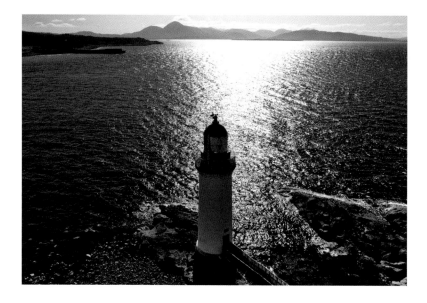

THE SKYE BRIDGE FROM KYLEAKIN LIGHTHOUSE BALCONY.
[BELOW] THE LIGHTHOUSE WITH ITS UNIQUE ACCESS BRIDGE

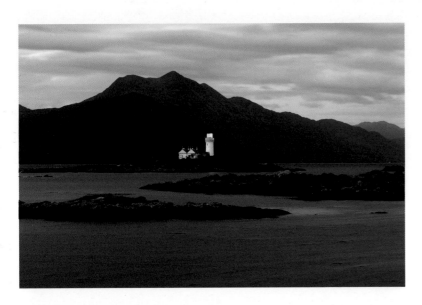

ORNSAY LIGHTHOUSE

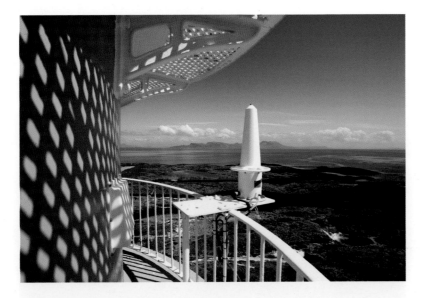

THE VIEW FROM HYSKEIR LIGHTHOUSE BALCONY
TOWARDS THE ISLAND OF EIGG

ORNSAY

Engineers:	David and Thomas Stevenson
Established:	1857
Automated:	1962
Character:	Occulting White every 8 seconds
Height:	19 metres
Status:	Operational
Authority:	NLB

HYSKEIR

The long drive over from the east coast has taken most of the night. I'm meeting Tom Cairns, the NLB's Area Maintenance Engineer in Mallaig just after breakfast to go out by boat to Hyskeir. The trip out there is spectacular; the scenery is simply stunning as we sail close to the coastline of Rum and Eigg. The skipper of the boat has never seen The Minch this calm before, with a flat glass like sea.

The lighthouse itself is in good condition. The huge hyper radial lens manufactured by Chance Brothers in 1904 is still in place in the lantern room.

Hyskeir is an attractive island with lots of colourful wild flowers and basalt columns of rock forming some interesting geological features. There's plenty of wildlife here too with a pair of seals playing in the nearby turquoise pool of water and two bonxies fighting overhead with the seagulls.

Engineer:	David A Stevenson
Established:	1904
Automated:	1997
Character:	Flashing (3) White every 30 seconds
Height:	39 metres
Status:	Operational
Authority:	NLB

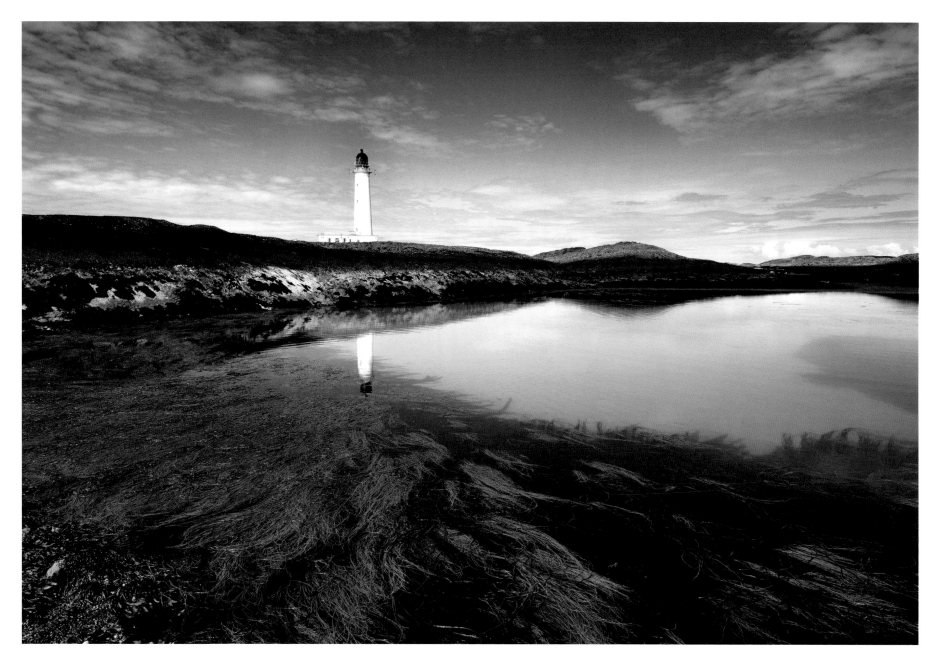

HYSKEIR LIGHTHOUSE

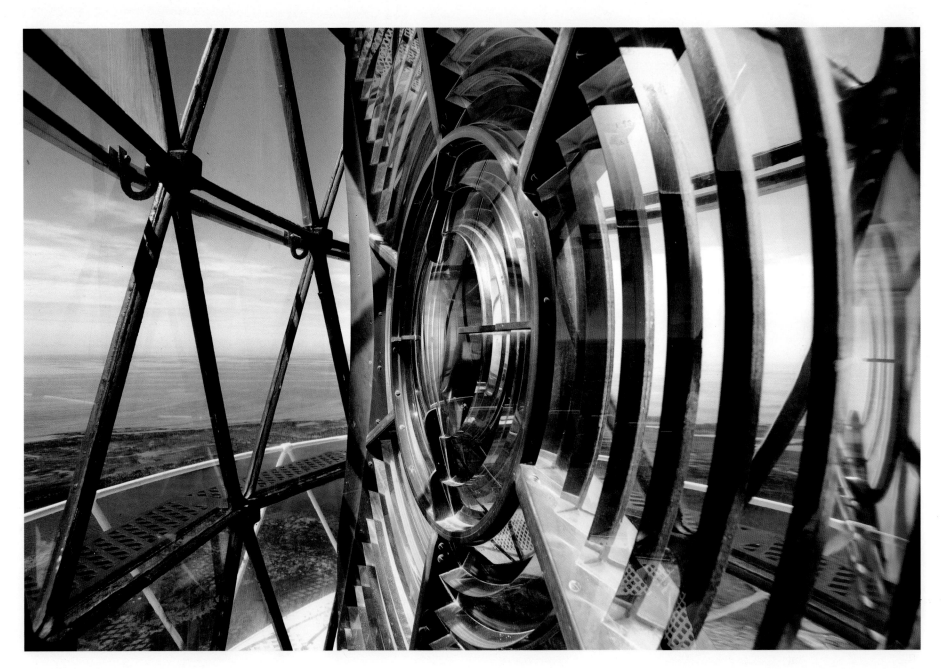

HYSKEIR LIGHTHOUSE — HYPER RADIAL LENS

SKERRYVORE

Skerryvore lighthouse stands on a treacherous reef in the Atlantic 12 miles south-west of the island of Tiree. On a visit in 1814 with Robert Stevenson to the (as yet unlit) rock, the writer Sir Walter Scott commented that "*It will be a most desolate position for a lighthouse – the Bell Rock and Eddystone a joke to it*".

Skerryvore was the second of the pillar rock towers to be designed for the Northern Lighthouse Board by the Stevensons. The task fell to Alan Stevenson who had by that time effectively taken over the job of designing lighthouses from his elderly father Robert.

A shore station, dock and pier were established at Hynish in Tiree from which men and materials could be shipped out to the rock. At the time there was opposition to the building of the lighthouse from some of the local population in Tiree who had done very well out of the cargo washed ashore from the many ships wrecked in the area!

Landing and work on the rock itself was only possible during the short summer season and commenced in 1838. The first summer's efforts were spent on the construction of the sturdy wooden legs on top of which the barrack for housing the workers on the rock would sit. This structure did not survive the winter, being washed away by the fury of one of the Atlantic storms which the site is well known for. Alan Stevenson then had to come up with a new design for securing the barrack to the rock.

The original plan was for the tower to be built from blocks of gneiss quarried in nearby Tiree. However, the gneiss proved to be an impractical material to work due to its hardness and the change was made to granite from the Ross of Mull after only a few courses had been laid. Like his father before him at the Bell Rock, Alan Stevenson spent a great deal of time at Skerryvore and endured many a stormy night in the barracks, experiencing the same tough conditions as the workmen.

Construction lasted until 1842, after which the interior was fitted out. The light first shone out over the Atlantic on 1st February 1844. The finished

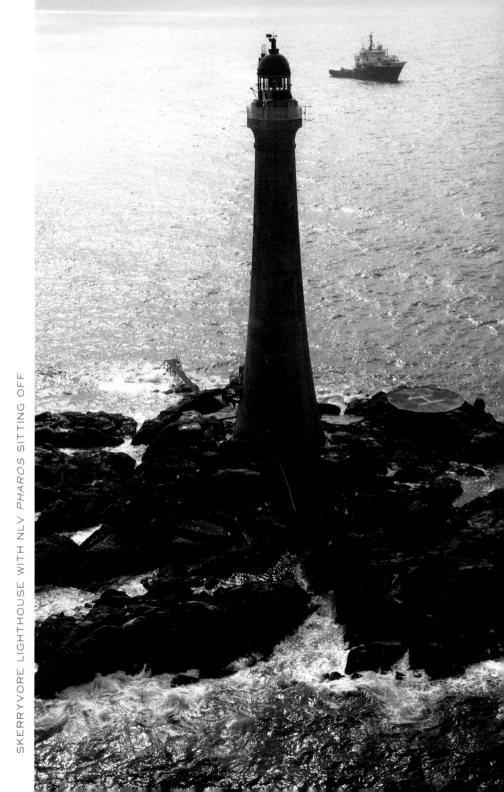

SKERRYVORE LIGHTHOUSE WITH NLV *PHAROS* SITTING OFF

tower is regarded as being the most graceful example of rock lighthouse design in the world. At 48m high, it is the tallest lighthouse in Scotland. Unlike the Bell Rock and many other rock lighthouses in the UK, the granite blocks at the base of the tower are not dovetailed and interlocking. Alan Stevenson calculated that the weight of the tower would provide the strength needed to resist the power of the seas – after nearly two centuries he has of course been proven right!

The most dramatic event in the lighthouse's history was on the evening of 16th March 1954 when a fire broke out in the tower and quickly spread upwards reaching the storeroom where the explosives used for the fog signal were kept. The subsequent blast spread the flames to both the upper and lower compartments of the lighthouse, completely gutting the interior and creating large cracks in the granite walls which are still visible to this day. The three keepers were fortunate as the sea conditions were calm and they were able to stand outside on the rock below after escaping from the tower. Indeed they were doubly fortunate, as the relief boat for the change of keepers was due that very next day.

The damage was not fully repaired and the lighthouse not manned again until 1959.

I catch the ferry from Oban to Tiree where I board Pharos and enjoy the hospitality of Captain Eric Smith and his crew. After anchoring off Hynish overnight we head to Skerryvore following breakfast.

It's grey and overcast during the 12-mile trip and we drop anchor just off the lighthouse. Much to my delight, the sun comes out as the helicopter-lifting operations commence. After taking a few shots from the deck of Pharos I board the helicopter and fly over on to Skerryvore. The pilot does a few turns around the lighthouse. The tower looks even more impressive from the air. Rising above the rock the slender design can really be appreciated as well as the extent of the reef.

Touching down on the helipad, it's a hive of activity on the ground as provisions are being transferred and diesel is pumped up into the tower.

The entrance door is 26ft above the rock and the walls are almost 10ft

THE SIGNAL TOWER AT HYNISH

THE EXTENDED PIER AND DOCK AT HYNISH WERE DESIGNED BY ALAN STEVENSON FOR THE CONSTRUCTION OF SKERRYVORE LIGHTHOUSE

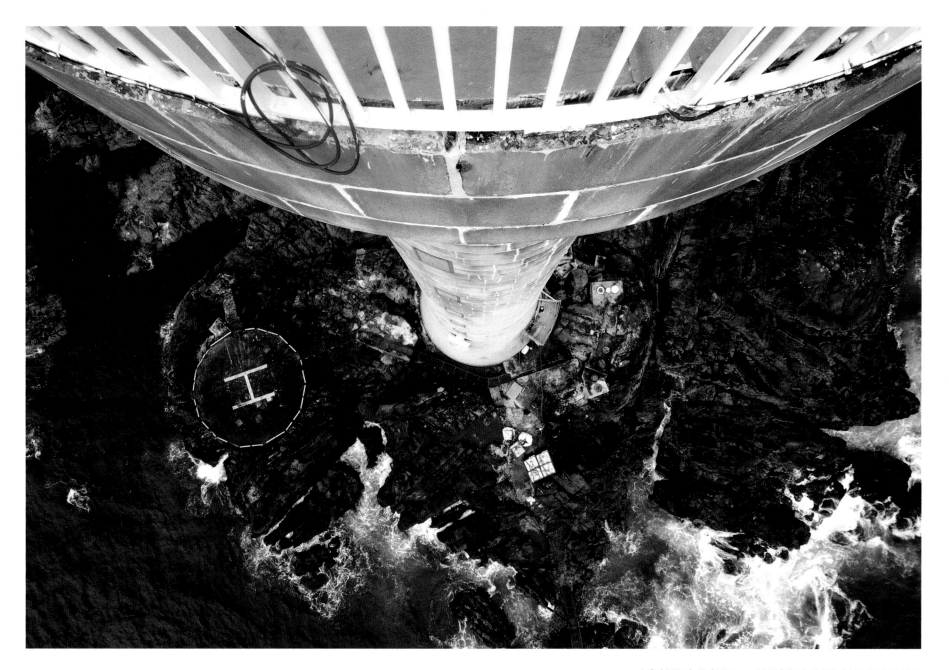

LOOKING DOWN — SKERRYVORE LIGHTHOUSE

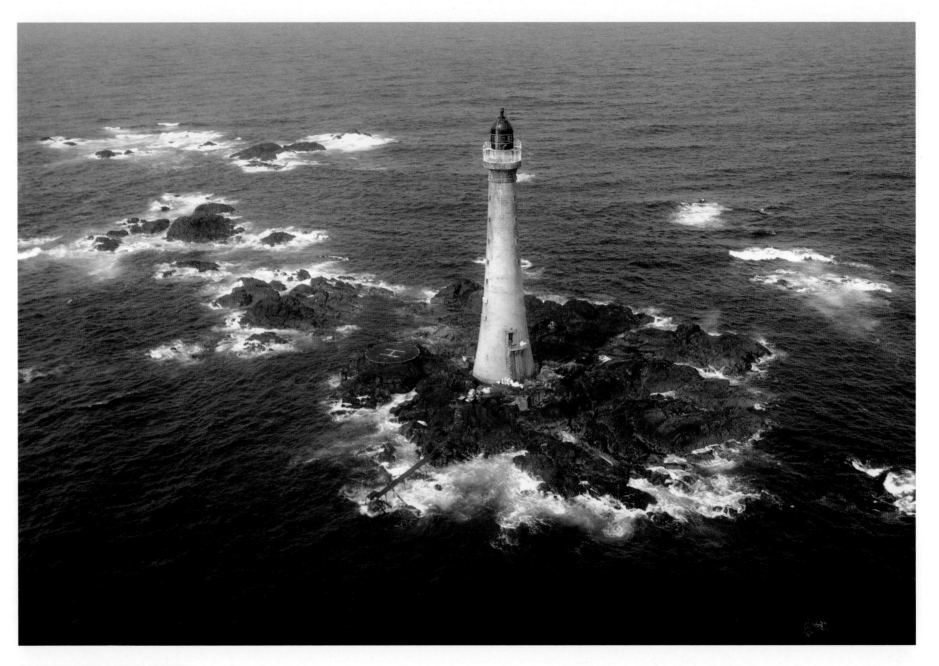

SKERRYVORE LIGHTHOUSE

thick at that point. A plaque just inside the solid metal door marks the occasion when the keepers finally left in February 1994.

Making my way up the tower and what seems like an endless climb, I pass engine rooms, diesel storage tanks and then the living accommodation. Out on the balcony I can see the sea serpent shaped handgrips around the lantern, one of the few original features to survive the fire of 1954.

Back down on the rock I admire the craftsmanship of the stonemasons work around the base of the lighthouse. There are other reminders of the past here too - the initials of lightkeepers carved into the surrounding gneiss and the seaweed-covered old cast iron landing stage, harking back to the days when the only way onto the rock was by sea.

Engineer:	Alan Stevenson
Established:	1844
Automated:	1994
Character:	Flashing White every 10 seconds
Height:	48 metres
Status:	Operational
Authority:	NLB

A BIRD'S EYE VIEW OF THE KITCHEN INSIDE SKERRYVORE

A BASKING SHARK NEAR SKERRYVORE

DUBH ARTACH

Dubh Artach (gaelic for 'the Black Rock') lies out in the Atlantic Ocean approximately 15 miles south-west of the Ross of Mull. The lighthouse was designed by David and Thomas Stevenson and was built to warn ships away from Dubh Artach itself and the deadly Torran Rocks nearby.

A shore station was set up on the island of Erraid off the Ross of Mull for the construction of the lighthouse. Activity on Dubh Artach itself began in 1867. The working season was limited to the summer months due to the exposed location. An iron barracks sitting on open metal legs was used to house the workers on the rock during construction. At one point the summer storms brought waves crashing onto the roof of the barracks, 77ft (23m) above sea level. The fourteen workers present were trapped inside for 5 days. The waves broke open the door to the barracks and soaked those inside, ruining their provisions in the process.

The lighthouse is built from granite quarried from Erraid. It has the most substantial base of all of the Scottish rock lighthouses - the Stevensons had to modify their original design and increase the solid part in height to 21 courses (up to the level of the red band) due to the severity of the location.

Robert Louis Stevenson visited both Erraid and Dubh Artach with his father Thomas during construction. He describes the situation in the barracks *"The men sat high up prisoned in their iron drum, that then resounded with the lashings of the sprays ... It was then that the foreman builder, Mr. Goodwillie, whom I see before me in his rock-habit of indecipherable rags, would get his fiddle down and strike up human minstrelsy amid the music of the storms"*

He also describes the rock as *"an ugly reef ... one oval nodule of black-trap, sparsely bedabbled with an inconspicuous fucus, and alive in every crevice with an insect between a slater and a bug. No other life was there but that of sea-birds, and of the sea itself, that here ran like a millrace, and growled about the outer reef for ever, and ever and again, in the calmest weather, roared and spouted on the rock itself"*.

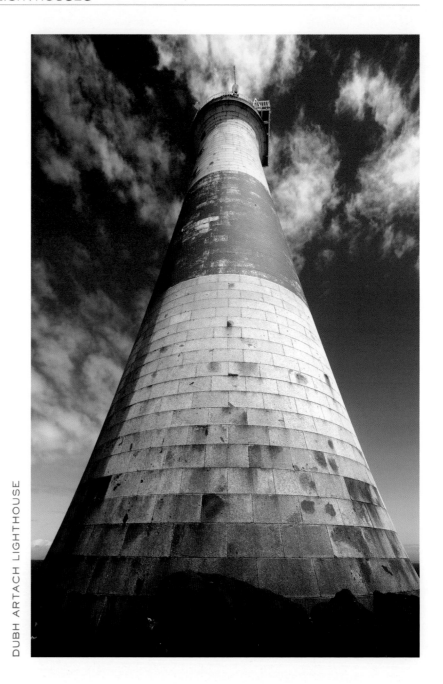

DUBH ARTACH LIGHTHOUSE

A red band was added to the lighthouse in 1890 to help distinguish it from nearby Skerryvore. The band is no longer required and has been allowed to fade naturally with the elements.

Dubh Artach is a place that has always intrigued me and high on my list of lighthouses to visit. However, it's not one which is easy to get to.

Sailing from Oban on Pharos, we make our way down the Firth of Lorn. Later when we've sailed out into the Atlantic I can see the Torran Rocks off the south west of Mull through the binoculars. I finally catch sight of Dubh Artach in the distance. I start to feel a bit sick from the motion of the boat. The only remedy is to avail myself of the excellent catering on the ship so tuck in to some burger and chips which soon settles my stomach!

After lunch, Pharos drops anchor off the rock. It's a dramatic scene with three technicians standing sheltering below the tower adding a human element and sense of scale.

I make my way up the outside ladder to the entrance door. Inside the tower there's another vertical ladder to climb which goes all the way up to the fourth floor. The accommodation at the top of the tower is cramped but probably quite cosy on a stormy night. Stepping out onto the balcony, I'm given a bird's eye view of the activity going on down below. There isn't a great deal of space for the helicopter to manoeuvre and I'm impressed by the skill of the pilot and NLB staff on the ground.

Just before boarding the helicopter I have time for a quick look around the base of the tower. The Erraid granite is discoloured in places after years of pounding by the sea. I can feel the spray as a breaker hits the rocks below – a gentle reminder of Dubh Artach's wildness.

THE HELICOPTER PAD AT DUBH ARTACH SITS ON THE SPOT WHERE THE IRON BARRACKS, USED DURING THE CONSTRUCTION OF THE LIGHTHOUSE, ONCE STOOD

Engineers:	David and Thomas Stevenson
Established:	1872
Automated:	1971
Character:	Flashing (2) White every 30 seconds
Height:	38 metres
Status:	Operational
Authority:	NLB

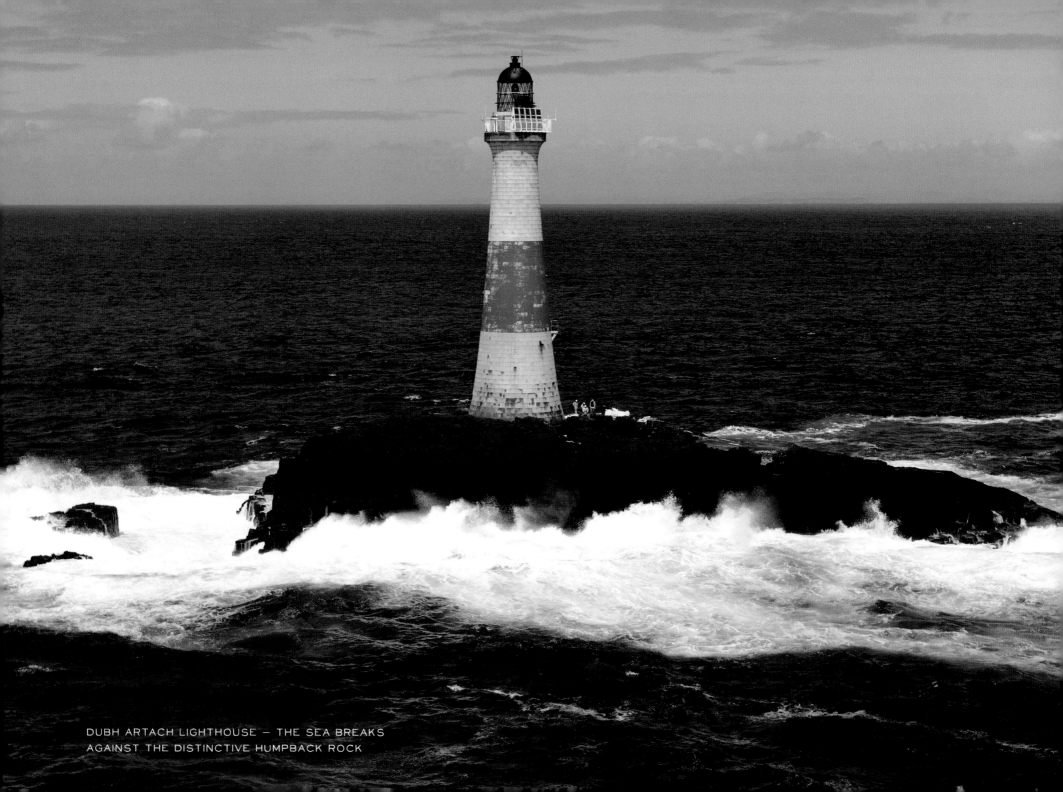

DUBH ARTACH LIGHTHOUSE – THE SEA BREAKS
AGAINST THE DISTINCTIVE HUMPBACK ROCK

RUBHA NAN GALL

Engineers: David and Thomas Stevenson
Established: 1857
Automated: 1960
Character: Flashing White every 3 seonds
Height: 19 metres
Status: Operational
Authority: NLB

RUBHA NAN GALL LIGHTHOUSE

LISMORE

Engineer: Robert Stevenson
Established: 1833
Automated: 1965
Character: Flashing White every 10 seconds
Height: 26 metres
Status: Operational
Authority: NLB

LISMORE LIGHTHOUSE

FLADDA LIGHTHOUSE

RUVAAL LIGHTHOUSE

FLADDA

Engineers:	David and Thomas Stevenson
Established:	1860
Automated:	1956
Character:	Flashing (2) White/Red/Green every 9 seconds
Height:	13 metres
Status:	Operational
Authority:	NLB

RUVAAL (RUBH 'A' MHAIL)

I catch the early morning ferry over to Islay and then take the road which heads northwards until it terminates at Bunnahabhain Distillery. There's no marked path, however the power lines which run the entire route to the lighthouse are a good guide. There are rainclouds in the distance but the rain thankfully stays away. Once I reach the lighthouse I enjoy the lovely views out towards Colonsay in the west and Jura on the east. I'm pleased to see that both the lighthouse and keepers' cottages are well maintained.

On the way back, one of the owners of the cottages says hello as they pass by on their quad bike. I have a deep admiration for anyone who chooses to stay in such a remote location where a trip to the shops involves a boat trip or bumpy ride across the moor.

Engineers:	David and Thomas Stevenson
Established:	1859
Automated:	1983
Character:	Flashing (3) White every 15 seconds
Height:	34 metres
Status:	Operational
Authority:	NLB

MCARTHUR'S HEAD

Engineer: David and Thomas Stevenson
Established: 1861
Automated: 1969
Character: Flashing (2) White/Red every 10 seconds
Height: 13 metres
Status: Operational
Authority: NLB

MCARTHUR'S HEAD

LOCH INDAAL

Engineer: David and Thomas Stevenson
Established: 1869
Automated: 1950s
Character: Flashing (2) White/Red every 7 seconds
Height: 13 metres
Status: Operational
Authority: NLB

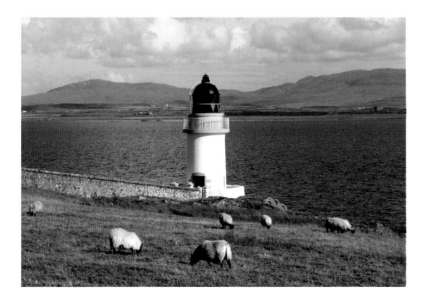

LOCH INDAAL LIGHTHOUSE

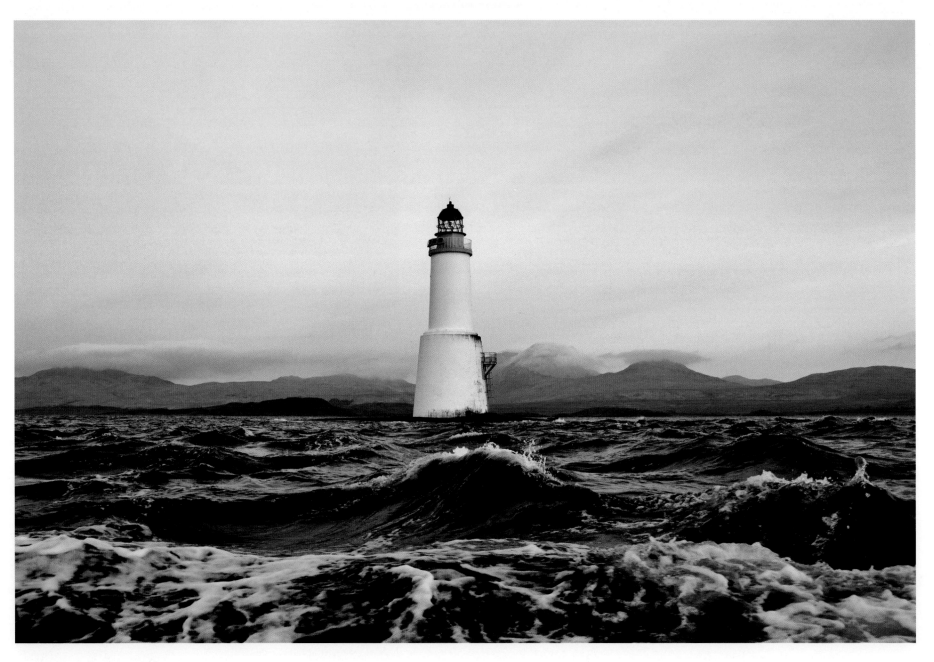

SKERVUILE LIGHTHOUSE

SKERVUILE

Engineer: David and Thomas Stevenson
Established: 1865
Automated: 1945
Character: Flashing White every 15 seconds
Height: 25 metres
Status: Operational
Authority: NLB

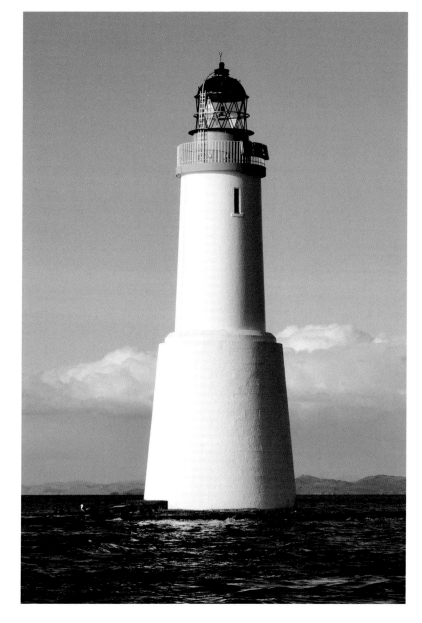

SKERVUILE WAS ONE OF THE EARLIEST NLB AUTOMATIONS

RINNS OF ISLAY

Engineer:	Robert Stevenson
Established:	1825
Automated:	1998
Character:	Flashing White every 5 seconds
Height:	29 metres
Status:	Operational
Authority:	NLB

[ABOVE] NEIL MACEACHERN (RLK FOR ISLAY) MAKES THE SHORT TRIP FROM THE ISLAND OF ORSAY BACK TO PORT WEMYSS

[LEFT] THE STAIRCASE AT RINNS OF ISLAY LIGHTHOUSE

[RIGHT] RINNS OF ISLAY LIGHTHOUSE

THE INFLUENCE OF THE STEVENSONS ABROAD

The Stevensons' expertise in lighthouse design was not only in demand in Scotland. The Stevensons themselves were approached for assistance on the design and construction of lighthouses in far flung locations such as New Zealand, Canada and India. In 1868 they trained Richard Henry Brunton (1841 –1901), an Aberdeenshire born railway engineer, to carry out the task of lighting the coastline of Japan. This task was carried out over a period of seven and a half years. Many of the lighthouses which Brunton designed are still in service, having been designed to withstand the earthquakes to which the region is prone.

James Melville Balfour (1831 –1869) was Thomas Stevenson's brother-in-law. He served an apprenticeship with the Stevenson family firm before emigrating to New Zealand in 1863. Many of New Zealand's early lighthouses were built under his direction, firstly in his capacity as Marine Engineer for the Otago Provincial Council and latterly as the country's Colonial Marine Engineer. Balfour's life was tragically cut short in 1869 when he drowned whilst travelling to a friend's funeral (ironically, his friend had also died as a result of drowning). The Stevenson connection with New Zealand did not end with Balfour's death with the firm continuing to design equipment and provide advice to the New Zealand government.

On a visit to Tokyo I take the opportunity to go for a day trip to see one of Brunton's lighthouses. Inubosaki Lighthouse dates from 1874 and is located in the city of Choshi. It's a windy day and the Pacific Ocean looks impressive as the large waves break against the promenade near the lighthouse. The lighthouse design is very reminiscent of the towers at Ardnamurchan and Covesea Skerries. It feels strange to see such familiar looking architecture so far from home.

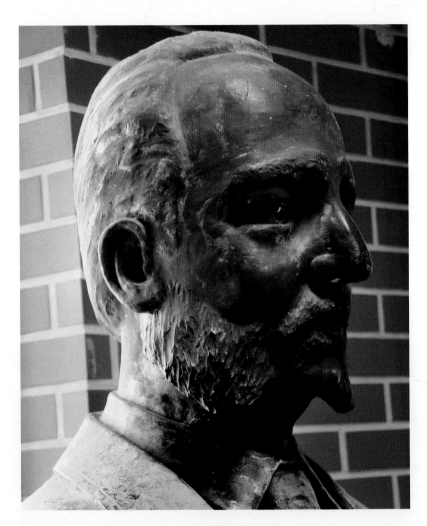

[ABOVE] A BUST OF RICHARD HENRY BRUNTON AT INUBOSAKI LIGHTHOUSE (JAPAN)

[RIGHT] INUBOSAKI LIGHTHOUSE (JAPAN)

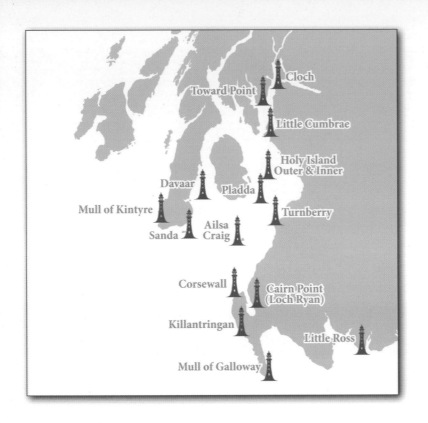

THE SOUTH-WEST
AND ARRAN

MULL OF KINTYRE

Engineer:	Thomas Smith
Established:	1788, later rebuilt by Robert Stevenson (1820s)
Automated:	1996
Character:	Flashing (2) White every 20 seconds
Height:	12 metres
Status:	Operational
Authority:	NLB

MULL OF KINTYRE LIGHTHOUSE

142

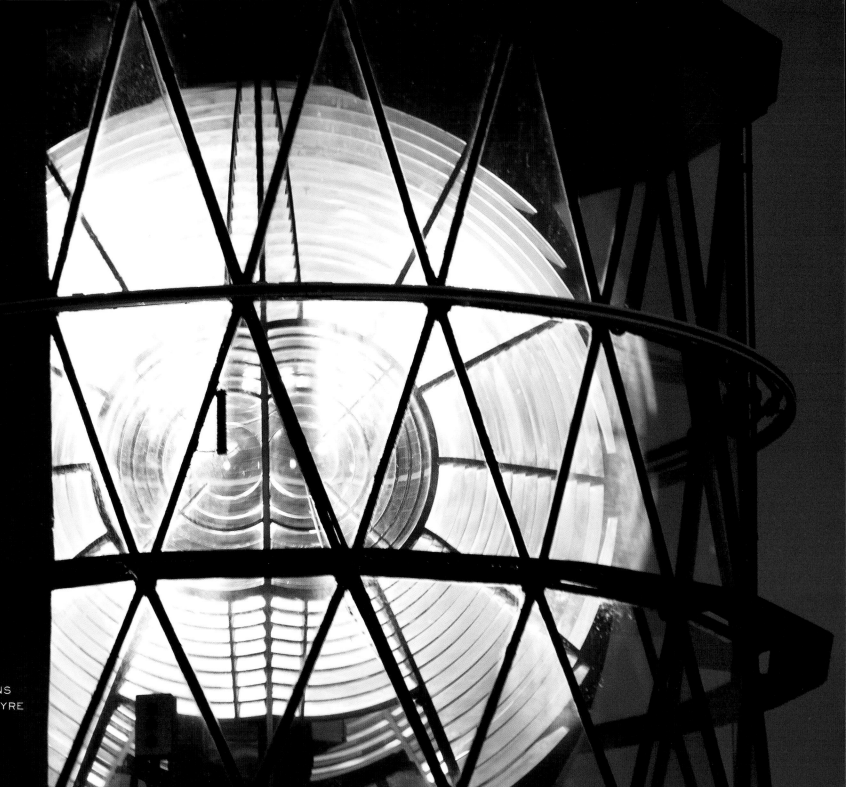

THE MAGNIFICENT LENS
AT THE MULL OF KINTYRE
LIGHTHOUSE

SANDA

Engineer:	Alan Stevenson
Established:	1850
Automated:	1993
Character:	Flashing white every 10 seconds
Height:	15 metres
Status:	Operational
Authority:	NLB

DAVAAR

Engineers:	David and Thomas Stevenson
Established:	1854
Automated:	1983
Character:	Flashing (2) White every 10 seconds
Height:	20 metres
Status:	Operational
Authority:	NLB

PLADDA

Engineer:	Thomas Stevenson
Established:	1790, later rebuilt by Robert Stevenson (1820s)
Automated:	1990
Character:	Flashing (3) White every 30 seconds
Height:	29 metres
Status:	Operational
Authority:	NLB

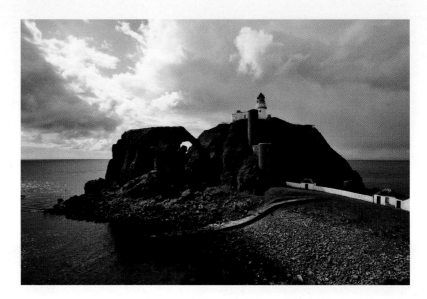

SANDA LIGHTHOUSE

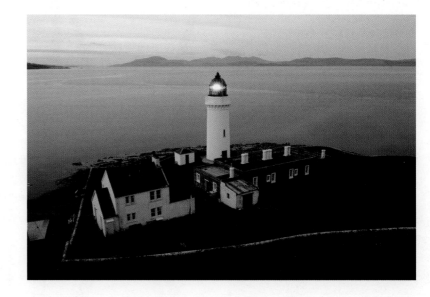

DAVAAR LIGHTHOUSE

PLADDA LIGHTHOUSE

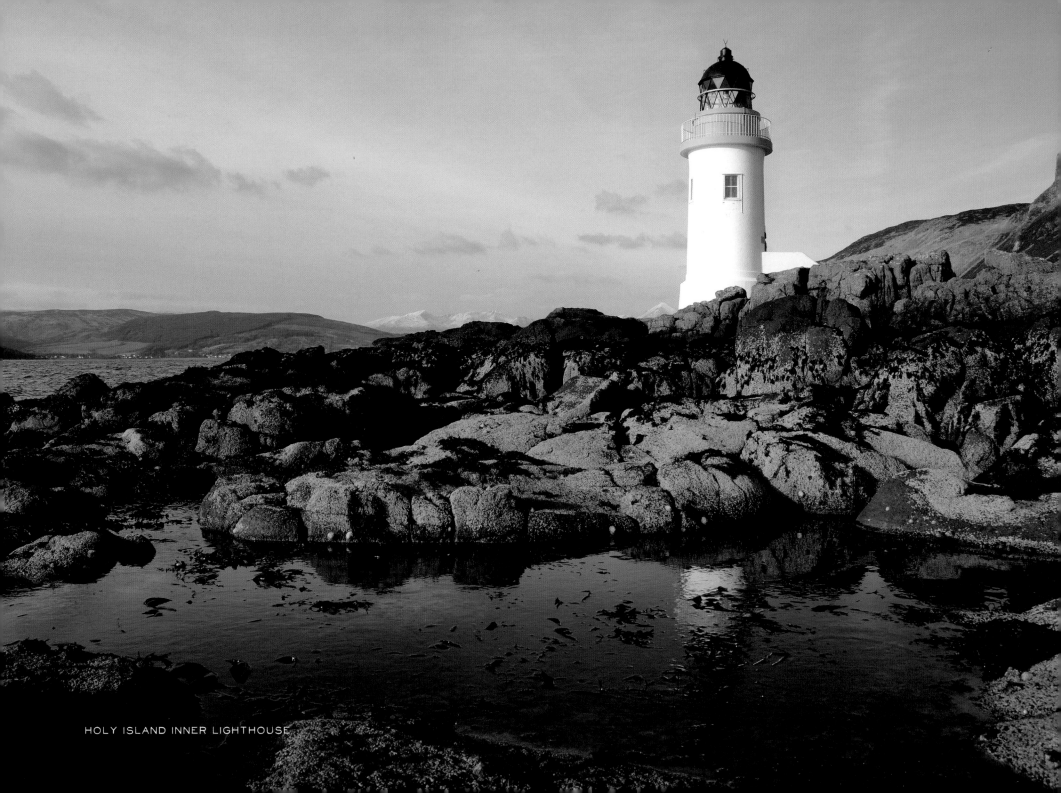

HOLY ISLAND INNER LIGHTHOUSE

HOLY ISLAND OUTER

Engineer:	David A Stevenson
Established:	1905
Automated:	1977
Character:	Flashing (2) White every 20 seconds
Height:	23 metres
Status:	Operational
Authority:	NLB

HOLY ISLAND INNER

Engineers:	David and Thomas Stevenson
Established:	1877
Automated:	1977
Character:	Flashing Green every 3 seconds
Height:	17 metres
Status:	Operational
Authority:	NLB

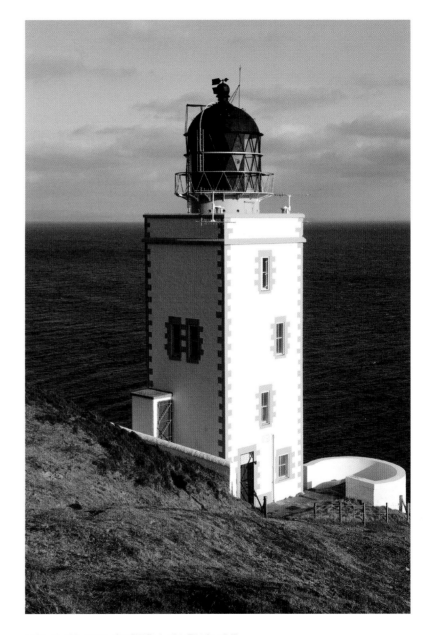

HOLY ISLAND OUTER LIGHTHOUSE

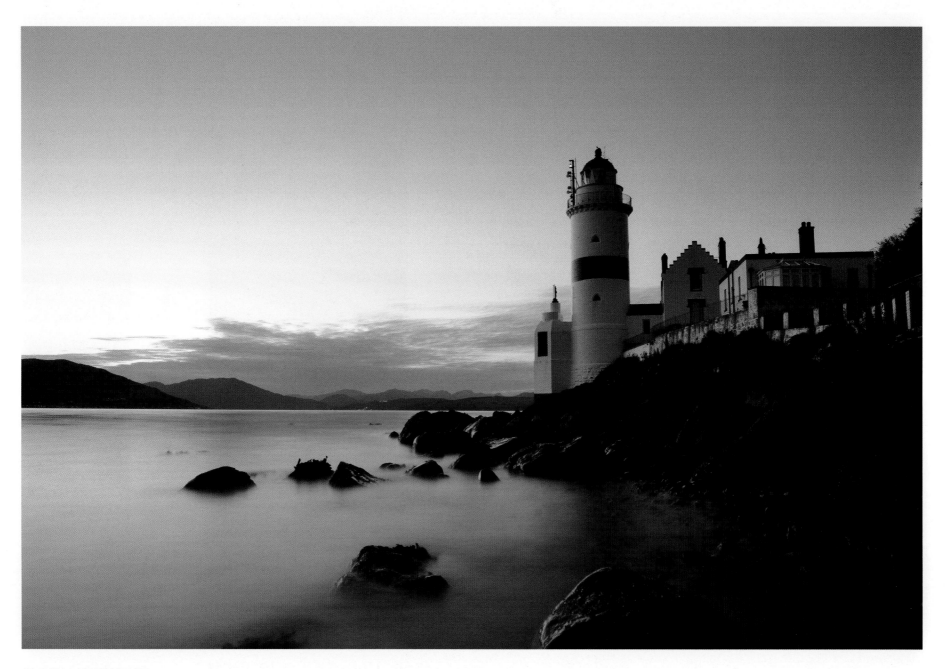

CLOCH LIGHTHOUSE

CLOCH

Unlike most of the Stevenson lights, the Cloch was built and operated by the Cumbrae Lighthouse Trust (which became the Clyde Lighthouses Trust in 1871) rather than the Northern Lighthouse Board. The other lights which Robert Stevenson designed for the Trust were Toward Point and Little Cumbrae (with Thomas Stevenson).

The lighthouses at Cloch and Toward are now operated by Clydeport Plc. The lighthouse on Little Cumbrae is no longer operational and has sadly fallen into disrepair.

I feel I've entered a timewarp as I look around the Cloch Lighthouse. The lens dating from 1903 is still there but no longer in use having been superseded by a small lens located outside on the balcony. The large chain which drove the clockwork mechanism is still in place in the centre of the tower.

Engineers:	Thomas Smith and Robert Stevenson
Established:	1797
Automated:	1973
Character:	Flashing White every 3 seconds
Status:	Operational
Authority:	Clyde Port Authority

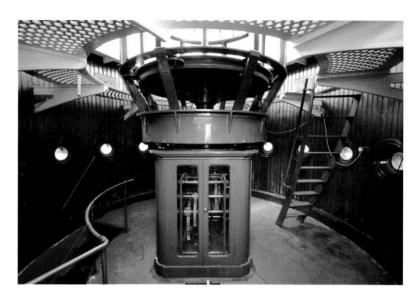

CLOCH WATCHROOM

IN THE DAYS WHEN THE LIGHTHOUSE WAS MANNED, A SYSTEM OF BELLS WAS INSTALLED AROUND THE LIGHTHOUSE COMPLEX SO THAT THE KEEPER ON WATCH COULD CALL FOR ASSISTANCE IF REQUIRED

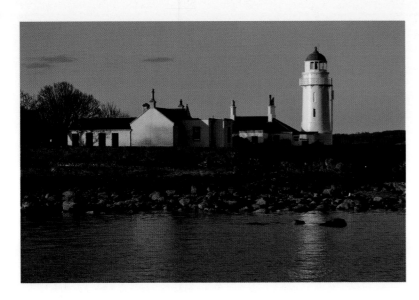

TOWARD POINT LIGHTHOUSE

LITTLE CUMBRAE

Engineer:	Thomas Smith
Established:	1793
Automated:	1977
Character	Flashing white every 6 seconds (Replaced by light on adjacent structure in 1997)
Status:	In private ownership

TOWARD POINT

Engineer:	Robert Stevenson
Established:	1812
Automated:	1974
Character:	Flashing White every 10 seconds
Height:	19 metres
Status:	Operational
Authority:	Clyde Port Authority

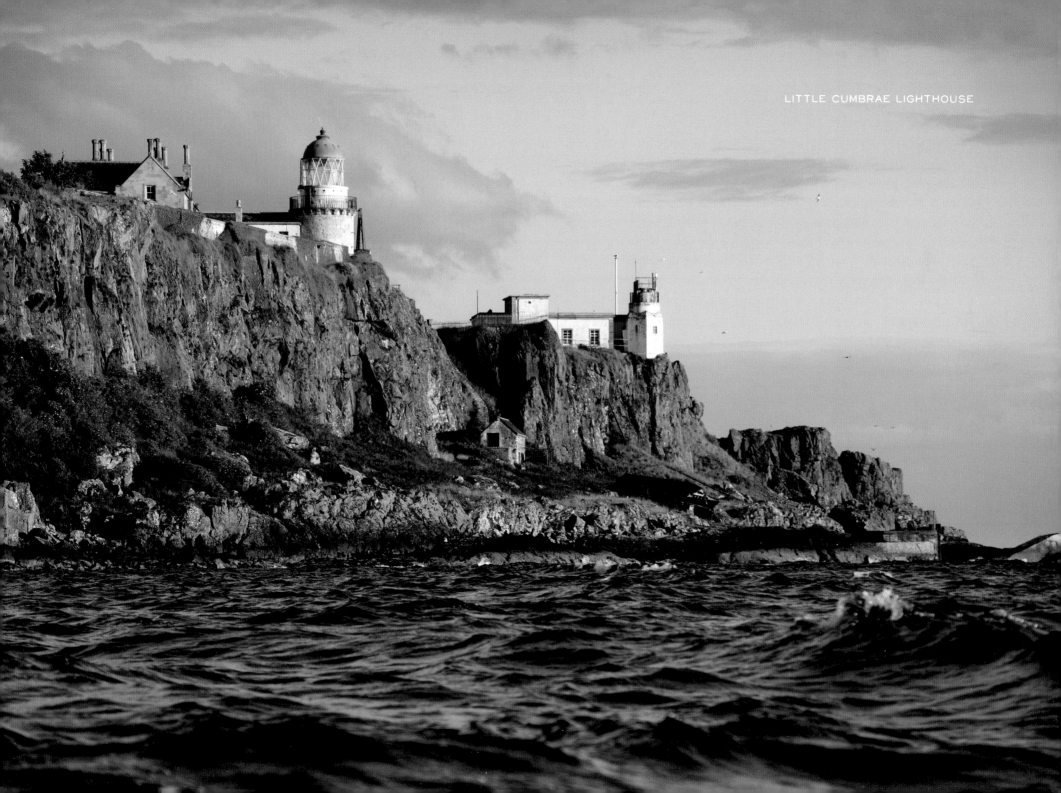

TURNBERRY

The iconic lighthouse at Turnberry will be instantly recognisable to golf enthusiasts around the world. It was a very popular posting amongst lightkeepers, particularly those who enjoyed a round of golf. The 9th hole of the world famous course where several Open Championships have been held is just outside the lighthouse compound. The lighthouse sits next to the ruins of an old castle which once belonged to the father of King Robert the Bruce and may have been the birthplace of the king himself.

The former keepers' houses are now owned by the Trump Turnberry Resort and are being turned into luxury accommodation and a half way house for golfers.

Engineers:	David and Thomas Stevenson
Established:	1873
Automated:	1986
Character:	Flashing white every 15 seconds
Height:	24 metres
Status:	Operational
Authority:	NLB

AS PART OF A REVIEW INTO AIDS TO NAVIGATION, THE LIGHT AT TURNBERRY WAS CHANGED TO A SHORTER-RANGE LIGHT MOUNTED ON THE BALCONY. [BELOW] THIS PICTURE WAS TAKEN BEFORE THE LONGER-RANGE LIGHT WAS REMOVED FROM SERVICE

AILSA CRAIG

Engineers:	Thomas and David A Stevenson
Established:	1886
Automated:	1990
Character:	Flashing white every 4 seconds
Height:	11 metres
Status:	Operational
Authority:	NLB

AILSA CRAIG LIGHTHOUSE

CAIRN POINT (LOCH RYAN)

A familiar sight to passengers on the ferry to Northern Ireland. The immaculately maintained lighthouse at Cairnryan sits rather forlornly amongst the surroundings of an old military port established in World War Two. The yard was later used for scrapping warships including the aircraft carrier *HMS Ark Royal* in 1980.

Engineer:	Alan Stevenson
Established:	1847
Automated:	1964
Character:	Flashing (2) Red every 10 seconds
Height:	15 metres
Status:	Operational
Authority:	NLB

CAIRN POINT (LOCH RYAN) LIGHTHOUSE

CORSEWALL LIGHTHOUSE

CORSEWALL

I'm staying at the Corsewall Lighthouse Hotel on a stormy December night. There can be few more atmospheric locations for a hotel. Stepping outside, I'm mesmerised by the old Fresnel lens casting beams of light out into the cold darkness of the Irish Sea.

The next day I enjoy spectacular views of Ailsa Craig in the distance and watch the ferry from Cairnryan as it sails close by on its way to Northern Ireland.

Engineer:	Robert Stevenson
Established:	1817
Automated:	1994
Character:	Flashing (5) White every 30 seconds
Height:	34 metres
Status:	Operational
Authority:	NLB

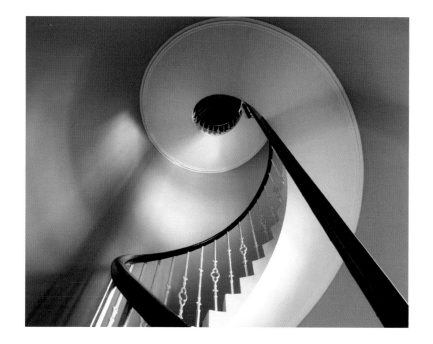

THE CORSEWALL LIGHTHOUSE OPEN STAIRCASE

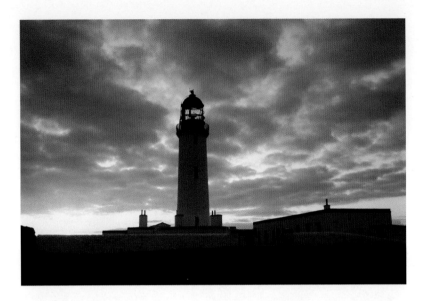

MULL OF GALLOWAY LIGHTHOUSE

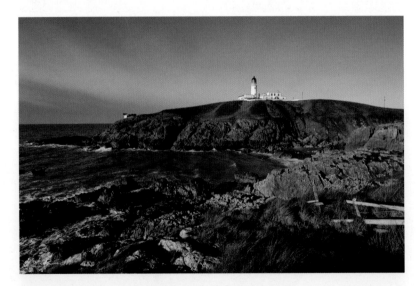

KILLANTRINGAN LIGHTHOUSE

MULL OF GALLOWAY

The Mull of Galloway is Scotland's most southerly point. In a joint venture between the Northern Lighthouse Board and South Rhins Community Development Trust, the lighthouse tower is open to the public.

The land and buildings surrounding the tower are now owned by the Mull of Galloway Trust and include an exhibition and the keepers' cottages operate as self-catering accommodation.

Engineer:	Robert Stevenson
Established:	1830
Automated:	1988
Character:	Flashing white every 20 seconds
Height:	26 metres
Status:	Operational
Authority:	NLB

KILLANTRINGAN

The most dramatic event in Killantringan's history occurred on 26th February 1982 when the container ship *Craigantlet* ran aground just below the lighthouse. She was carrying a cargo of hazardous chemicals and the lighthouse keepers had to leave their homes for several weeks until the area was made safe. The bow of the *Craigantlet* can still be seen at low tide.

Engineer:	David A Stevenson
Established:	1900
Automated:	1988
Character:	Flashing (2) White every 15 seconds (Discontinued)
Height:	22 metres
Status:	Discontinued 2007, now privately owned

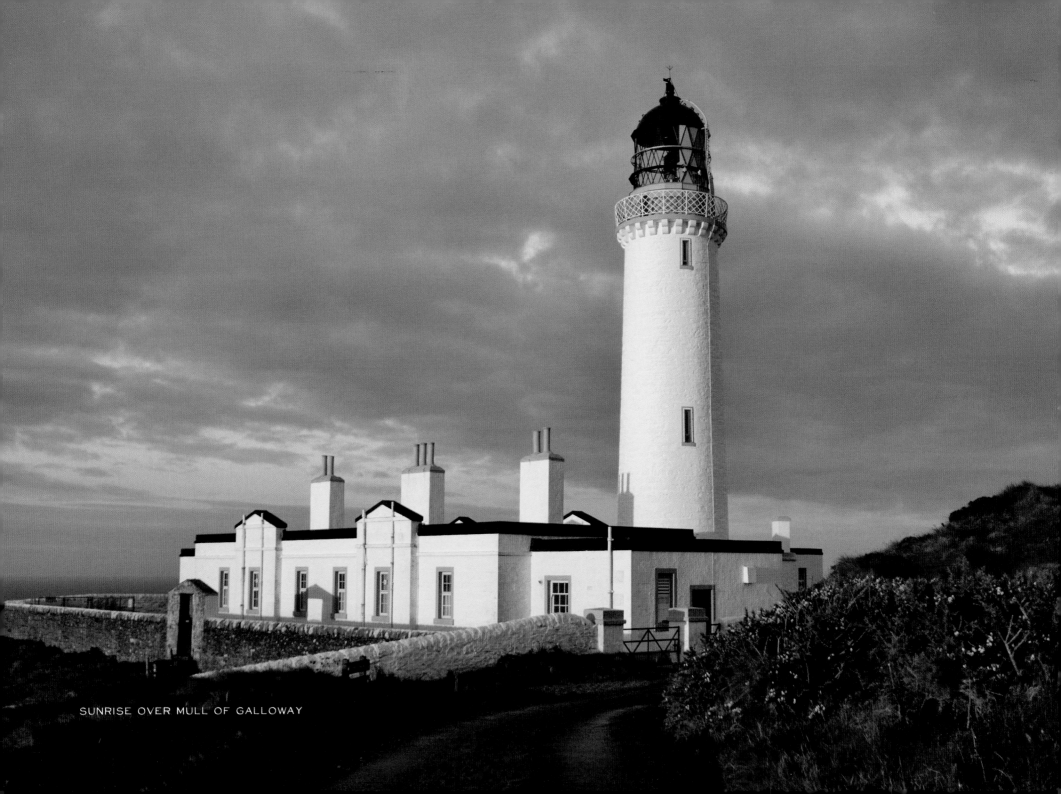

SUNRISE OVER MULL OF GALLOWAY

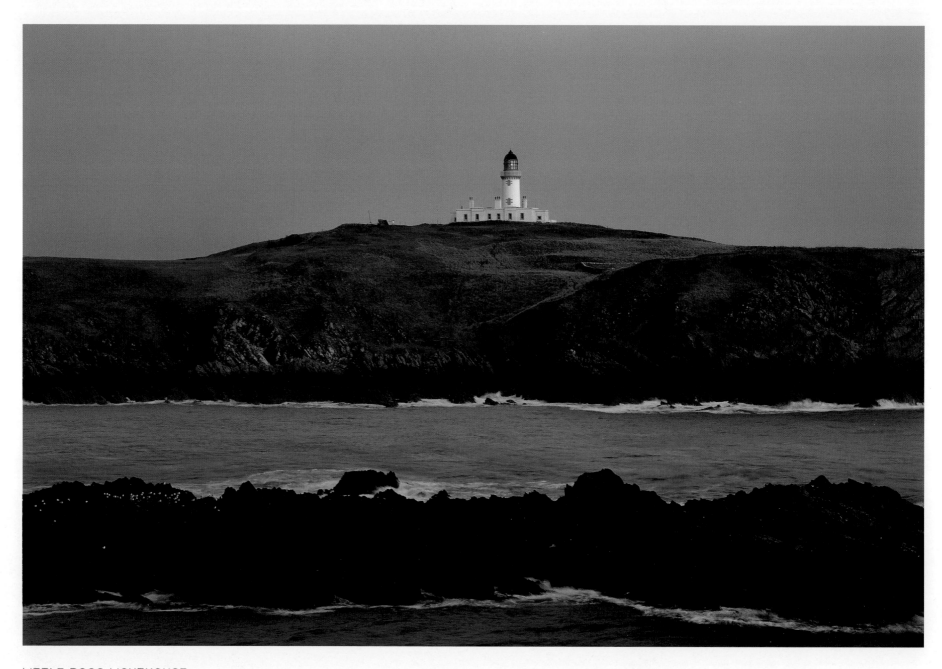

LITTLE ROSS LIGHTHOUSE

LITTLE ROSS

Little Ross Lighthouse would have a fairly undistinguished history had it not been the scene of a murder in August 1960. The local relief keeper was shot and killed by another keeper who had only been in the lighthouse service a short time. It later turned out that he had a criminal record.

Ironically, a representative from the Northern Lighthouse Board arrived on the island a short time later that same day to give the news that the lighthouse was about to be automated.

Following a trial in Dumfries, the keeper was convicted of murder and sentenced to hang. The sentence was later commuted to life imprisonment. He took his own life a few years later in prison.

It's a short drive over some muddy back roads from Kirkcudbright to get to the closest point to the island of Little Ross. I'm hoping to get some shots of the lighthouse after sunset and end up standing in something which resembles (and smells!) like silage. It's a bit breezy and I struggle to keep the camera steady on the tripod to get some shots.

I've already stayed too long and need to get going as I've been invited for tea by a young lady in Dumfries. My clothes are very smelly and the walking boots end up being dumped at the side of the road. I need to find somewhere to stay, have a shower and then find my dinner date's house (I've never been to Dumfries before). It's a mad rush but somehow I just make it (smelling fine too!) The meal is lovely and my visit to Dumfries ends up being the first of many (the young lady is now my wife)!

Engineer:	Alan Stevenson
Established:	1843
Automated:	1960
Character:	Flashing White every 5 seconds
Height:	20 metres
Status:	Operational
Authority:	NLB

AUTOMATION

In 1894, Oxcars Lighthouse in the River Forth became the first lighthouse in Scotland to be automated when the two lightkeepers were withdrawn. The light was operated using gas controlled by a clockwork timer. Regular visits were made by boat from Granton to wind up the timer and replenish the gas supplies. Around this time, the Stevensons also started building automatic gas operated beacons in locations where longer range lights were not required.

The automation programme in Scotland started in earnest in the 1960s and 70s when automatic lights were installed at a number of offshore lighthouses. These lights ran on acetylene gas, a sun-sensitive gas valve was used to supply gas to the light during the hours of darkness. The gas pressure was also used to rotate the lens around the light.

The programme was accelerated in the 1980s as new technology became available. On 31 March 1998 the keepers left Fair Isle South Lighthouse for the last time; this was the last manned lighthouse to be automated in Scotland. The event was marked with a special ceremony attended by HRH The Princess Royal who is the current Patron of the Northern Lighthouse Board.

A MODERN CONTROL PANEL IN THE WATCH ROOM AT SULE SKERRY LIGHTHOUSE

NLB ACCEPTANCE ENGINEER STEVE DAILLY

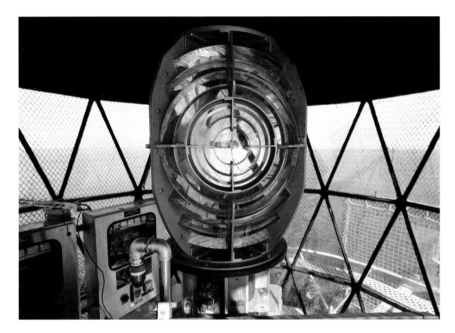

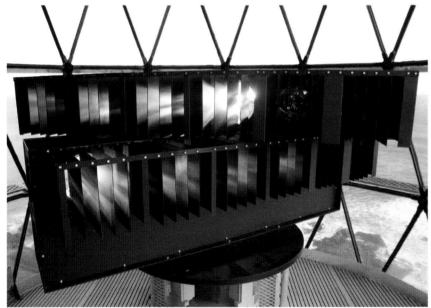

[ABOVE] A PLAQUE MARKING THE 150TH ANNIVERSARY OF SKERRYVORE AND ITS AUTOMATION ON 1ST FEBRUARY 1994

[TOP LEFT] THE CURRENT LENS AT BELL ROCK WAS INSTALLED UPON AUTOMATION AND INITIALLY RAN ON ACETYLENE GAS. THIS HAS NOW BEEN CONVERTED TO SOLAR POWER

[LEFT] THE SEALED BEAM UNIT AT GIRDLE NESS LIGHTHOUSE USING A SERIES OF HEADLAMPS. SEALED BEAM LIGHT TECHNOLOGY WAS USED EXTENSIVELY DURING THE AUTOMATION PROCESS DURING THE 1970S AND 80S

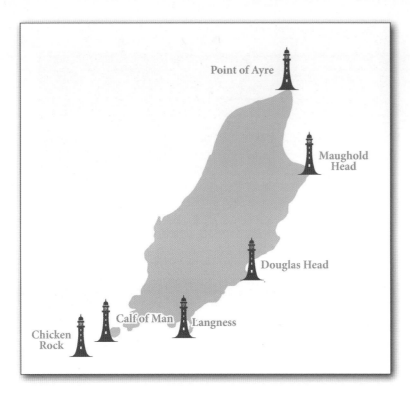

THE ISLE OF MAN

At the beginning of the 19th century there were calls for lights to be erected to mark the increasingly busy trade routes between the west coast of England and east coast of Ireland. This included the unlit coastline of the Isle of Man which was neither the responsibility of the Northern Lighthouse Board or Trinity House.

As early as 1802, Robert Stevenson had identified the need for a lighthouse on the Calf of Man. However, it was not until 1815 that an Act of Parliament was passed giving the Northern Lighthouse Board the necessary authority to build a lighthouse at that location along with another lighthouse on the main island. The Act also allowed for light dues to be charged for their upkeep.

The two leading lights on the Calf of Man and a lighthouse at the Point of Ayre were established in 1818.

Another Act of Parliament in 1854 gave the Northern Lighthouse Board the powers to build other lighthouses on The Isle of Man.

POINT OF AYRE

Engineer:	Robert Stevenson
Established:	1818
Automated:	1991
Character:	Flashing (4) White every 20 seconds
Height:	30 metres
Status:	Operational
Authority:	NLB

162

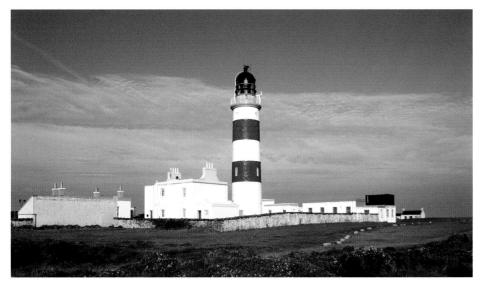

POINT OF AYRE LIGHTHOUSE

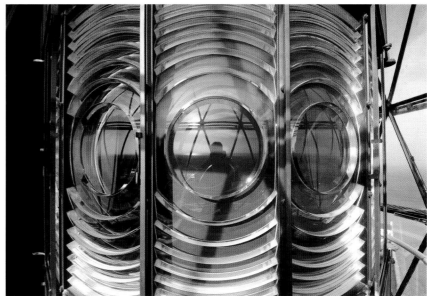

A BRASS VENTILATOR IN THE WATCH ROOM

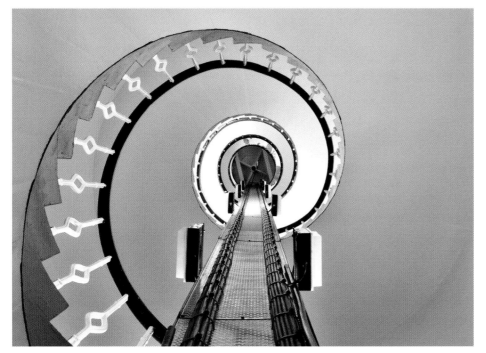

THE LENS AT POINT OF AYRE WAS INSTALLED IN THE TOWER
IN 1891 AND MODIFIED UPON AUTOMATION IN 1991

MAUGHOLD HEAD

Maughold Head is perhaps my favourite of all the Manx stations. It's perched on the side of a cliff and still retains the magnificent first order lens manufactured by Chance Brothers of Birmingham in 1913.

I'm being shown around by Fred Fox, the RLK for the four land-based lights on the Isle of Man. He's an ex-lightkeeper who proudly continues in that tradition by keeping all the brasswork and glass immaculately polished just like days of old.

Engineer: David A Stevenson
Established: 1914
Automated: 1993
Character: Flashing (3) White every 30 seconds
Height: 23 metres
Status: Operational
Authority: NLB

MAUGHOLD HEAD LIGHTHOUSE LOOKING UP
AND LOOKING DOWN

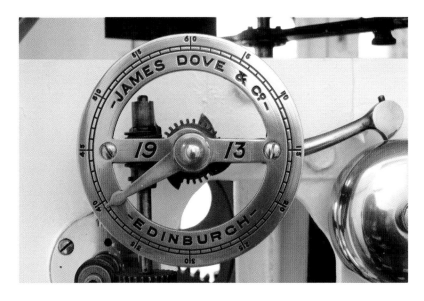

CLOCKWORK MACHINERY WAS BY JAMES DOVE OF EDINBURGH

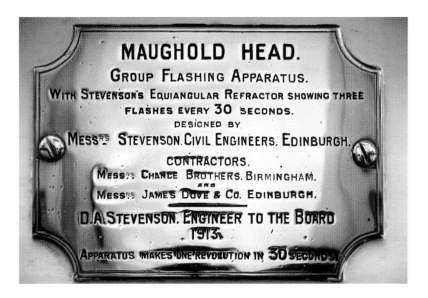

MAUGHOLD HEAD LIGHTHOUSE LENS MANUFACTURED BY
CHANCE BROTHERS OF BIRMINGHAM

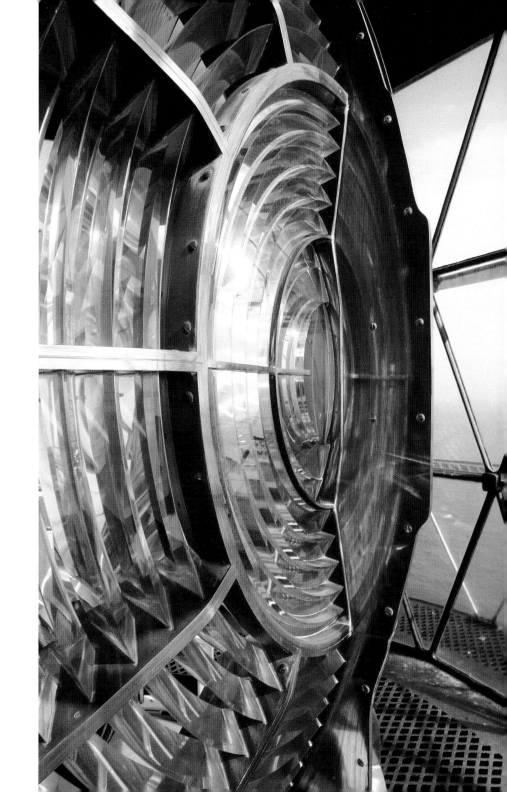

LANGNESS LIGHTHOUSE

LANGNESS

Engineers:	David and Thomas Stevenson
Established:	1880
Automated:	1996
Character:	Flashing (2) white every 30 seconds
Height:	19 metres
Status:	Operational
Authority:	NLB

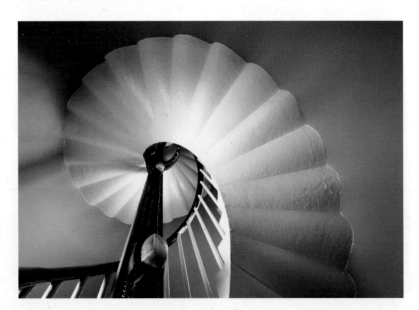

DOUGLAS HEAD STAIRCASE

DOUGLAS HEAD

Engineer:	Robert Stevenson
Established:	1832 (Rebuilt 1892 by David A Stevenson)
Automated:	1986
Character:	Flashing White every 10 seconds
Height:	20 metres
Status:	Operational
Authority:	NLB

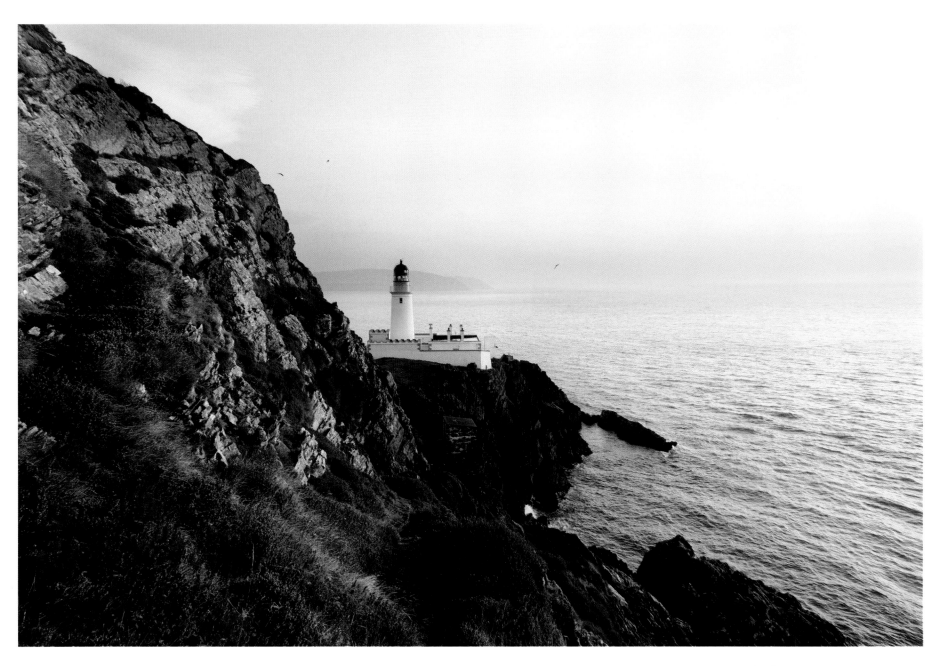

DOUGLAS HEAD LIGHTHOUSE

THE HIGH LIGHT

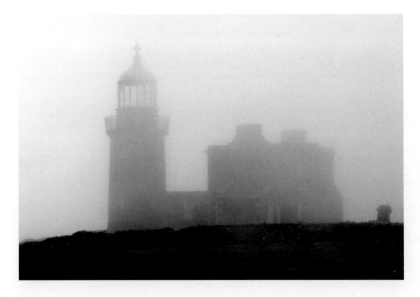

THE LOW LIGHT

CALF OF MAN

The two lights on the Calf of Man were frequently obscured by fog and were replaced in 1875 by the lighthouse on Chicken Rock. With their original cast iron lanterns and unpainted stonework, they provide a good indication of how many of the Stevensons' towers would have looked when they were first built.

Engineer:	Robert Stevenson
Established:	1818
Status:	Discontinued 1875, now owned by Manx National Heritage

CHICKEN ROCK

The last of the great pillar rock towers to be designed by the Stevenson family. Construction commenced during the building of another rock lighthouse at Dubh Artach. Unlike that project and the earlier rock towers at Skerryvore and the Bell Rock, there was no requirement for a temporary barracks to be sited on the rock. The workmen were shipped in from nearby Port St Mary each day. Chicken Rock was built to replace the two lights on the Calf of Man which were frequently obscured by fog.

In 1960 a fire broke out in the lighthouse and the three keepers had to escape via ropes from the lighthouse balcony. One keeper was rescued by the Port St Mary lifeboat via breeches buoy. The high tide and heavy swell deemed the rescue of the other keepers by this means to be too dangerous. They were left to shelter in the entrance doorway for several hours until the tide receded and the lifeboat could approach the exposed rock. The damage to the lighthouse was repaired using techniques similar to that employed at Skerryvore a few years previously. An automatic light was also installed at this time.

On our visit to The Calf of Man, we make a detour out to Chicken Rock. The mist which the Isle of Man is renowned for rolls in from the Irish Sea and there is no sign of the lighthouse.

Suddenly the top of the lighthouse appears making for an unusual shot. As we get closer the lighthouse disappears from view and then reappears.

Engineers:	David and Thomas Stevenson
Established:	1875
Automated:	1961
Character:	Flashing white every 5 seconds
Height:	44 metres
Status:	Operational
Authority:	NLB

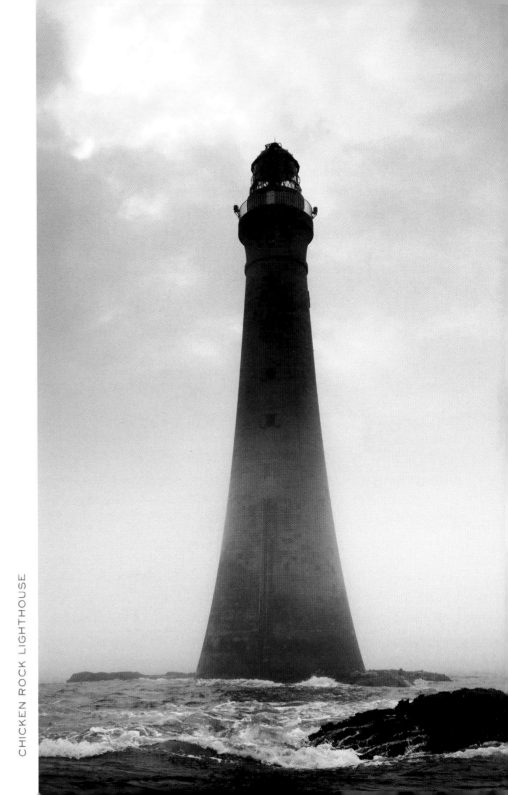

CHICKEN ROCK LIGHTHOUSE

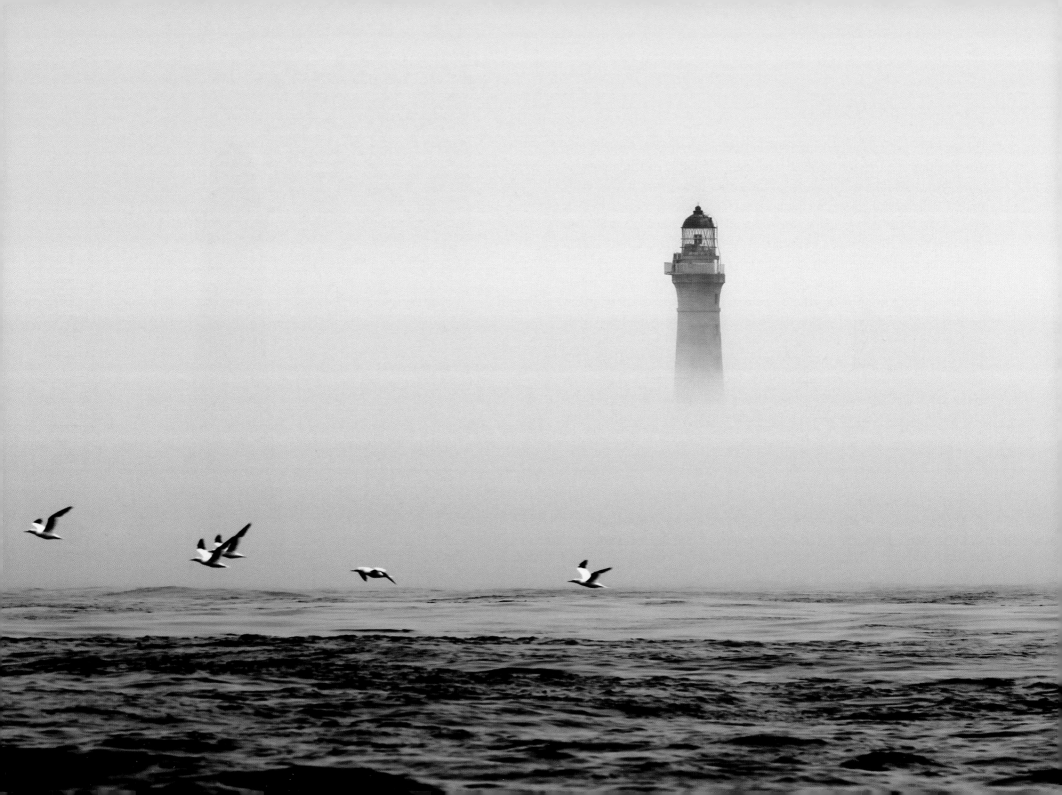

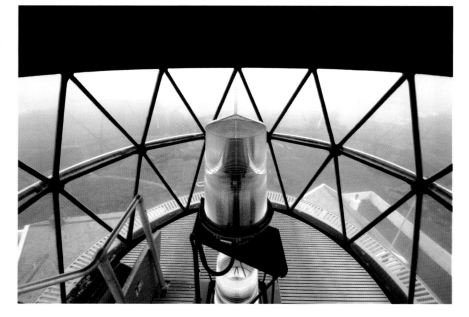

[BELOW] LANGNESS LIGHTHOUSE

[ABOVE] THE MOTTO OF THE NORTHERN LIGHTHOUSE BOARD ON THE
FORMER CHICKEN ROCK SHORE STATION, PORT ST MARY

[LEFT] CHICKEN ROCK APPEARS FROM MIST

THE NORTHERN LIGHTHOUSE BOARD TODAY

The story of the lighthouses around our shores did not end with the completion of the Northern Lighthouse Board's automation programme on 31st March 1998. This period was a time of great change which was not without its trials as technological advances led to an inevitable reduction in staffing requirements. The Northern Lighthouse Board's depots at Granton and Stromness were closed whilst the base at Oban underwent a major refurbishment to improve the facilities for berthing ships, landing and refuelling helicopters, and maintaining buoys.

The Board presently operates two ships. The current *Pharos* came into service in 2007 and is the tenth lighthouse tender to bear that name. The current *Pole Star* was built by Ferguson Shipbuilders on the River Clyde and launched in 2000. She is the fourth tender to bear that name. Both vessels are equipped with dynamic positioning, buoy deployment capability, a hydrographic survey suite, and wreck finding equipment. The *Pharos* has a helideck which is used for servicing and storing offshore lighthouses.

Over the last two decades, all the Northern Lighthouse Board's gas operated lights and buoys have been replaced with safer and environmentally friendly solar powered ones. Many of the old cast iron towers used as minor lights have been replaced with modern aluminium or glass reinforced plastic structures. A number of lighthouses have been switched off or transferred to the ownership of local port authorities. Conversely, a number of new lighthouses have been established on shipping routes which have become busier in recent years.

THE NORTHERN LIGHTHOUSE BOARD'S BASE AT OBAN

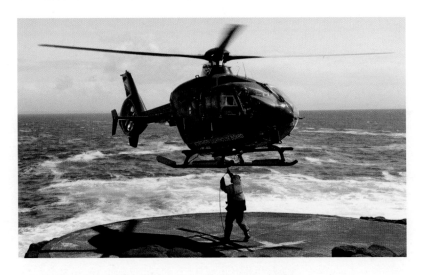

HELICOPTER OPERATIONS AT DUBH ARTACH

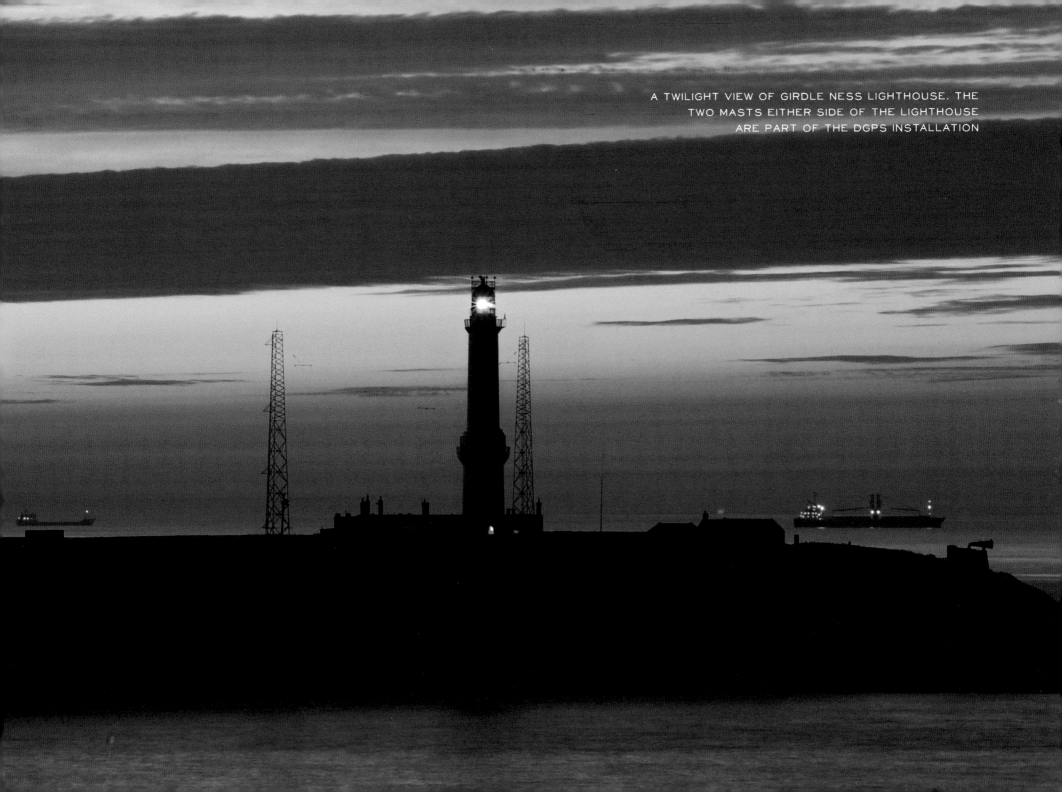

A TWILIGHT VIEW OF GIRDLE NESS LIGHTHOUSE. THE
TWO MASTS EITHER SIDE OF THE LIGHTHOUSE
ARE PART OF THE DGPS INSTALLATION

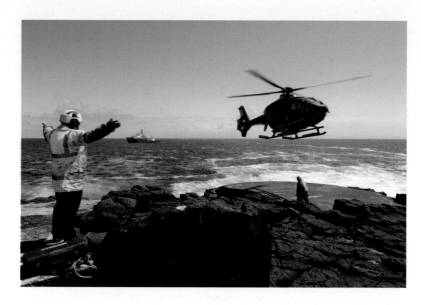

HELICOPTER OPERATIONS AT DUBH ARTACH

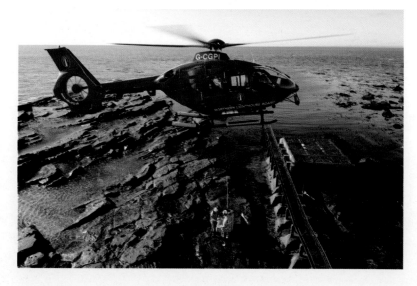

LIFTING MATERIALS AT THE BELL ROCK DURING
A ROUTINE STORING OPERATION

Every lighthouse is covered by a rolling maintenance and painting programme to offset the effects of exposure to the harsh marine environment. In areas which are accessible by road this is relatively straightforward. However, the logistics of work in offshore locations requires a great deal of planning.

The Board's 206 lighthouses are centrally monitored for any faults 24 hours a day, 365 days a year. During working hours this is done from 84 George Street in Edinburgh. Outside normal working hours the lights are monitored from Trinity House's offices in Harwich.

Land-based lighthouses with good accessibility are visited on a monthly or bi-monthly basis by Retained Lighthouse Keepers (RLKs) to ensure everything is functioning correctly. A team of technicians are responsible for the more remote and offshore lighthouses and normally visit these once or twice a year by small boat or helicopter. In the case of the rock towers these visits can involve living in the lighthouse for up to 10 days.

In addition to the physical aids to navigation such as lighthouses, beacons and buoys, a number of other aids are provided. These include RACONS (radar beacons) which appear on ships' radar screens and AIS (Automatic Identification System) shown on satellite based navigation systems. The Northern Lighthouse Board also operates Differential Global Positioning System (DGPS) stations at Girdle Ness, Sumburgh Head and Butt of Lewis lighthouses as well as an inland station in Stirling. The satellite based Global Positioning System (GPS) used by ships can be inaccurate. These four stations continually monitor for errors in the Global Positioning System (GPS) and transmit corrections to the mobile receivers on ships.

Funding

The service provided by the Northern Lighthouse Board and Trinity House, its counterpart in England and Wales, comes mostly from light dues. These are charged on commercial shipping (other than tugs, fishing vessels and pleasure boats which make periodical payments) when they call at ports in the UK. The charges are based on the net registered tonnage of the vessel. None of the Northern Lighthouse Board's funding comes from UK tax payers.

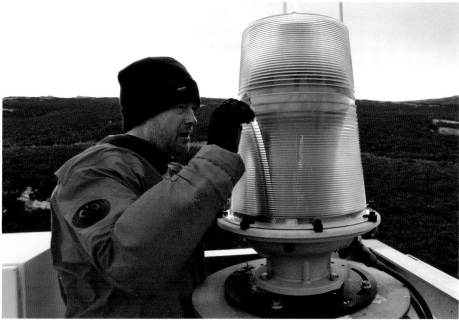

[ABOVE] ELECTRICAL ENGINEERING TECHNICIAN CRAIG
PAKE INSPECTS THE LIGHT AT LOCH ERIBOLL

[TOP LEFT] THE MODERN LIGHT ERECTED
AT LOCH ERIBOLL IN 2003

[BOTTOM LEFT] A LED LIGHT AT
LOCH RYAN LIGHTHOUSE

[ABOVE AND TOP RIGHT AND OPPOSITE PAGE] NLV *PHAROS*

NLV *POLE STAR*

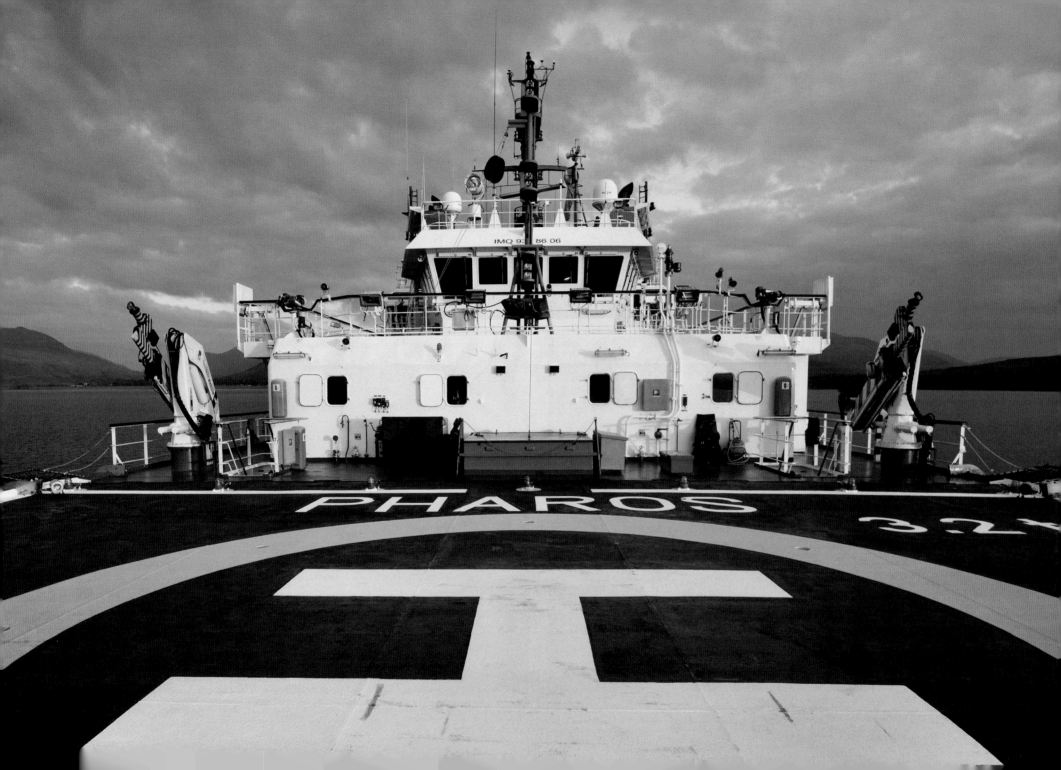

PAINTING WORKS AT LISMORE

STEVIE WELSH, SEAMAN

CAPTAIN ERIC SMITH

DAVIE GALLAGHER – SHIPS CATERER

[ABOVE] LEFT TO RIGHT — ANTHONY ADAMSON, SEAMAN, ERLEND MANSON, BOSUN , IAN MCAULAY — SEAMAN

[ABOVE RIGHT] CRAIG FIELD, CIVIL ENGINEERING TECHNICIAN

[RIGHT] BACK ROW — HROLF DOUGLASSON, ELECTRICAL TECHNICIAN (ORKNEY), STEVE DAILLY, ACCEPTANCE ENGINEER, RALPH PAXTON, SEAMAN, DONALD BROWN, PO DECK MAINTAINER. FRONT ROW — CRAIG PAKE, ELECTRICAL ENGINEERING TECHNICIAN, STEVIE WELSH, SEAMAN, CRAIG FIELD, CIVIL ENGINEERING TECHNICIAN

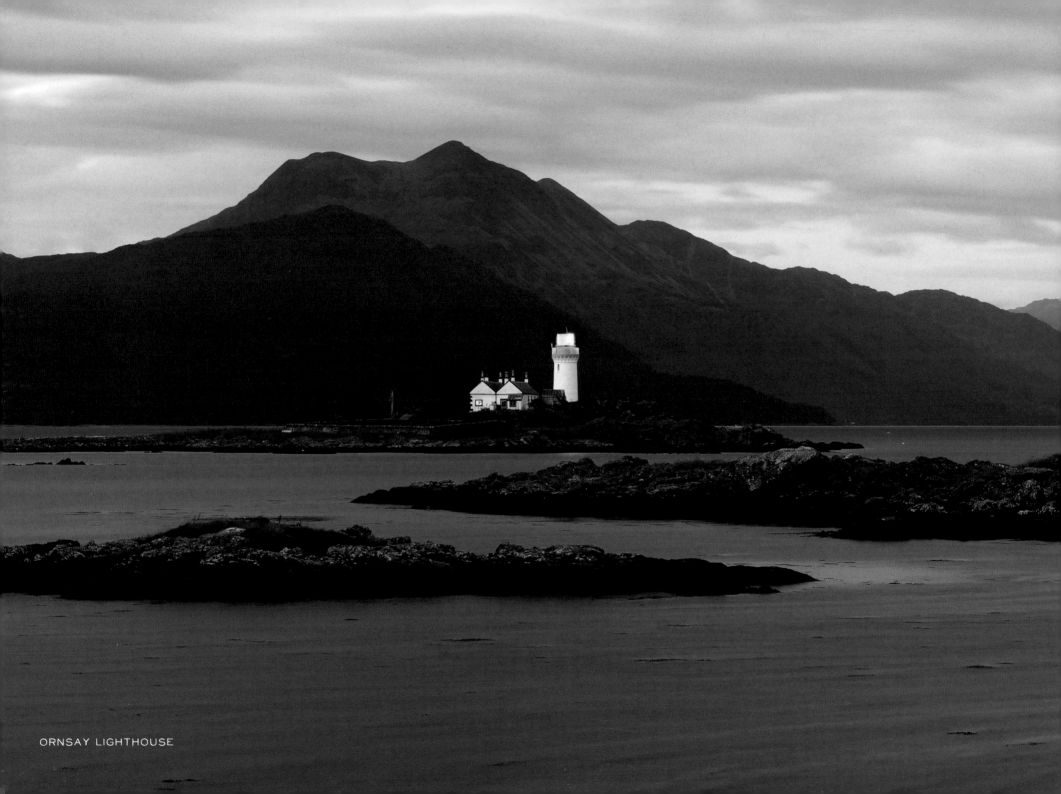

ORNSAY LIGHTHOUSE

BIBLIOGRAPHY

A Light in the Wilderness — David M Hird

At Scotland's Edge — Keith Allardyce and Evelyn M Hood

At Scotland's Edge Revisited — Keith Allardyce

The Lighthouse Stevensons — Bella Bathhurst

A Star for Seamen — Craig Mair

Northern Lights — Alison Morrison-Low

Scottish Lighthouses — RW Munro

Rock Lighthouses of Britain — Christopher Nicholson

Dynasty of Engineers — Roland Paxton

The New Lighthouse on the Dhu Heartach Rock, Argyllshire — Robert Louis Stevenson

An Account of the Bell Rock Lighthouse — Robert Stevenson

The Bell Rock Lighthouse, the Stevensons and Emerging Issues in Aids to Navigation. Conference on Friday 4th February 2011. The Royal Society of Edinburgh

David Taylor's Bell Rock website www.bellrock.org.uk

Northern Lighthouse Board website www.nlb.org.uk

The Royal Commission on the Ancient and Historical Monuments of Scotland (RCAHMS) www.rcahms.gov.uk/

Trinity House website www.trinityhouse.co.uk

Stevenson Archive, National Library of Scotland www.nls.co.uk

PLACES TO VISIT

National Museum of Scotland, Edinburgh. Lens from Inchkeith and model of the Bell Rock Lighthouse

Nelson Monument, Calton Hill, Edinburgh – Rubha Nan Gall lens and exhibition

Trinity House, Leith - model of the Bell Rock Lighthouse

The Isle of May – occasional lighthouse open days

North Carr Lightship, Dundee

Signal Tower Museum, Arbroath

Aberdeen Maritime Museum – original lens from Rattray Head

Museum of Scottish Lighthouses, Fraserburgh

Lossiemouth Fisheries and Community Museum – lens from Covesea Skerries

Covesea Skerries Lighthouse

Wick Heritage Centre – lens from Noss Head

Stromness Museum – lens from Hoy Low

Start Point Lighthouse – lighthouse open days

North Ronaldsay Lighthouse Visitor Centre

Fair Isle South Lighthouse – public access

Sumburgh Head Visitor Centre – lens from Fair Isle North and tours of the lighthouse

Shetland Museum, Lerwick – lens from Bressay

Eilean Ban Lighthouse, Ring of Bright Water Visitor Centre, Kyleakin

Gairloch Heritage Museum – original lens from Rubha Reidh

Ardnamurchan Lighthouse Visitor Centre – original lens and access to the lighthouse

Skerryvore Lighthouse Museum, Hynish, Tiree

War and Peace Museum, Oban - Model of SS Hesperus

Atlantic Islands Centre, Isle of Luing – lens from Fladda

Colonsay House and Gardens – original lens from Ruvaal

Campbeltown Museum – artifacts from Mull of Kintyre

Mull of Galloway Lighthouse – lens from McArthur's Head and access to lighthouse

Stewartry Museum, Kirkcudbright – lens from Little Ross

Science Museum, London – lens from Eilean Glas

National Maritime Museum, Greenwich, London – lens from Tarbat Ness

USEFUL LINKS

The Association of Lighthouse Keepers www.alk.org.uk

The Association of Lighthouse Keepers provides a forum for everyone interested in lighthouses, lightships and maritime aids to navigation. The ALK publish a quarterly magazine and organise a number of events including visits to lighthouses not normally open to the public.

World Lighthouse Society http://worldlighthouses.org